Traditional
Woodblock Prints
of Japan

THE HEIBONSHA SURVEY OF JAPANESE ART

CONSULTING EDITORS

Katsuichiro Kamei, *art critic*
Seiichiro Takahashi, *Chairman, Japan Art Academy*
Ichimatsu Tanaka, *Chairman, Cultural Properties Protection Commission*

Traditional Woodblock Prints of Japan

by SEIICHIRO TAKAHASHI

translated by Richard Stanley-Baker

New York · WEATHERHILL/HEIBONSHA · Tokyo

This book was originally published in Japanese by Heibonsha under the title *Edo no Ukiyo-e-shi* in the Nihon Bijutsu Series.

First Edition, 1972

Jointly published by John Weatherhill, Inc., 149 Madison Avenue, New York, New York 10016, with editorial offices at 7-6-13 Roppongi, Minato-ku, Tokyo 106, and Heibonsha of Tokyo. Copyright © 1964, 1972, by Heibonsha; all rights reserved. Printed in Japan.

LCC Card No. 74-162683 *ISBN 0-8348-1002-6*

Contents

Traditional
Woodblock Prints
of Japan

CHAPTER ONE

The Rise of Ukiyo-e

THE UKIYO-E AND THE SOCIAL SCENE Scattered references to a genre of paintings and prints called ukiyo-e first appear in Japanese literature around the 1680's. The term is an apt one, for *ukiyo* means "floating world," and *e* means "pictures," and thus we can define ukiyo-e as "pictures of the floating world." It is a floating world in two senses: first, in the traditional Japanese sense of a transitory, illusory place and, second, in the sense of the hedonistic life of the age in which the ukiyo-e evolved—that is, the world of fleshly pleasure centering in the theater and the brothel. We also find references around this time to "Yamato ukiyo-e," which are described as pictures that portray the "froth and frippery of society."

The Edo period (1603–1868), which witnessed the birth of ukiyo-e, was at once the age of the most totally integrated feudal system in the history of Japan and the age in which the same system deteriorated and collapsed. It was an age of unprecedented peace after almost a century of civil strife, and it was favorable to the growth of a skillful and affluent merchant class. The merchants, however, suffered under the oppression of the feudal authorities. They had no true freedom, and the full development of their financial strength was severely obstructed, with the result that mercantile wealth was largely squandered in extravagant and unproductive ways.

The townsmen of the time gave themselves over to fleeting delights and spendthrift behavior, drowning their cares in the enticements of the pleasure quarters. As one of their songs had it, "Life is but a dream—enjoy it while you can." And the *ukiyo-e-shi*, the artists who skillfully depicted this floating world, were admiringly described as "those who painted the Naka-no-cho, which no artist of the Kano or the Tosa school could do." In other words, the *ukiyo-e-shi* pictured such sights as the main street of the Yoshiwara, the celebrated brothel district of Edo (present-day Tokyo), choosing subjects that no painter of the established academic schools would ever dare to portray.

Second only to the pleasure quarters as centers of entertainment were the theaters. One of the favorite themes of the ukiyo-e artists was the Kabuki theater (Fig. 5), whose very life lay in the expression of formal pictorial beauty, particularly in the climactic scenes of the drama. In contrast with the court-sponsored Bugaku dances of the Nara (646–794) and Heian (794–1185) periods and the warrior-sponsored Noh drama of the Muromachi period (1336–1568), Kabuki was the dramatic art of the merchant townsmen of the Edo period. Similarly, in contrast with the *yamato-e* style of painting sponsored by the Heian-period nobility and the Chinese-style *kanga* (painting in the manner of the Sung and Yuan dynasties) that developed under the patronage of the warrior class in the Kamakura (1185–1336) and Muromachi periods, ukiyo-e was the graphic art of the Edo-period mercantile class.

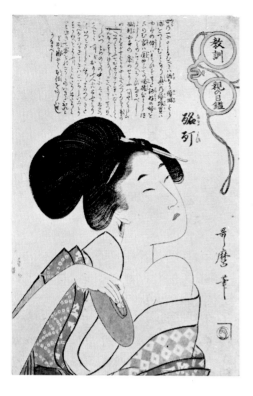 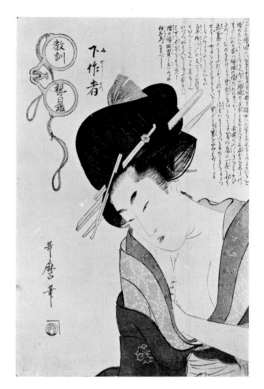

And like Kabuki, which from its birth was licentious and bizarre, ukiyo-e began as a sensual art form aimed at popular tastes. While early Kabuki, with its use of actresses and, a bit later, of young male actors, or *wakashu* (Fig. 18), tended to stress sensuality, the emphasis gradually shifted to the quality of the performance itself. Still, the effeminate young actors, who played female roles and were known as *iroko* (catamites), remained a distinctive feature of the Kabuki for some time, serving the double function of actors and boy prostitutes. Ukiyo-e artists, by frequently depicting the illicit and eccentric passions in which the *iroko* played their part, amply satisfied the tastes of the rising merchant class.

In fact, in order to fulfill the demands of their patrons, the ukiyo-e artists repeatedly portrayed the intimacies of the bedroom. As painters who devoted their attention to the pleasures of the float-ing world, they were ultimately obliged to picture the sexual passions of men and women, and there were indeed few of them who did not paint *higa* (erotic pictures). Interestingly enough, in the Edo period the term ukiyo-e was often used as a synonym for *higa*, and in the contemporary book *Taikan Zakki* (Jottings at Leisure) there are indications that the author, Shirakawa Rakuo* (1758–1829), regarded ukiyo-e and *higa* as one and the same thing.

It was not long, however, before ukiyo-e were subjected to government pressure. They became a target for vengeance, notably on the part of those officials who favored sumptuary retrenchment in their extensive efforts to strengthen the feudal sys-

*The names of all premodern Japanese in this book are given, as is this case, in Japanese style (surname first); those of all modern (post-1868) Japanese are given in Western style (surname last).

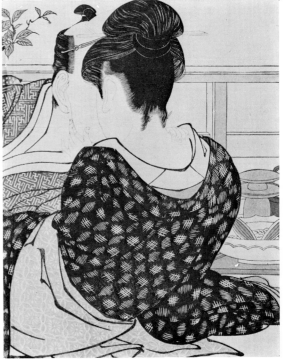

⊲ 1 (*opposite page, left*). *Kitagawa Utamaro:* The Tipsy Courtesan *from* Through the Parents' Moralizing Spectacles. *Oban nishiki-e. Between 1801 and 1804.*

⊲ 2 (*opposite page, right*). *Kitagawa Utamaro:* The Lazy Daydreamer *from* Through the Parent's Moralizing Spectacles. *Oban nishiki-e. Between 1801 and 1804.*

3. *Kitagawa Utamaro: detail from an illustration for an erotic book. Dated 1788.*

tem. When the publication of "licentious material" was banned, the ukiyo-e artists, who had been producing not only pictures of actors and beautiful women (their main stock in trade) but also pictures of heroic warriors (Fig. 40), innocent children, and the like, undertook to present the latter subjects in such a manner that they too became licentious. In a similar effort to evade official censure, they aped the administrative procedures of the shogunate government by hanging out signboards resembling the government's own proclamation boards and, taking advantage of the currently fashionable Sekimon *shingaku,* a puritanical code of ethics that outlined correct conduct for the merchant class, they embellished their work with grandiose phrases of moralistic tone. In the Kyowa era (1801–4), for example, Kitagawa Utamaro published a set of prints entitled *Kyokun Oya no Megane* (Through the Parents' Moralizing Spectacles), of which two are shown in Figures 1 and 2. One of these depicts a tipsy courtesan (Fig. 1), and its inscription informs us that "one of the things a woman should learn to relish is sakè" and goes on to note that the astute buyer of courtesans is decidedly not one to choose a tipsy harlot. The heart of the matter, however, seems to be revealed in the succeeding sentence: "The client who favors a winebibbing whore is surely one who thinks her performance will be all the better when it comes to the intrigues of the inner chamber."

The development of *fukeiga,* or ukiyo-e landscape prints, was also possibly related in some respects to a partial and often simulated observance of the sumptuary edicts of the shogunate: the enforcement of thrift and the official restrictions on entertainment. These policies motivated both woodblock-print artists and the publishers of their works to seek themes outside the pleasure quarters and the

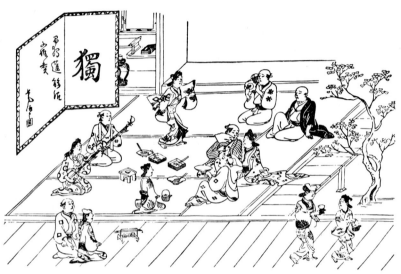

4. *Hishikawa Moronobu:* Courtesans, Guests, and Musical Entertainers *from* The Style and Substance of the Yoshiwara. *Horizontal oban sumizuri-e. Dated 1678.*

5. *Torii Kiyotsune:* Interior of the ▷ Nakamura-za *from* Uki-e of Theater Scenes. *Horizontal oban benizuri-e. Dated 1765.*

theater. Another important background factor in the development of landscape prints was the shogunate's imposition of severe restrictions on travel —a prohibition that must have increased the demand for pictures of places in Japan that could not actually be visited by those who bought the prints.

The ukiyo-e artists produced not only *hanshita-e,* or underdrawings for prints, but also *nikuhitsuga,* or ukiyo-e paintings. In fact, some of these artists spent their lives in fulfilling the demand for *nikuhitsuga* and made no woodblock prints at all. But, as the late Sohachi Kimura pointed out, although it is also possible that there were ukiyo-e artists who never produced a *nikuhitsuga,* without the production of woodblock prints the genre we know today as ukiyo-e would probably not have come into existence at all.

At the risk of overgeneralization it may be observed that *nikuhitsuga* were in many cases painted by artists who had already made a name in the production of prints and who, in their mature years, began to accept orders from the rather affluent merchant class. These print artists, who had habitually relied on the block carver's chisel to give strength and life to their lines and on the printer's brush and *baren* pressing pad to bring out the beauty of the colors, must have had to face new problems when they turned to the production of paintings alone. Once they had left the familiar medium of the small-sized paper used for the underdrawing and were confronted with a relatively large area of paper or silk, they must have realized how weak their brushlines actually were and, at the same time, no doubt became acutely conscious of problems in painting that could not be solved by techniques that had served for color printing.

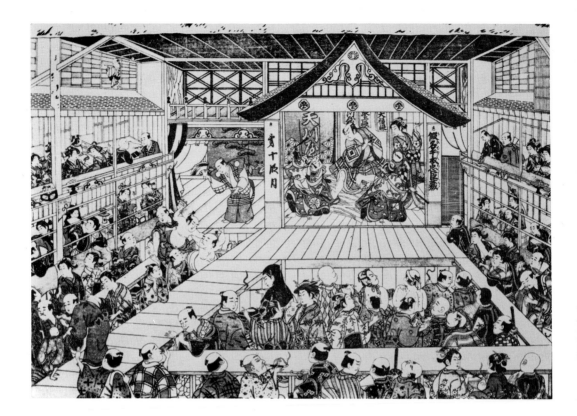

TECHNICAL DEVELOPMENTS IN WOODBLOCK PRINTING

Ukiyo-e prints were the products of a collective effort by a variety of craftsmen—painters, carvers, and printers—who were all organized under the direction of dealers known as *jihon-don'ya*. The dealers also handled the distribution of the finished prints.

In the early stages of development a large number of plain black-ink prints (*sumizuri-e*) were produced along with prints that were colored by hand, mainly with *tan* (a red-lead pigment) or *suo* (a dark-red pigment obtained from sapanwood). Around the beginning of the Kyoho era (1716–36), however, we note the appearance of numerous prints that employed, in particular, a deep pink color known as *beni,* and in some of these prints the pigment was mixed with glue to produce a prominent glazed effect. Such prints were called *beni-e* (red prints) or *urushi-e* (lacquer prints), but since there are some *beni-e* in which no glue was used, it may be possible to make a distinction between *beni-e* and *urushi-e*.

It appears that during the age of *beni-e* the work of coloring the prints by hand was largely entrusted to pieceworkers who performed the task at home. These simple *beni-e* could be printed at the rate of about two hundred a day and were immediately turned over to the colorers, who adjusted their pace to that of the printers and thus colored a large number of prints at great speed. Eventually, however, the colorers could no longer keep up with the printers, and at this point the hand-colored *beni-e* came to be replaced by the simple *benizuri-e*, for which the colors were applied directly to the printing block. The decline of the *beni-e*, accompanied by

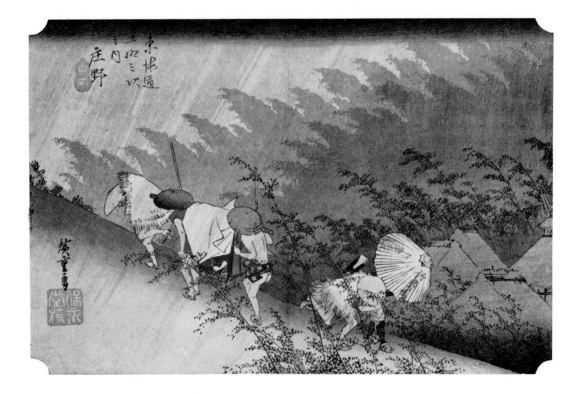

東海道五拾三次之内
庄野
白雨

6. *Ichiryusai Hiroshige:* Shono *from* The Fifty-three Stations on the Tokaido. *Oban nishiki-e. Dated 1833.*

7. *Katsushika Hokusai: design of plovers and waves for the cover of an erotic book. About 1813.*

the gradual emergence of the *benizuri-e,* is considered to have taken place around the Enkyo and Kan'en eras (1744–51).

The peddlers of *beni-e* may not all have been such comely youths as the one called Edohachi who appears in Enomoto Torahiko's Kabuki drama *Genroku Hanami Odori* (Flower-viewing Dance of the Genroku Era), but it is most likely that *beni-e* were

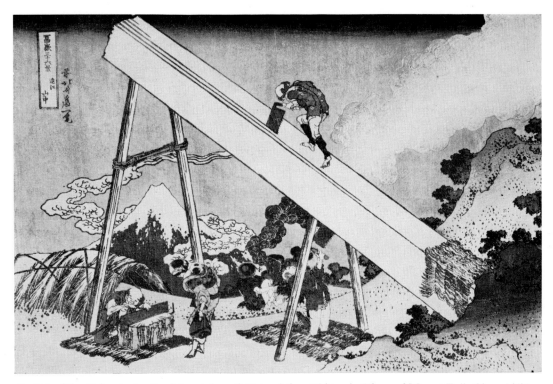

8. *Katsushika Hokusai:* In the Mountains of Totomi *from* Thirty-six Views of Mount Fuji. *Oban nishiki-e.* *Between 1823 and 1833.*

sold from door to door by under-age youths who walked the streets of Edo crying their wares in melodious tones. One print that survives from the age of *beni-e* is a charming portrait of a young man selling single-sheet prints (Fig. 12). It pictures him holding a bamboo pole hung with *beni-e* and carrying on his back a box surmounted by a model of one of the pleasure houses in the Yoshiwara. The box is inscribed with the legend "fashionable *beni*-colored portraits."

The peddling of single-sheet prints (*ichimai-e*) appears to have continued until about the middle of the Kansei era (1789–1801). In Yamada Keio's *Horeki Genraishu* (Collection from the Present Era of Horeki), published in 1831, the author tells us that "until the middle of the Kansei era, *ichimai-e,* booklets, and the like used to be sold on the streets at

New Year's, but later the peddlers came no more." It is thought that after this time single-sheet prints were sold mainly in shops.

During the regime of the shogunate's grand chamberlain Tanuma Okitsugu—that is, from 1767 to 1786—when enforcement of the sumptuary laws was extremely lax, the woodblock print gradually increased its repertoire of colors from two to three and then four and five or more and was eventually transformed into the resplendent *nishiki-e,* or polychrome print. It is interesting to note that the *nishiki-e* originated as a form of amusement among the leisure class and that it was men of fashion who first supplied the design ideas for such prints. But it was not long before this pastime of leisured sophisticates was taken over and commercialized by the shrewd merchant townsmen.

CHAPTER TWO

The Life and Status of the Ukiyo-e Artists

THE UKIYO-E ART-ISTS AND THE WHOLESALE DEALERS The previously noted *jihon-don'ya* were wholesale dealers who for the most part handled "soft" literature like the *kusazoshi* (illustrated storybooks) as opposed to the more serious "hard" literature (scholarly works) that emanated from the Kyoto-Osaka region, and it was they who also sponsored the publication of the polychrome prints known as *nishiki-e*. The ukiyo-e artist, having received an order from a dealer, produced an underdrawing for inspection and approval by a specially appointed representative of the dealers' corporation or, in later times, by a government official. Once the underdrawing had been accepted and marked with a stamp of approval, it was handed over to the artisans who carved the wooden blocks for the prints. The system of the stamp of approval is said to have originated from edicts issued to local authorities by the shogunate government in May and September of 1790, although one theory claims that before the Tempo reforms of 1841–51 the inspections were carried out autonomously by the corporation of wholesale dealers and that after that time they became the responsibility of lower-ranking civil servants. The system became more complicated as time went on. Single-sheet prints and other publications in the category of "soft," or popular, literature were first subjected to a brief examination by the publishers themselves while still in draft form and then were handed on to the corporation-appointed official in charge of checking such materials. If they received his approval, they were sent on to the appropriate government official for final approval and issuance of a permit for publication.

The actual production of the prints began, of course, with the block carvers, who, like most other artisans, were required to put in about ten years of apprenticeship before they were considered masters of their craft. Once the black-ink block and the color blocks had left their hands, the printers took over and employed the blocks, one by one, to print the basic design and the colors on sheets of *masa* (a straight-grained handmade paper) or *hosho* (a high-quality traditional paper, also handmade). Before the final printing began, proof copies taken from the blocks were printed on a strong paper known as *minogami* and shown to the artist so that he could give instructions concerning the color tones. The process thus included redirections based on the proof copies. After printing was completed, the finished *nishiki-e* were transferred to distributors called *setori* who then delivered them to shops scattered all over the city.

The wholesale dealers formed trade corporations

9. Hishikawa Moronobu: Behind the Painted Screen. *Oban tan-e. Between 1673 and 1681.*

and joint stock companies and thereby attempted to obstruct the operation of business firms controlled by people who were not members of their organizations. The dealer corporations had originally been formed for the purpose of eliminating harmful commercial practices and of promoting the common profit of their members. At the same time the government authorities permitted the existence of such corporations because of the obvious advantages they offered for the supervision of commerce in general. In effect, the Tokugawa shogunate policy of safeguarding the interests of tradesmen in Edo, in particular, resulted in the establishment of what Japanese historians have called an economic feudal system subsidiary to the military feudal system and thus, in turn, raised the position of members of corporations and joint stock companies to that of an economic aristocracy.

Like other wholesalers, the dealers in prints and popular literature were financed by the issuance of shares and were organized into eleven *kogumi* (old guilds) and seven *karigumi* (temporary guilds). The *karigumi* were the guilds added to the *kogumi* in a restoration of the system after the above-noted Tempo reforms had achieved the temporary abolition of all stock companies from 1841 on. In 1851, when certain laws of the Bunka era (1804–18) were revived, the trade corporations were granted recognition on the basis of their status quo in that era in order to prevent unemployment among carvers and printers. As a result of this legislation the corporations acquired a monopolistic position and succeeded in obstructing operations by all enterprises other than those of the wholesale-dealer shareholders. Thus the nonshareholding dealers were totally excluded from legal publishing and

 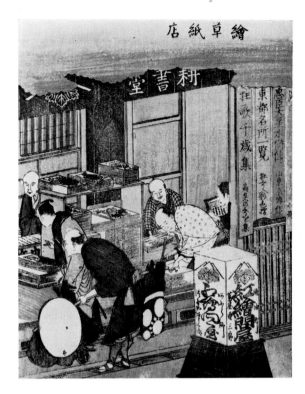

were treated as unlicensed wholesalers. It should be noted as a matter of interest, however, that bartering in shares was, as a rule, unrestricted.

The wholesalers of polychrome prints differed from the wholesalers of other common goods in that they made no distinction among the three activities of wholesaling, brokerage, and retailing. Those who commanded a fair amount of capital could often administer the diverse functions of publishing, wholesaling, and retailing. There were others, however, who did not open shops on the main streets for retailing but confined their operations to publishing and wholesaling.

The shops that retailed prints and popular literature were normally located in the heart of the city, and many of the ukiyo-e artists, including Kitagawa Utamaro, Kitao Masayoshi, Katsushika Hokusai, Utagawa Toyokuni I, and Utagawa Kunisada II, pictured the scene at the front of them. At such shops, polychrome prints and the

like were suspended from horizontally stretched pieces of thin kite string so that they were readily visible to passersby (Fig. 10). When a customer indicated the print of his choice, the shopkeeper gave it a light pull to free it from its bamboo clips, deftly rolled it up, wrapped it in thin paper, and presented it to him.

Shops like these were still to be found in Tokyo as late as the end of the Meiji era (1868–1912). In Kyoka Izumi's novel of 1902, *Sammai Tsuzuki* (Triptych), there is a description of such a shop in the back streets of Tokyo where a mother and her daughter who have seen better days manage to make a meager living. But the shops disappeared one by one as the Meiji era came to a close.

In Figure 11, which is taken from Katsushika Hokusai's series *Ehon Tokyo Ryo* (Illustrations of Entertainment in the Eastern Capital), published in 1802, we see the wholesale shop of Tsutaya Juzaburo, who was nicknamed Tsutaju. Figure 10

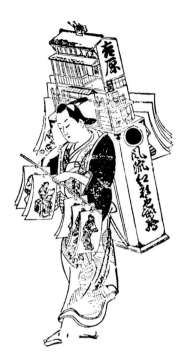

10 (*opposite page, left*). *Baichoro Kunisada (Kunisada II):* In Front of the Print Shop *from an illustrated book entitled* The Story of the Wake at the Nezumi Shrine. *Black-ink print. Dated 1867.*

11 (*opposite page, right*). *Katsushika Hokusai:* Tsutaya Juzaburo's Picture-Book and Print Shop *from the illustrated book* Entertainments in the Eastern Capital. *Color print. Dated 1802.*

12. *Unknown artist:* The Beni-e Seller. *Sumizuri-e. Between 1716 and 1736.*

reproduces an illustration by Baichoro Kunisada (Kunisada II) from a book by Ryutei Tanehiko II published in 1867, and here we see the shop of a retailer who sells prints and popular-style literature.

| THE LIFE AND CHARACTER OF THE PRINTMAKERS | For the three groups of artist-craftsmen who took part in printmaking—the painters, the carvers, and |

the printers—the wholesalers played the role of something like bankers, for their command of capital enabled them to control the activities of the craftsmen and force them into positions of dependence. Some of the wholesalers, in fact, provided living expenses for their able painters and attempted to monopolize their talents. The artist Hanegawa Chincho, who was known as a man of strict integrity, is said to have turned down the offer of one such wholesaler with the statement "I will never sell my brush in order to sponge on others."

Utamaro, however, lived for some time on the hospitality of the above-mentioned Tsutaya Juzaburo, owner of the Koshodo publishing house.

Ukiyo-e painters were also book illustrators. In the early days of printmaking, publishers paid one hundred *mon* per illustration (a *mon* at this time equaled a little over seven cents) for use in the currently popular storybooks. By the time of Kitao Shigemasa (1739–1820), who was recognized as a master ukiyo-e artist, the rate had risen to nearly two hundred *mon* per illustration, and it later went as high as five hundred. Shigemasa was an openhearted man of simple wants who tended to leave questions of price to his manager and did not ask much for his work. Nevertheless, he had an increasing number of admirers who clamored for his pictures, and although at first he lived in a slum district, he gradually became more and more prosperous. Hokusai (1760–1849) and Toyokuni I (1769–1825), who were extremely popular painters in

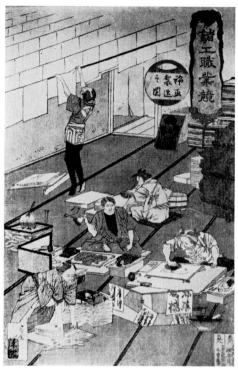

13. *Toshikazu Hosoki:* Printmakers at Work *from* Various Trades and Crafts. *Oban nishiki-e. Dated 1879.*

14. *Katsushika Hokusai: diptych color print from the picture book* Views of ▷ Both Banks of the Sumida River. *Dated 1806.*

their time, are said to have received a commission of one *bu,* two *shu* each for their illustrations of vendetta stories: an amount that equaled about $17.25 or three times the average cost of living per month in Edo. Ukiyo-e painters who kept abreast of contemporary tastes and became popular were able, by virtue of their artistic skill, to achieve a kind of personal monopoly in certain types of pictures and thereby to resist in some measure the capital monopoly of the wholesalers.

Toyokuni I, the most popular ukiyo-e artist of his time, was commissioned by the publisher Igaya Bunkido to illustrate a multivolume novel by the social satirist Santo Kyoden (1761–1816). Although he had received his fee in advance, he was so proud of his artistry that he would not lightly set to work. When he informed the publisher of his reluctance to begin, he was presented with luxurious gifts of food and drink and with an expensive silk coat bearing both his own crest and that of Kyoden. In addition,

he was invited to the theater and feted with banquets at choice restaurants. As if this were not enough, Toyokuni complained that he was being kept from his task by the constant stream of visitors to his studio and the importunities of other publishers, whereupon he was supplied with specially rented quarters in a back street and, on top of this, had his daily meals and his sakè delivered to him there—all at Igaya Bunkido's expense and with the eventual result that the poor publisher was unable to realize a profit on the venture because of the incidental expenses. Yet even the famous Toyokuni is said to have started out as an unpaid painter in the employ of Izumiya Ichibei of the Kansendo publishing house, whom he begged to accept his underdrawings for woodblock prints.

Gototei Kunisada, a disciple of Toyokuni's who later styled himself Toyokuni II (he was actually Toyokuni III), was a highly successful ukiyo-e artist whose polychrome prints and triptychs com-

manded substantial prices. He was so prosperous, in fact, that it was said of him; "Publishers of *nishiki-e* are his obedient slaves and flock to beg for his work." In contrast with most other ukiyo-e artists, he was born into a relatively well-to-do family, and he painted with great vigor throughout his seventy-eight years of life. Although he was a man of considerable means, he was rather tightfisted by nature, and when his publishers' employees came to collect the finished work from him, he would hand over a receipt for his fee together with the painting, thus making sure that he exchanged the work for cash. A remark made in his old age, however, betrays his feelings about such arrangements, for he said: "I don't know why, but collecting the fee makes me feel rather sad." We learn to our interest that he took a geisha for his second wife and then built a luxurious retreat in the Kameido district of Edo. Later he gave this villa to his daughter and her husband and built a new one in Yanagishima.

In comparison with Kunisada's prints of beautiful women and actors, the work of his colleague Ichiyusai Kuniyoshi, who was known as Musha-e no Kuniyoshi (Kuniyoshi of the Warrior Prints), was much less expensive, for he apparently received two *shu*, or about $5.75 for a triptych. While he was still an unknown artist, his publisher, seeing that his work would sell, bought the products of his painstaking labor for the price of about three Tempo-era *sen* (about $5.60) for three pictures. It is said that when Kuniyoshi was about twenty-seven or twenty-eight he was still the "associate of three Tempo *sen* for three prints."

Unlike his senior colleague Kunisada, Kuniyoshi was a typical Edokko (a true denizen of Edo) of the artisan class who would "never let tomorrow's sun rise on the earnings of today." We are told that he accepted any order from a publisher if he liked him, regardless of the fee involved, but that when he was not happy about the publisher he would refuse an

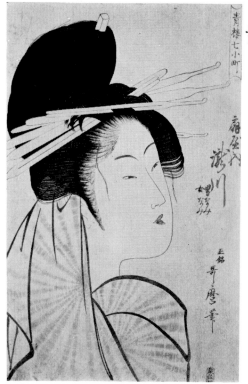

Even the great ukiyo-e master Hokusai never managed to escape a life of extreme poverty, although for seventy-odd years he was widely favored with orders for his work and painted anything and everything in his stalwart style. He was an eccentric figure who changed his name as an artist some twenty times and changed his place of residence at least ninety times during the course of his life. It is thought that his frequent taking of new art names resulted from the need to sell his discarded names to his disciples—a practice by no means uncommon. Similarly, his remarkably numerous changes of address were very probably dictated by his straitened circumstances.

Nor was the famous Hiroshige an exception in this respect. Throughout the sixty-one years of his life this gentle and diligent painter of great landscapes obeyed the wholesalers' orders implicitly and was satisfied to receive for each of his paintings a fee that was only twice the daily wage of common laborers who were then working on the construction of a fort at Shinagawa designed for the defense of Edo. He simply worked in quiet concentration to produce his *hanshita-e* and, unlike other artists, never broke a promise made to his publishers. Nor was he ever late with his work. But even though he labored industriously, producing a total of some eight thousand prints during his career, it seems that he was never able to enjoy a comfortable life. We know that he sold off his first wife's clothing, combs, and other hair ornaments in order to defray his travel expenses. His second wife once served as a housemaid in the residence of the Wakui family, whose head was one of the senior officials of Edo. After her marriage to Hiroshige she visited the family regularly, bringing copies of her husband's prints as gifts, and was treated to food and wine in return. It is said that she also borrowed money from the family from time to time and that Mineko, the mistress of the household, would often complain: "Oyasu has come again. What a nuisance!" Again, we are told that Kishimoto Kyushichi, one of the

order, even if it promised to pay well. After he had made his name, he acquired numerous disciples, and his income was quite substantial, but it was his custom to divide the takings among his students and buy fine clothes for his wife, while he himself continued to dress like a penniless artisan and had barely a change of clothing in his wardrobe. Moreover, he often borrowed money.

The comic storyteller San'yutei Encho was apprenticed to Kuniyoshi early in his career, but his father, Tachibana Entaro, then began to have doubts about how much wealth his son could actually accrue, even if he became a well-known artist. Becoming pessimistic about Encho's future he exerted pressure on him to give up painting. When he learned of Entaro's objections Kuniyoshi could only sigh and say: "It is hard to achieve wealth and honor with the painter's brush. What Entaro says is true." And he told Encho to leave.

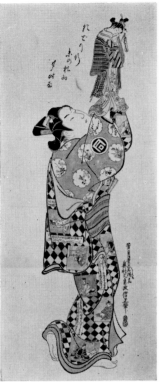

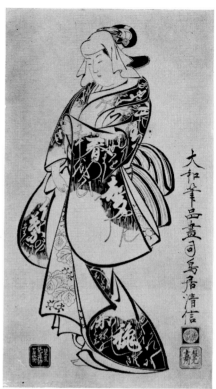

16. *Okumura Masanobu:* The Actor Sanokawa Ichimatsu as a Puppeteer. *Large oban urushi-e. Between 1736 and 1741.*

17. *Torii Kiyonobu:* A Beautiful Woman. *Large oban sumizuri-e. Between 1704 and 1716.*

official purveyors of money to the daimyo, assisted Hiroshige with his living expenses.

Around 1877 the fees paid to Yoshitoshi Tsukioka, an illustrator in the ukiyo-e world of the Meiji era, amounted to no more than three yen, fifty sen (about $1.75) for a triptych. Later, however, they rose to five yen ($2.50), and in October 1884, when Buemon Akiyama of the Kokkeido, in Tokyo, published his great work *Tsuki Hyakushi* (One Hundred Views of the Moon), he received an average of ten yen ($5) for a triptych.

The sharp increase in the income of the noted ukiyo-e painters of this time and the extraordinary improvement in their standard of living were occasioned by the competition among the illustrated newspapers to attract the best illustrators. Yoshitoshi was employed by the *E-iri Jiyu Shimbun* (Illustrated Liberty News) for a monthly salary of forty yen ($20) and furnished with a jinrikisha decorated

with the Tsukioka family crest to take him to and from work. Later his salary was increased to one hundred yen a month, and he was given twenty bonus shares in the company in addition to his own private jinrikisha—all to the open-mouthed astonishment of his contemporaries.

It appears that some publishers resented the high fees of the famous ukiyo-e artists and endeavored to employ only nameless artists. To crown it all, they induced these artists to produce forgeries of the works of well-known artists. We know, for example, that the artist Shiba Kokan deceived people with his imitations of Suzuki Harunobu, since he himself admitted it. Utamaro occasionally signed his works "the genuine signature of Utamaro" (Fig. 15), from which it is clear that he too was the victim of forgery. In his *Nishiki-ori Utamaro-gata Shin Moyo* (New Polychrome Prints in the Utamaro Style) he boasted: "My fees are as high as my pride" and

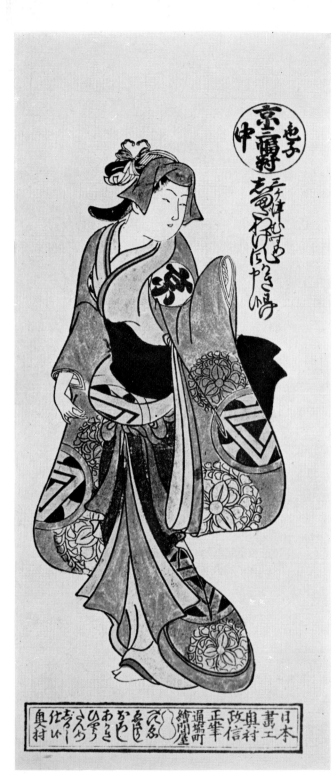

18. *Okumura Masanobu:* Kyoto *from* Iroko of the Three Great Cities. *Hosoban beni-e. Between 1716 and 1748.*

19. *Toshusai Sharaku:* The Actor Ichikawa Ebizo ▷ as Takemura Sadanoshin. *Oban mica nishiki-e; height, 36.6 cm.; width, 24.8 cm. Dated 1794.*

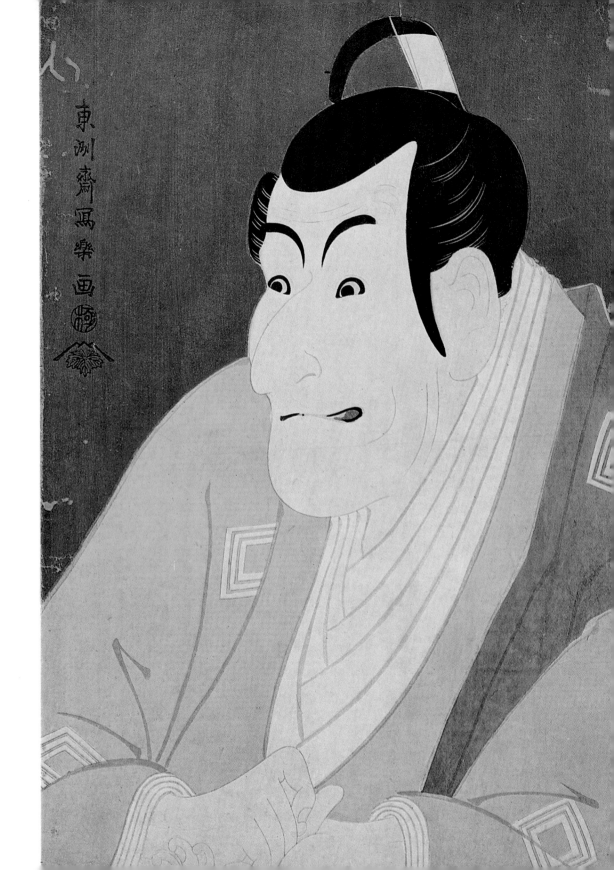

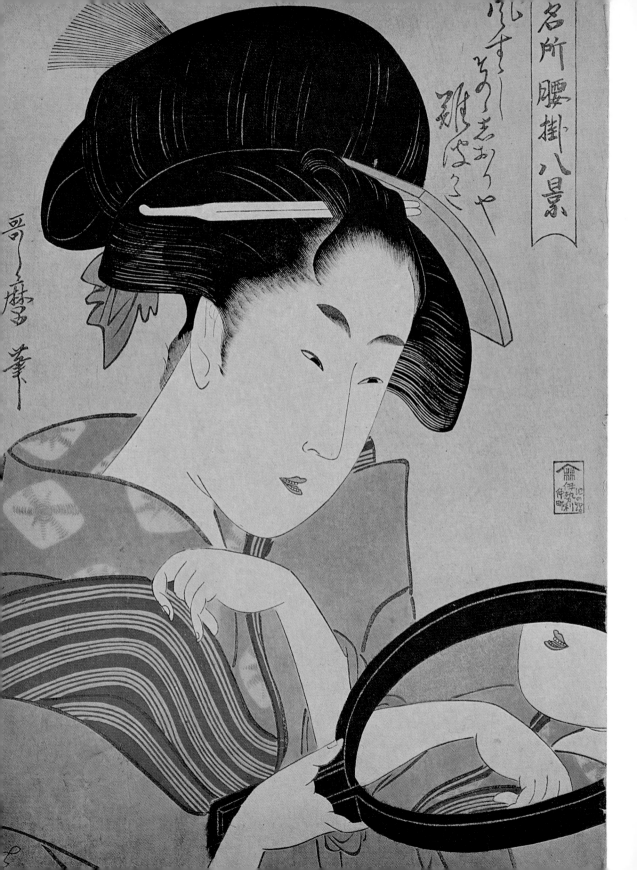

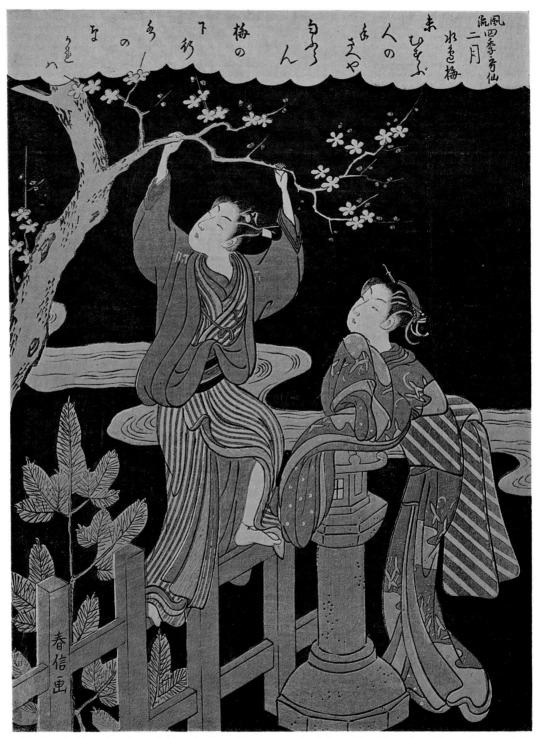

21. *Suzuki Harunobu:* Second Month: Plum Blossoms at the Edge of the Water *from* Elegant Poetry of the Four Seasons. *Chuban nishiki-e; height, 27.9 cm.; width, 20.8 cm. About 1769.*

◁ 20. *Kitagawa Utamaro:* Okita of the Naniwaya *from* Eight Views of Famous Teahouses. *Oban mica nishiki-e; height, 36.3 cm.; width, 26.1 cm. About 1790.*

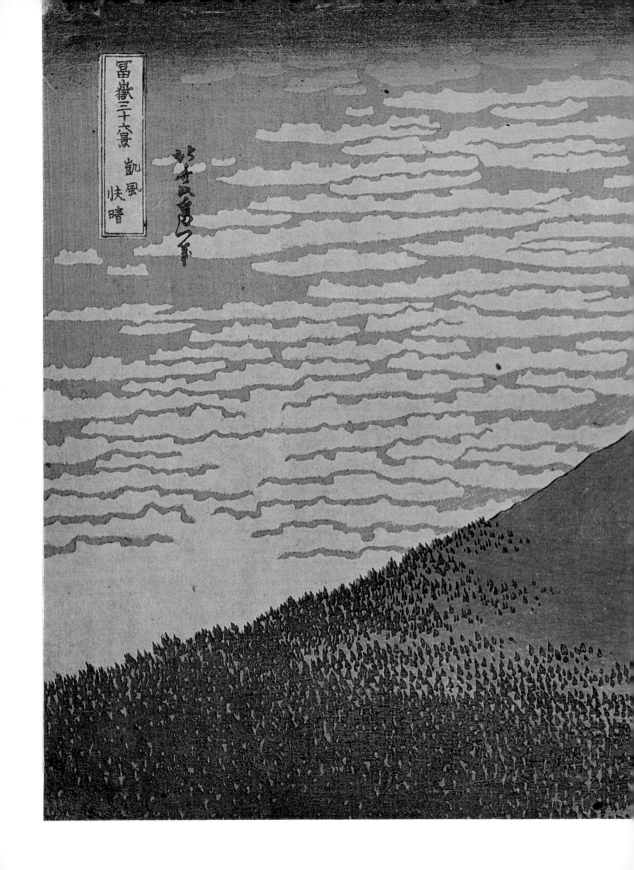

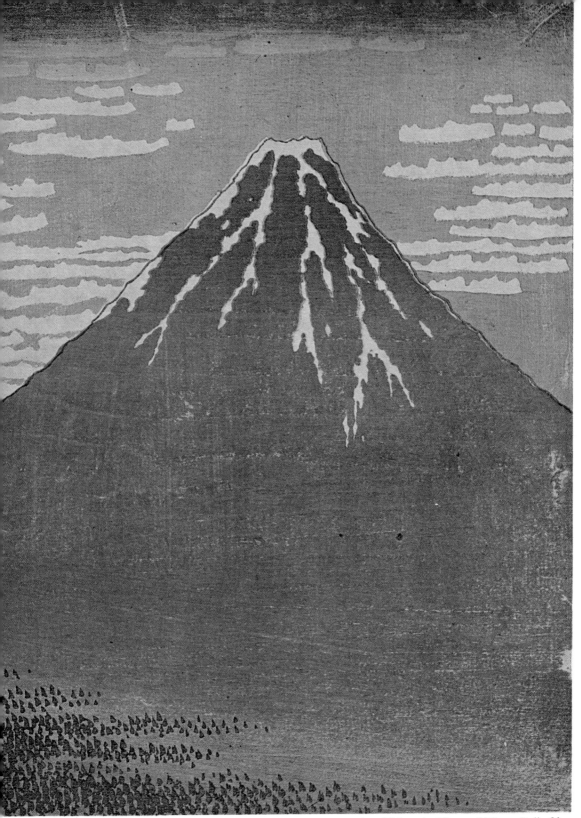

22. *Katsushika Hokusai:* Southerly Wind and Fine Weather *from* Thirty-six Views of Mount Fuji. *Oban nishiki-e; height, 25.8 cm.; width, 37.6 cm. Between 1823 and 1833.*

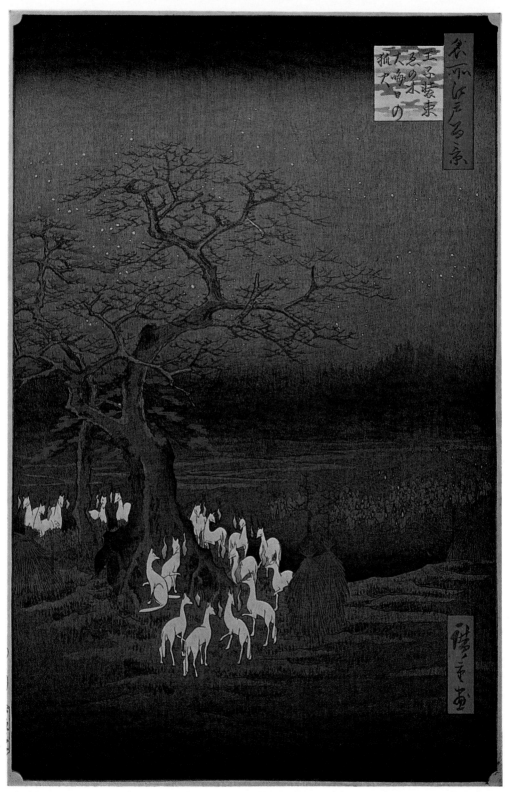

23. *Ichiryusai Hiroshige:* Gathering of Foxes at the Nettle Tree in Oji on New Year's Eve *from* One Hundred Views of Famous Places in Edo. *Oban nishiki-e; height, 33.7 cm.; width, 22.1 cm. Dated 1857.*

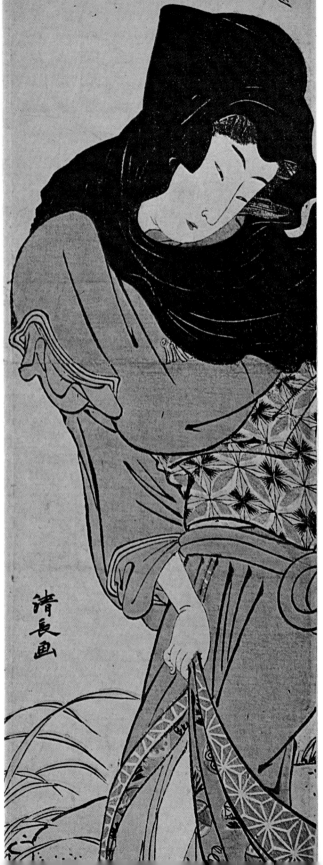

25. *Torii Kiyonaga: detail from* The Wind. *Hashira-e; dimensions of entire print (see Figure 85): height, 60.9 cm.; width, 12.8 cm. About 1780.*

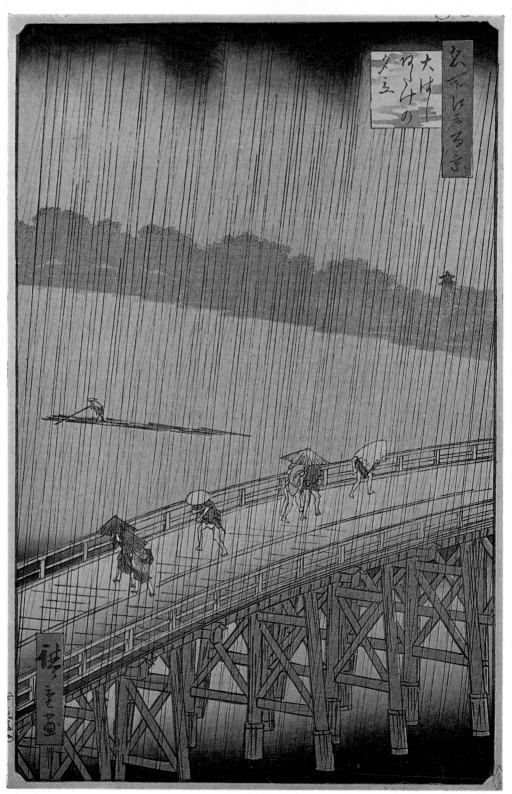

24. Ichiryusai Hiroshige: Sudden Shower at Ohashi *from* One Hundred Views of Famous Places in Edo. *Oban nishiki-e; height, 33.8 cm.; width, 22.1 cm. Dated 1857.*

27 (above, left). Ishikawa Toyonobu: The Actors Nakamura Kiyosaburo and Ichimura Kamezo as Okiku and Kosuke. *Oban benizuri-e Dated 1751.*

28 (above, right). Ichiryusai Hiroshige: Suzaki in Fukagawa *from* One Hundred Views of Famous Places in Edo. *Oban nishiki-e. Dated 1857.*

29. Kitagawa Utamaro: Sellers of Magic Charms on New Year's Morning *from an illustrated book of comic poems. Color print. Dated 1786.*

went on to compare himself to the high-class courtesan whose price was a thousand pieces of gold, as opposed to immature painters, whom he likened to low-grade streetwalkers, thus jeering at the "shameless publishers who buy cheap goods."

The artist Keisai Eisen (1790–1848), in his *Musei O Zuihitsu* (Essays of A Nameless Old Man), delivered a scathing condemnation of "avaricious publishers who think of nothing but profit and make light of painters and authors alike, being unable to appreciate their skill and treating them all as inferiors; who cannot tell bean-jam buns from horse turds or sesame paste from dog turds; and who think musk smells like cattle dung." But even Eisen was unable to withstand the influence of their money, for he went on to say: "Their bungling is like that of a stupid horse that pays no heed to 'whoa' or 'giddap.' 'Stupid beast!' we may swear to ourselves, but to what avail? We are inescapably

tethered in their harness of gold and silver. The world is going to the dogs. How can we who love to paint pictures get along with such a mean bunch?" Doubtless Eisen was far from being the only ukiyo-e artist who wished to quit his occupation and find a new one but who stayed with it nevertheless.

The carvers and the printers, although they slaved away diligently at their tasks, had to resign themselves to the same low pay as most of the artists and, in many cases, to even lower pay. In *Takarabune Katsura no Hobashira* (The Redbud Mast of the Treasure Ship), written by the comic novelist Jippensha Ikku and illustrated by Ichiyusai Hiroshige, there is a *kyoka* (comic verse) that runs:

> Work hard. Although it's nothing more
> Than making tiny lines with a small knife,
> The block carver's art digs out gold.

But the lot of the woodblock carver was such that,

30 (opposite page, left). *Suzuki Haru-shige:* Komachi Descending the Steps at Kiyomizu Temple *from* The Seven Ages of the Poetess Komachi in Current Style. *Chuban nishiki-e. Dated 1770.*

31 (opposite page, right). *Suzuki Harunobu:* Beauty on a Veranda. *Chuban nishiki-e. Between 1764 and 1770.*

32 (right). *Toshusai Sharaku: detail from* The Actor Segawa Kikunojo as Oshizu, Wife of Tanabe Bunzo. *Oban mica nishiki-e. Dated 1794.*

33 (below). *Torii Kiyonaga:* Enjoying the Evening Cool at Shijo-gawara in Kyoto. *Oban nishiki-e triptych. About 1784.*

no matter how hard he worked, he was almost never able to carve out any gold for himself. The result of earning the meager wages paid him for the delicate work of making the carved blocks produce gold was that all the gold fell into the publisher's hands.

Nevertheless, it appears that in the early period of ukiyo-e prints there were occasionally woodblock carvers who also operated as publishers, just as there were carvers who later became publishers. We know, for example, that the carver Shichirobei's shop published Hishikawa Moronobu's *Tokaido Bunken Ezu* (Pictorial Perspectives of the Tokaido Highway) in 1690 as well as *tan-e* (red-lead prints) by Torii Kiyonobu.

The carver's task began with pasting the *han-shita-e* (underdrawing) on the block, which in most cases was made of cherry wood. He then set to work with a variety of chisels, knives, and scrapers to produce a black-ink key block for the making of proof copies on which color notations were made. The next step was the production of the color blocks—one for each color required.

The blocks themselves were obtained from a dealer who specialized in such materials, and the wood most preferred was that of the *yamazakura,* or mountain cherry: a fine-textured, hard-grained wood. Material for blocks was used with extreme economy, and in later years, when high-quality cherry wood was hard to come by, carvers would sometimes inlay a section of boxwood in a block of lower-quality wood at places where fine carving was necessary. Old blocks were often sold to archery-equipment shops for use in making targets.

The carver, properly seated at a low table, employed his knives and chisels with intense concentration, securing the block so that it could not move in any direction. Although it is often said that the carving of blocks was done as side-line work by

lower-ranking retainers of the shogun who were in financial difficulties, the work of such amateurs was limited to the making of blocks for printed texts, while the carving of blocks for pictures and particularly the heads of human figures (as in the courtesan portraits of Utamaro and the actor portraits of Sharaku) was chiefly the work of specialists. An apprentice carver began his training by learning to carve blocks for such books as *gogyobon* (texts for narrators of the *gidayu* ballad drama) and then progressed to the carving of color blocks and finally black-ink key blocks for ukiyo-e prints. Thus he advanced through the ranks of *dobori,* or junior carvers, to that of *kashirabori,* or master carver, so named because he specialized in the carving of heads (*kashira*) for human-figure prints. The wretched position of the junior carvers in the society of the time is reflected in the saying "That fellow is nothing more than a *dobori*."

The master carver parceled out the work among his subordinates according to their degrees of skill, giving the more difficult tasks to the more experienced carvers and thereby trying to realize the fullest benefits from a division of labor. Such arrangements were particularly important when the master found himself growing older, since the only way he could maintain his reputation was through the skillful management of his younger carvers' talents.

The printers occupied a position even lower than that of the carvers. Even as late as 1877, some ten years after the collapse of the shogunate and the entry of Japan into the modern world, their wages were incredibly small, and they ranked among the lowest orders of society.

For the most part, the names of carvers and printers have been irretrievably lost. Although we do know the names of some carvers from the Genroku and Hoei eras (1688–1711), hardly any printers' names survive. A rare exception is the illustrated book *Umi no Sachi* (The Bounty of the Sea), published in 1762, in which both the names of the carvers and those of the printers who made the woodblock prints are recorded. Also, on two or three extant pieces of wrapping paper for polychrome prints by Suzuki Harunobu published in the Meiwa era (1764–72), we find the names of the

carvers and the printers alongside that of the artist. After this time, however, even though some carvers' names were recorded, the names of the printers are in most cases completely lost. After the Kaei era (1848–54), it seems that many of the carvers began to make a point of registering and stressing their names, but the names of printers do not appear at all. We know, however, that both carvers and printers used a variety of nicknames, many of which combined an epithet with the first syllable of a given name—for example, Foolish Takè, Bald Yoshi, and Bucktoothed Sei.

Even in the Meiji era there were probably many carvers and printers who did not relinquish their artisan character and, although of humble status, retained their pride in their work and continued, though vainly, to take pleasure in displaying their ability. The printers were not the ones to take up the *baren* pressing pad for the sake of acquiring a reputation, for it was not a question of whether they made a name for themselves or not. Also, for many of them, the support of their families with the income they received was a secondary motivation, since they were almost universally addicted to wine and women.

A clear distinction was drawn between black-ink printers and color printers. After the advent of polychrome prints, it was the color printers who naturally took precedence, and they delighted in ridiculing the black-ink printers with such epithets as "drainage-ditch printers" and "guttersnipes." The master printer, like the master carver, assigned work according to the skills of his underlings and thus the distinctions were emphasized.

The implements used by the printer included mainly an assortment of large and small brushes for applying pigments to the carved blocks and a similar assortment of *baren,* the pads used for pressing the paper on the block and rubbing it to secure a satisfactory impression. Until the end of the Edo period the pigments consisted chiefly of vegetable dyes. After that time, however, chemical pigments from the West were introduced, and the ukiyo-e prints thereby not only lost much of their original flavor and beauty but also entered the final stage of their decadence.

CHAPTER THREE

From the Primitives to the Early Polychrome Masters

MORONOBU AND THE HISHIKAWA SCHOOL Hishikawa Kichibei Moronobu (1625?–94) was born in Awa Province (the modern Chiba Prefecture) as the son of a family engaged in the trade of dyeing and embroidering. In his spare time as a worker in the family business, he studied the styles and techniques of the Kano and Tosa schools of painting and, in the course of time, generated the mercantile-class art of the ukiyo-e.

It is thought that Moronobu came to Edo soon after the great fire of the Meireki era (1655–58), which in 1657 destroyed more than half of the city, including part of Edo Castle, where the shogun resided, and all the adjacent mansions of the daimyo. In this conflagration practically all evidence of the Kyoto-Osaka culture that had formed the basis for the culture of the early Edo period was literally burned to ashes, and in consequence the arts of Edo unconsciously began to shake off the influence of the traditional culture of the old capital of Kyoto. Those who suffered most from the disastrous fire were the members of the feudal military class, and in the reconstruction work that followed it was the merchant class that derived the most profit. In the words of one chronicler, "As the residences of the great lords shrank in scale, the dwellings of the ordinary populace increased in ostentation." Already blessed by a long period of peace, "even townsfolk came to know the meaning of pleasure," we are further told. Having acquired enough leisure time to enjoy at least some aspects of art, these townsfolk of Edo, although they were still ranked as the lower middle class, initiated a demand for inexpensive works of art suitable to their position in society. At the same time, because frequent large-scale fires and other calamities brought financial ruin to affluent families and forced them to sell their possessions to obtain money, the mercantile townsmen of Edo found it fairly, easy to buy paintings that satisfied their tastes and yet were well within their means. We must note, however, that paintings of the type generally favored by the feudal ruling class were not at all to the townsmen's liking.

It was around this time that the wholesale dealers began to market black-ink prints produced from the underdrawings of Moronobu by means of the unsophisticated yet delightful art of the carvers (Figs. 4, 35, 50). These prints, which appeared not only in picture books and illustrated works of fiction but also in single-sheet form, strike us today as both naive and charming, and we admire the carvers' skill. Although we must view them as minor works of art, they nonetheless brim with vivacity and a sense of warm generosity.

35. *Hishikawa Moronobu: detail from* The Tale of Ushiwaka and Princess Joruri. *Tan-e. Between 1688 and 1694.*

The woodblock print was not an innovation of the Edo period, for it had already been in use for hundreds of years, first for the propagation of Buddhist teachings, then for the printing and illustration of literary works in the late sixteenth and early seventeenth centuries, and, around the same time, for the production of storybooks printed in the easy-to-read *kana* syllabary and of texts for the *joruri* ballad drama. But now, with the publication of single-sheet works by Moronobu, woodblock prints were at last emancipated from their subordinate position as mere illustrations and were offered to the people of Edo as independent art objects.

Moronobu and his followers monopolized the world of the ukiyo-e and the woodblock print during the Genroku era (1688–1704) and popularized throughout the country what was termed by the haiku poet Ransetsu as "the image of the eastern provinces in the Hishikawa style"—that is, by ex-

tension, the portrayal of manners and customs in eastern Japan, with the de facto capital of Edo at its center, in a new and distinctive fashion. Regrettably, however, Morofusa, who was Moronobu's eldest son, and Shigefusa, who represented the third generation in the line of artists, both gave up painting and returned to the traditional family business of dyeing and embroidering, and thereafter the Hishikawa school suffered a gradual decline.

THE TORII SCHOOL The main current of the the ukiyo-e print soon shifted from the Hishikawa to the Torii school, whose founder, Torii Kiyonobu (1664–1729), was born in Osaka as the son of a Kabuki actor and occasional painter of posters for the Kabuki theater. After the family had moved to Edo, Kiyonobu also engaged in the painting of posters for Kabuki

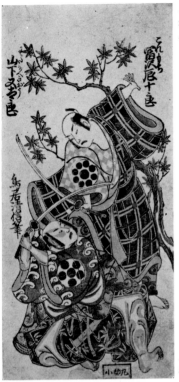

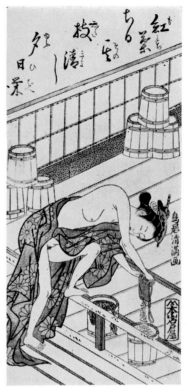

36. *Torii Kiyonobu II:* The Actors Tomi-zawa Tatsujuro and Yamashita Matataro. *Hosoban benizuri-e. Between 1704 and 1711.*

37. *Torii Kiyomitsu:* The Bath. *Hosoban benizuri-e. Between 1751 and 1772.*

theaters and thereby laid the foundations for the hereditary line of Torii artists who still serve the Kabuki in this capacity today.

In addition to his theatrical posters (*kamban-e*) and programs (*banzuke*) Kiyonobu produced a large number of bold, black-lined, hand-colored prints (Figs. 17, 45, 53). He was a great ukiyo-e artist: the personification of the age of *tan-e,* or prints colored with a red-lead pigment. His actor portraits, reflecting the untrammeled and bombastically heroic style of acting that emerged at this time in the Kabuki world of Edo, employed such effects as *hyotan ashi* (gourd-shaped legs) and *mimizugaki* (earthworm brush strokes)—that is, vigorous lines with emphatic variations in thickness—to create an impression of matchless virility and to portray most vividly the essence of contemporary Kabuki drama. But Kiyonobu did not limit himself to depicting the romance of the Edo stage, for he also produced a number of courtesan portraits whose subjects impress one as possibly having been modeled upon Kabuki actors of female roles. We can say, in fact, that with Kiyonobu the ukiyo-e was dramatized.

One record of the times tells us that "from the last years of the Genroku era there began to appear printed pictures that were colored by hand with red and yellow pigments and were called *tan-e,* and most of these were the work of Kiyonobu and his son Kiyomasu." It is also recorded that "the ukiyo-e of the present age all follow the style of the Torii family."

In a certain sense the ukiyo-e genre of painting was a revival of *yamato-e,* the purely Japanese style (as contrasted with the frequently imitated Chinese style) of painting sponsored by the imperial court

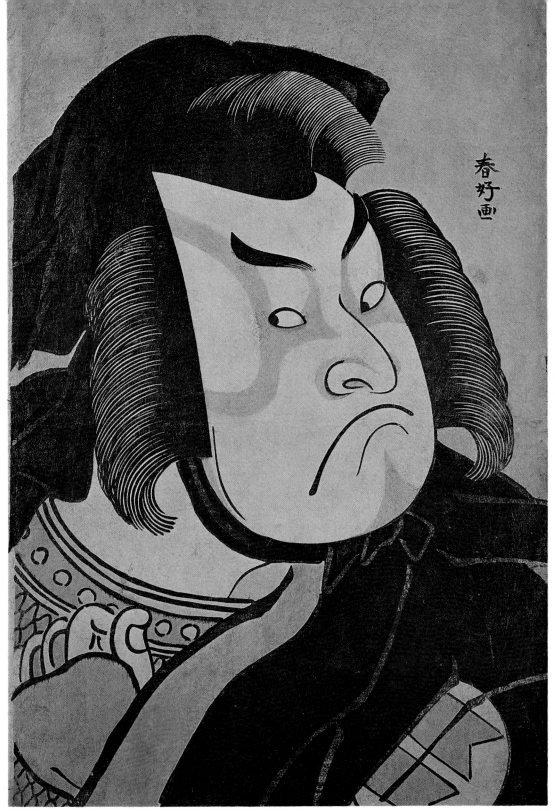

春好画

38. *Katsukawa Shunko:* The Actor Sakata Hangoro. *Oban nishiki-e; height, 38.5 cm.; width, 25.8 cm. Between 1781 and 1789.*

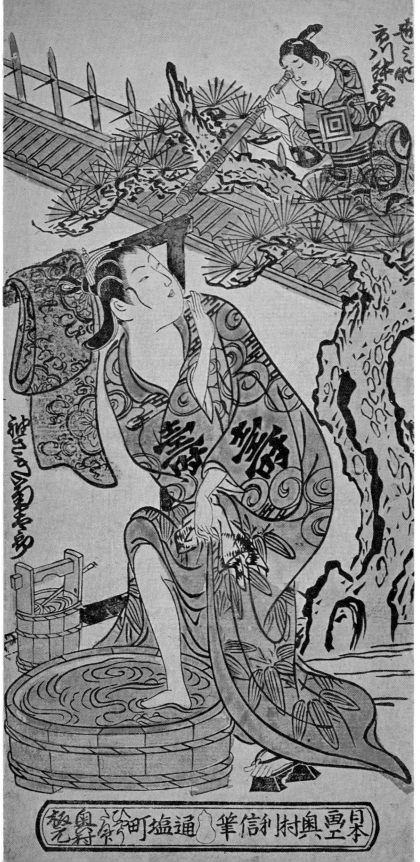

39. *Okumura Toshinobu: scene from* The Life of an Amorous Man. *Hosoban beni-e; height, 33 cm.; width, 15.7 cm. Between 1716 and 1736.*

40. *Okumura Masanobu: detail* ▷ *from* The Death of Yoshinaka. *Oban tan-e; dimensions of entire print: height, 26.1 cm.; width, 35 cm. Between 1716 and 1736.*

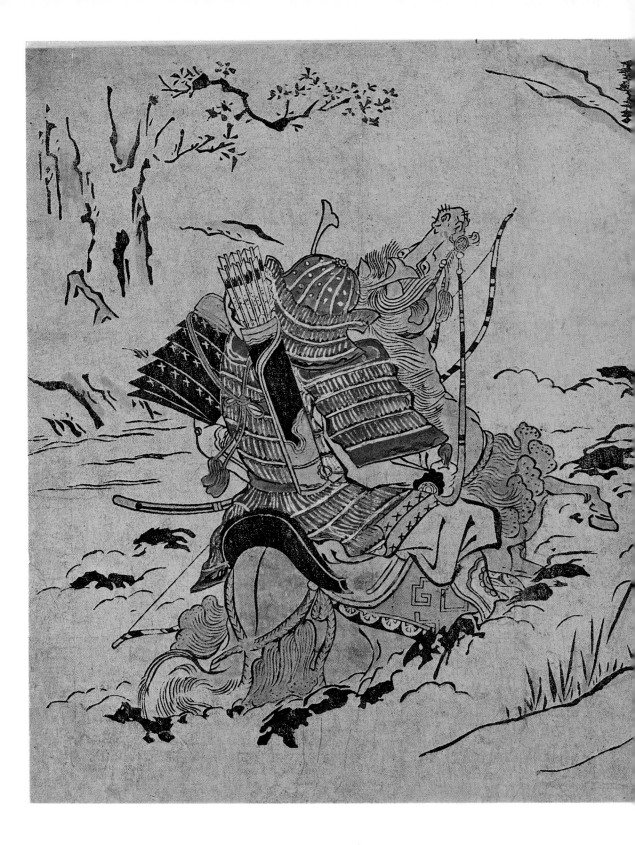

風
堀
三
ツ
の
さ
め

よ
る
ら

扨
や
ま
う
の
か
よ
う
ら

日
の
出
う
申

41. Isoda Koryusai: Sunrise *from* Three Elegant Beginnings. *Chuban nishiki-e ; height, 26.3 cm. ; width, 19 cm. Between 1772 and 1781.*

42. *Torii Kiyomitsu:* The Actor Bando Hikosaburo as Shiba no Kotaro. *Hosoban benizuri-e; height, 31.2 cm.; width, 14.5 cm. Dated 1759.*

43. *Ishikawa Toyonobu:* The Flower Bucket. *Nagaban benizuri-e;* ▷ *height, 65.6 cm.; width, 16.8 cm. Between 1736 and 1764.*

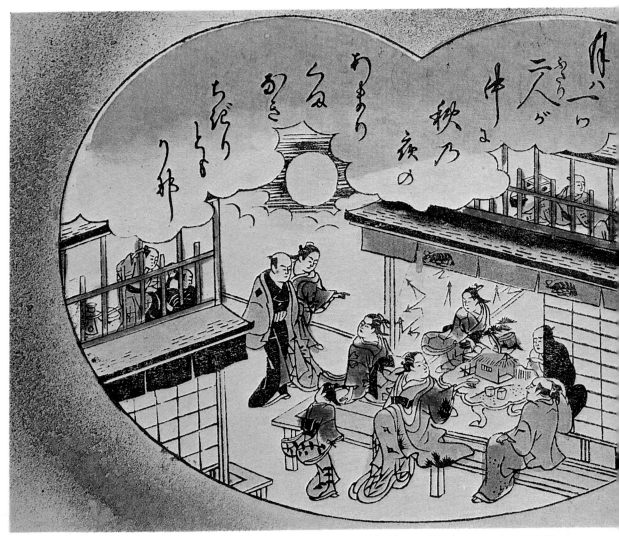

44. *Torii Kiyomasu:* Autumn Moon at Ageya-cho *from* Eight Views of the Yoshiwara. *Hosoban tan-e; height, 15.5 cm.; width, 34 cm. Between 1711 and 1716.*

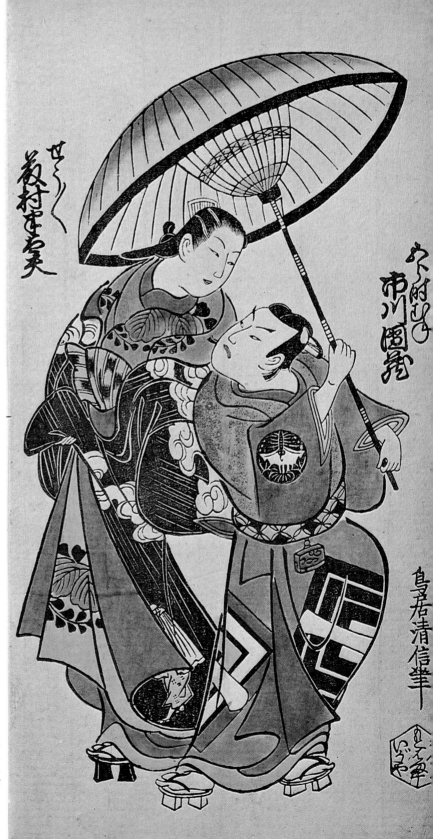

45. *Torii Kiyonobu:* The Actors Ichikawa Danzo and Fujimura Handayu as Soga no Goro and Sho-sho. *Hosoban beni-e; height, 33.5 cm.; width, 15.8 cm. Dated 1721.*

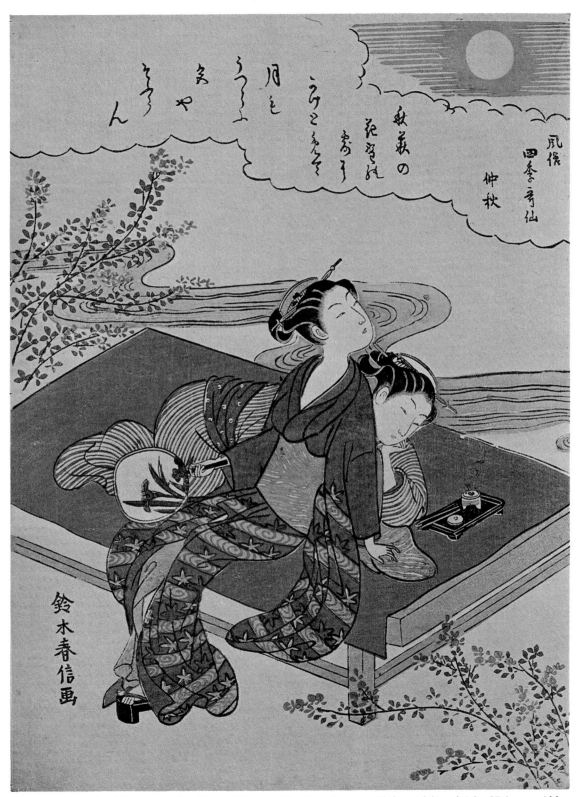

46. *Suzuki Harunobu:* Midautumn *from* Elegant Poetry of the Four Seasons. *Chuban nishiki-e ; height, 27.8 cm. ; width, 20.8 cm. Between 1764 and 1770.*

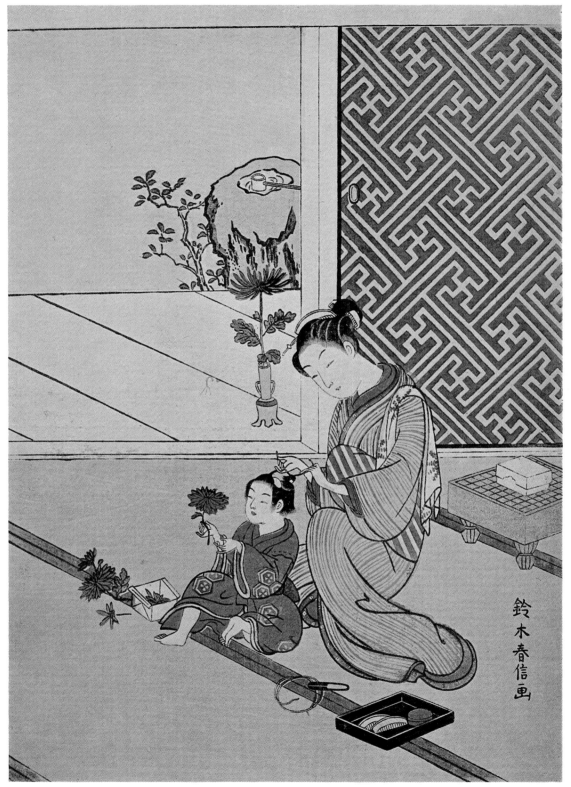

47. *Suzuki Harunobu:* One Chrysanthemum. *Chuban nishiki-e; height, 27.8 cm.; width, 20.5 cm. Between 1764 and 1770.*

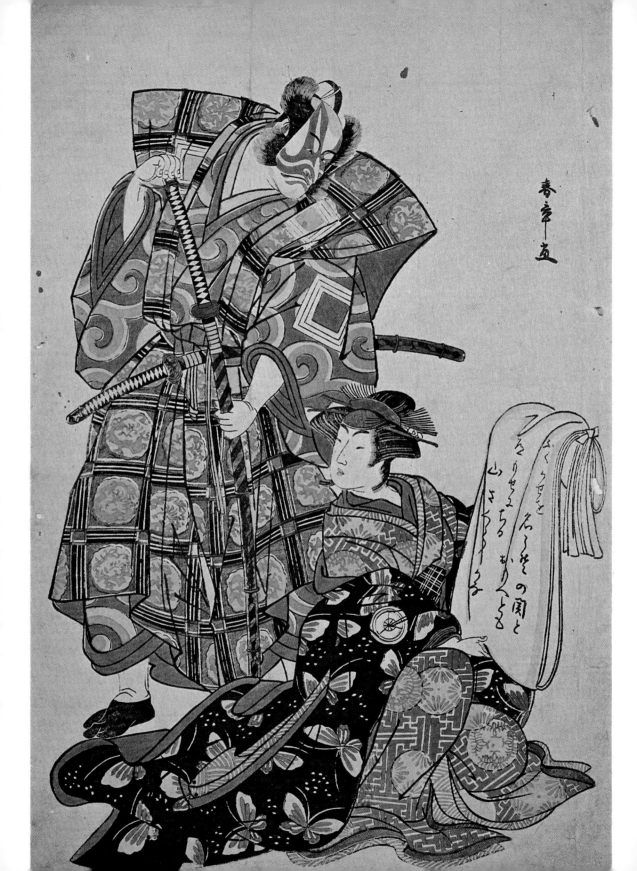

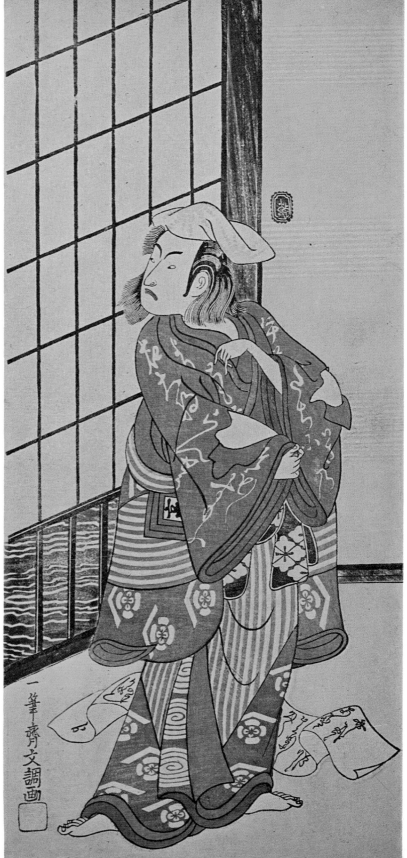

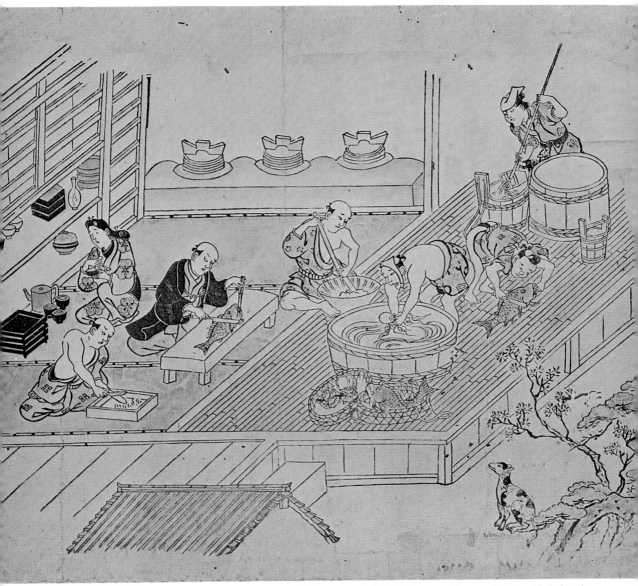

50. *Hishikawa Moronobu:* Kitchen *from* The Style and Substance of the Yoshiwara. *Oban sumizuri-e with light colors; height, 27.5 cm.; width, 41 cm. Dated 1678.*

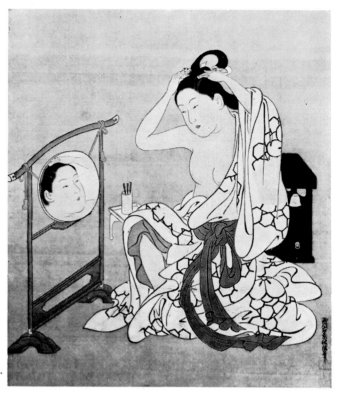

51. Nishikawa Sukenobu: Before the Mirror. *Color painting on silk. Between 1716 and 1751.*

and the nobility during the Heian period. During the Edo period, from around the 1660's to the 1680's, the *yamato-e* tradition was infused with new life and re-emerged as the art of the mercantile class. An instinctive desire to revive Japanese-style painting as opposed to Chinese-style painting is evident in the titles proudly adopted by such early ukiyo-e painters as Moronobu and Kiyonobu—for example, Nihon Eshi, Wa Gashi, Yamato Gako, and Yamato Hitsuzu Gashi, all of which have the meaning "painter of Japan."

Just as the Kabuki actor Ichikawa Danjuro II polished and perfected the Ichikawa style of aggressively heroic acting created by his great predecessor Danjuro I, so Torii Kiyomasu I (Figs. 44, 52) tempered with gentleness and a more refined beauty the grandiose style of the actor prints created by his father, Kiyonobu. In addition to Kiyomasu, who

worked from 1696 into the early 1720's and apparently died fairly young, the direct line of descent included Kiyonobu II (Fig. 36), who is presumed to have been another of Kiyonobu's sons, and his son Kiyomasu II, but there were other artists who bore the family name Torii and continued to paint in the style of Kiyonobu—for example, Kiyoshige, Kiyotada, and Kiyotomo. The Torii school, however, gradually came to seek other subjects than actors, and in the third generation Kiyomitsu (c. 1735–85; Figs. 37, 42, 177) and his disciple Kiyohiro (Fig. 59) were already attempting to bring new life to prints of beautiful women—a movement that culminated in the emergence, in the fourth generation, of Kiyonaga (Figs. 25, 33, 82–86, 90, 160), a great painter of glamorous women who rose to be the most brilliant star of the Temmei era (1781–89).

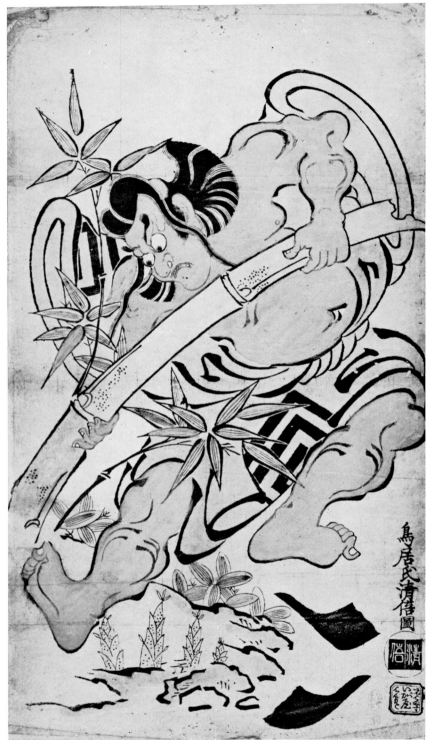

52. Torii Kiyomasu: The
Actor Ichikawa Danjuro as
Soga no Goro Uprooting a
Bamboo. *Large oban tan-e.
Between 1704 and 1716.*

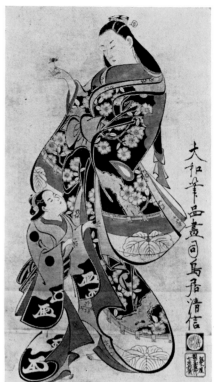

53. *Torii Kiyonobu:* Courtesan and Attendant. *Large oban sumizuri-e, Between 1704 and 1716.*

THE KAIGETSUDO SCHOOL

The first two decades of the eighteenth century saw the flowering of the Kaigetsudo school, whose artists, by specializing in portraits of courtesans, aimed at satisfying the demands of nouveau riche habitués of the pleasure quarters. The little that is known about the founder of the school can be set down quite briefly. He is traditionally assigned the dates 1671 to 1743. His art name was Kaigetsudo Yasunobu (or Ando, by a variant reading of the characters). His legal name appears to have been Okazaki Genshichi, and we are told that he resided in a house that he had built in the Asakusa district, near the Yoshiwara. Early in 1714 he was arrested as an accomplice in the notorious Ejima-Ikushima scandal, which resulted from a clandestine love affair between the Kabuki actor Ikushima Shingoro and the senior lady-in-waiting Ejima in the shogun's retinue at Edo Castle.

Not only these three persons but also corrupt shogunate officials, purveyors to the shogun, and other ladies-in-waiting were involved. A number of the principals in the affair were punished by exile, and Yasunobu was accordingly banished to the barren volcanic island of Izu Oshima, south of Edo Bay. It seems that Yasunobu, before his banishment, produced a large number of paintings in response to the orders of wealthy patrons and that he had a number of disciples. On the basis of the refined quality of his works (Fig. 56), some scholars consider that he might have been a specialist in painting the votive pictures known as *ema*.

It seems that a number of painters worked in Yasunobu's studio, but it is not clear whether they were genuine disciples or whether they were simply artists who studied the style of his school. These self-designated "last descendants of the Japanese cartoon artist Kaigetsudo" include the following,

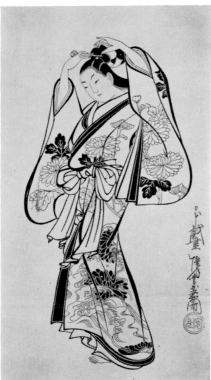

54. Kaigetsudo Anchi (Yasutomo): Standing Beauty. *Large oban sumizuri-e. Between 1711 and 1736.*

55. Kaigetsudo Doshin (Nobutatsu): Standing Beauty. *Large oban sumizuri-e. Between 1711 and 1736.*

with the variant readings of their names given in parentheses: Nobuhide (Doshu), Nobutatsu (Doshin), Nobutane (Doshu), Nobushige (Dohan), and Choyodo Yasutomo (Anchi). Of these five artists, only Yasutomo was granted permission to use the first character (*yasu* or *an*) of his teacher's given name, and for this reason, together with the fact that he signed himself Choyodo, it seems probable that he alone was one of Yasunobu's blood relatives.

No prints by the artists Yasunobu, Nobutane, or Nobuhide have so far been discovered, although we have prints by Yasutomo, Nobutatsu, and Nobushige in the extra-large size known as *toku oban* or *o-oban* (Figs. 54, 55). Yasutomo's prints were published by Maruhachi of Higashi Yoko-cho; Nobutatsu's by Nakaya of Toriabura-cho; and Nobushige's by Igaya of Motohama-cho—all in Edo. There are no surviving works apart from the mas-

ter's paintings that are signed Kaigetsudo, but the work of painters like Hakushoken Matsuno Chikanobu clearly derives much from such paintings.

A satirical *senryu* verse of the Kansei era (1789–1801) says: "The Yoshiwara and the theater are two sides of the same coin," and indeed there seems to have been a certain mutual dependence between the courtesan portraits of the Kaigetsudo school and the actor portraits of the Torii school. Just as the Torii artists Kiyonobu and Kiyomasu I chose to paint only the popular actors of the time, so the Kaigetsudo artists depicted only the famous courtesans. Some years ago it was thought that the Torii school owed much to the Kaigetsudo, but that opinion has since been reversed, and many scholars now claim that the Kaigetsudo school incorporated the techniques of the Torii school.

Kitamura Nobuyo, a scholar of the late Edo

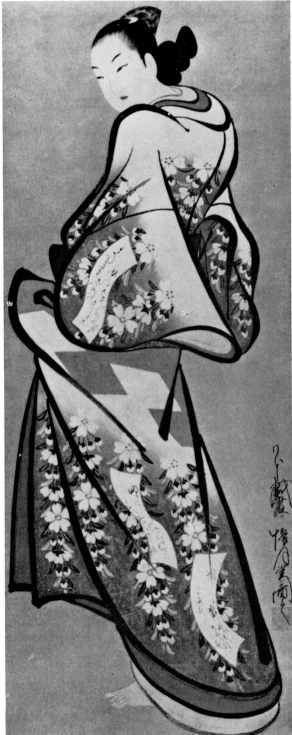

period, dismissed the Kaigetsudo *onna-e* (pictures of women) as "unskillful paintings," and Kiyokata Kaburagi, a twentieth-century painter of female figures, has lightly passed them off with the comment that they are "somewhat like modern poster paintings, and one can hardly say that they are of very high quality." To be sure, the paintings of beauties by artists of the Kaigetsudo school, while not necessarily "unskillful," are perhaps not of outstanding quality. Nor can criticism on the grounds of monotony be rejected out of hand. Nevertheless, within the monotony of format and style we detect a certain quiet and appealing simplicity, and in the apparently changeless figures of these courtesans a sensitive and mysterious quality of change is latently expressed. One might say, in fact, that within what seems at first glance to be an array of expressionless faces there is hidden an endless variety of expressions.

OKUMURA MASANOBU AND ISHIKAWA TOYONOBU

Okumura Shimmyo Masanobu (c. 1686–1764), who styled himself Furyu Yamato Eshi, or Elegant Japanese Painter, was outstanding among the artists who flourished in the age of *beni-e*, which followed the age of *tan-e*. As a craftsman who was confident of his technical skill and proud of his profession, he signed his prints with the inscription "Genuine work of the Japanese painter Okumura Masanobu." In addition to his main occupation of painting he ran a wholesale shop in Torishio-cho in Edo that specialized in *beni-e* and illustrated storybooks and had for its trademark a red gourd. He first took orders from such shops as the Emiya in Shimmeimae Yoko-cho and the Kurihara shop in Hasegawa-cho. Later, after he had opened his own retail shop in Edo, it seems that he feared the pirating of his own works, for a record of the times states that he advertised: "Please buy genuine Okumura pictures."

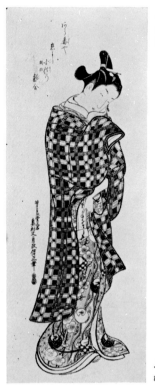

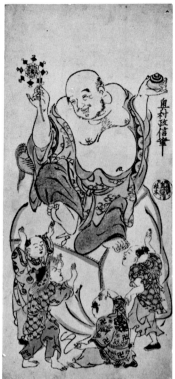

57. *Okumura Masanobu:* The Actor Bando Hikosaburo II as the Page Kichisaburo. *Large urushi-e in hashira-e format. About 1758.*

58. *Okumura Masanobu:* The God Hotei. *Oban urushi-e. Between 1710 and 1720.*

When we come from the prints of Kiyonobu to those of Masanobu (Figs. 18, 40, 57, 58, 60), we observe that the bold strength of Kiyonobu's work is lost at the same time that a high degree of elegance and beauty is added. It is as though we had turned from the blustering *aragoto* style of Kabuki acting to the romantic *wagoto* style: the style employed for roles of handsome young lovers. We react similarly to the prints of Okumura Toshinobu (Figs. 39, 61, 62), an outstanding artist who is variously identified as either the son, the younger brother, or a disciple of Masanobu.

Even among the best preserved of *beni-e* and *urushi-e*—those in which the original color has held up without a trace of fading, in which the *beni* is a beautiful flaming red and none of the gold dust has come off—one finds upon close examination that the coloring by hand has been done in a very care-

less manner. This flaw is most likely the result of sloppy and slapdash work on the part of poorly paid colorers. As we have noted earlier, the colorers, however hastily and therefore imprecisely they worked, were finally unable to keep pace with the printers and, as the demand for *beni-e* increased, printed coloring came to be used in a new type of print known as the *benizuri-e*.

Although primitive techniques for printing with colors had long been known in Japan, it appears that the printing of single-sheet prints in color did not begin until around the Enkyo and Kan'en eras (1744–51), after the age of *beni-e* and *urushi-e* had ended and *benizuri-e* began to be produced. And the ukiyo-e artist who produced the largest volume of fine works in the new age of *benizuri-e* was Ishikawa Toyonobu.

Ishikawa Shuha Toyonobu (1711–85) was the

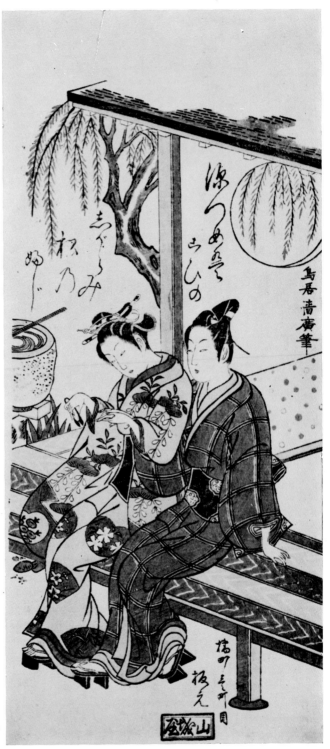

59. Torii Kiyohiro: Cutting a Lover's Fingernails.
Hosoban benizuri-e. Between 1751 and 1764.

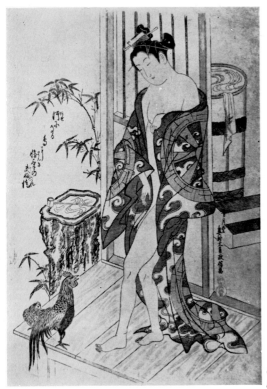

60. *Okumura Masanobu:* After the Bath. *Oban benizuri-e. Between 1744 and 1764.*

son-in-law of Nukaya Shichibei, an innkeeper of Kodemma-cho in Edo, and the father of Ishikawa Masamochi, a scholar of Japanese classics who employed such noms de plume as Yodoya no Meshimori and Rikujuen. Although Toyonobu produced a great many prints of sensual charm (Figs. 27, 43, 63, 64), he was a man of austere conduct who is said never to have set foot in the pleasure quarters.

MIYAGAWA CHOSHUN AND NISHIKAWA SUKENOBU During this age, when the ukiyo-e genre developed predominantly through the medium of the print, Miyagawa Choshun (1683–1753) was an ukiyo-e painter who occupied a position strictly midway between that of a *goyo eshi*, or government-employed painter, and that of a *hanshita eshi*, or woodblock-print artist. Choshun never in his life produced a design for an ukiyo-e print, but by developing what one of his contemporaries called a "rich and free use of colors" he infused new life into the ukiyo-e painting of the early decades of the eighteenth century (Fig. 65).

Choshun, whom we can readily imagine to have been aware of the strict differentiation maintained between the two types of ukiyo-e artists—namely, those who were painters only and those who produced underdrawings for woodblock prints—probably enjoyed a certain authority in his position and was no doubt incensed at the arrogant attitude of the official *goyo eshi*, who looked down on all ukiyo-e artists with great disdain. The wide difference between the government-supported painters and the wage-earning common painters was spotlighted by a tragedy that occurred in 1751. Before we come to

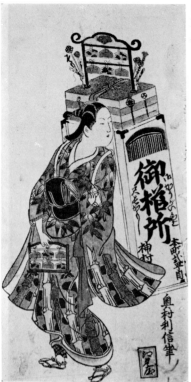

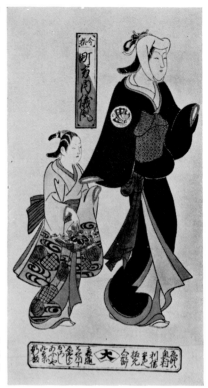

61. Okumura Toshinobu: Seller of Hair Ornaments. *Hosoban beni-e. Between 1716 and 1744.*

62. Okumura Toshinobu: The Fashionable Wife and Daughter of a Townsman. *Hosoban beni-e. Between 1716 and 1744.*

the event itself, however, it is necessary to look briefly at the background against which it took place.

When the Tosho-gu and the Daiyu-in Reibyo, the shrines at Nikko dedicated to the memory of the first and third Tokugawa shoguns—Ieyasu and Iemitsu respectively—were to be renovated, the retouching of the wall paintings and other decorative features was delegated to the *oku eshi* and the *omote eshi* of the Kano school. The *oku eshi* (literally, "inner painters") worked only for upper-class clients, while the *omote eshi* (literally, "outer painters") were available to all levels of the urban bourgeoisie. Both groups were classified as *goyo eshi,* or official government painters.

The *oku eshi* received an annual stipend of one hundred *koku* (about five hundred bushels) of rice: enough to support twenty people for a year. They

comprised four branches of the Kano school, all named after the areas in Edo in which their artists resided and worked: Nakabashi, Kobiki-cho, Kaji-bashi, and Hama-cho.

The *omote eshi,* also working in Edo, represented a considerable number of branches of the Kano school. First there were the seven main branches in this category: Surugadai, Okachimachi (also known as the Kyuhaku Kano), Ippommatsu, Yamashita (at Kurumazaka in Ueno), Fukagawa Kiba, Matsunaga-cho, and Adagoshita. Next there were the four disciple branches: Ogyonomatsu, Odawara-cho, Kansugi Katamachi, and Daichi, as well as five subordinate branches of these. In addition there was the Hatchobori Kano (or Inaribashi Kano) branch founded by Shunko Genchin.

In 1750 (some chroniclers say 1737), Kano Shunga, son of the *goyo eshi* Shunko mentioned

immediately above, was ordered to take charge of the renovation of the shrines at Nikko. We should note here that Shunga, commonly known as Sadanobu, is sometimes identified as a disciple of Shunsetsu Nobuyuki of the Yamashita Kano school.

When a *goyo eshi* received orders of this kind, he would usually proceed to Nikko accompanied by his disciples, and if these were too few in number, he would enlist other painters to augment the group. In this case Shunga, by means of a subcontract, hired Miyagawa Choshun, who was an expert in the handling of colors. Accordingly, Choshun took his son and several of his disciples with him to Nikko and finished the work in the following year. The agreement had been that the wages were to be paid on the spot after the work was completed, but Shunga, inventing any number of excuses, refused to pay. The commission to undertake the renova-

tion of the Nikko shrines involved considerable financial difficulties, even for an *oku eshi*, and for an *omote eshi* like Shunga, who was merely a low-ranking retainer of the shogun, there was actually little in the way of compensation. With mounting expenses, Shunga was probably somewhat pressed for funds.

But Choshun was also in difficult straits, and in December of the same year (1751), he went to Shunga's house and demanded payment for the work. The two men quarreled, and the upshot of the encounter was that Choshun was beaten up by Shunga's disciples, tied up with rough straw rope, and thrown onto a rubbish heap behind the house. In the meantime, Choshun's son Tadakichi (also known as Chojo), becoming anxious about his father's lateness in returning home, set off for Shunga's house. Arriving there, he heard the groans

◁ *63 (opposite page, left). Ishikawa Toyo-nobu:* The Actor Segawa Kikuno-jo II as the Greengrocer's Daughter Oshichi. *Hosoban benizuri-e. About 1758.*

◁ *64 (opposite page, right). Ishikawa Toyonobu:* Itinerant Minstrels. *Hoso-ban benizuri-e. Between 1751 and 1772.*

65. Miyagawa Choshun: detail from Manners and Customs of the Courtesans. *Color painting on silk. Between 1716 and 1751.*

of the aged Choshun and quickly discovered what had taken place.

After first having helped his father home, Tada-kichi screwed up his courage, armed himself with a sword, and broke into Shunga's household in the dead of night. There he mortally wounded Shunga and three of his disciples in the fight that ensued and, at the same time, sustained wounds of his own. According to one account, he thereupon committed suicide. According to another, he at once gave himself up to the district magistrate and, following interrogation, was sentenced to death. It seems that Choshun, once his wounds from the beating had healed, was banished from Edo and drifted as far away as Niijima in the province of Izu. As a result of this tragic incident, the Hatchobori Kano family became extinct. Two years after the incident, Choshun was pardoned and allowed to return to Edo,

where he resided in Honjo Kikukawa-cho until, in late 1753, he died of an illness at the age of seventy.

Nishikawa Sukenobu (1671–1751; Figs. 51, 72), who used the art name Jitokusai Bunkado, brought a new breath of life to the picture books and *niku-hitsuga* (ukiyo-e paintings) of the Kyoto-Osaka region at a time when single-sheet prints were still the special product of the consumer city of Edo. Sukenobu was highly praised by the literati painter Yanagisawa Kien (1706–58), who said in his *Hitorine* (Sleeping Alone), a book published around 1724: "Nishikawa Sukenobu is the only man who can be said to be a famous painter. He is a master of ukiyo-e." But Sukenobu was also denounced—for example, by one critic who wrote: "These works are without exception lacking in spirit. They do not have what it takes to establish a healthy school of painting." In any event, Sukenobu studied not

66. *Suzuki Harunobu:* Ofuji of the Motoyanagiya Teahouse. *Aiban nishiki-e. Between 1764 and 1770.*

only the styles of Kano Eino and Tosa Mitsusuke but also those of the Hishikawa school (that is, the school founded by Moronobu) and the painter Yoshida Hambei of the Kyoto-Osaka district. In addition, he founded a school of his own.

SUZUKI HARUNOBU AND HIS FOLLOWERS

As we have previously noted, ukiyo-e prints may be divided into three categories: black-ink prints (*sumizuri-e*), hand-colored prints (*tan-e* and *beni-e*), and printed-color prints (*benizuri-e* and *nishiki-e*). These categories are listed in the chronological order of their development, and the *nishiki-e*, or polychrome print, remained the dominant type for a long period after it superseded the single-colored *benizuri-e*.

As we have also noted before, polychrome prints originated as a pastime of the Edo leisure class.

According to the famous scholar of Western learning Hiraga Gennai (1728–79), in his *Hogokago* (Wastebasket), it was around 1765 that it became popular among the sophisticates of Edo to hold gatherings at which the members presented designs for simplified or abbreviated calendars, so that the group, acting somewhat in the manner of an association of artists' patrons, might pass judgment on their merits. From this time on, says Gennai, it became the practice to print such designs with a series of seven or eight color blocks. Thus the polychrome print was born.

Unlike the great majority of *benizuri-e*, which employed thin paper and cheap pigments, polychrome prints were expensive products made with costly pigments and paper of extremely high quality. In addition, they employed such gaufrage techniques as *karazuri* and *kimekomi* to produce

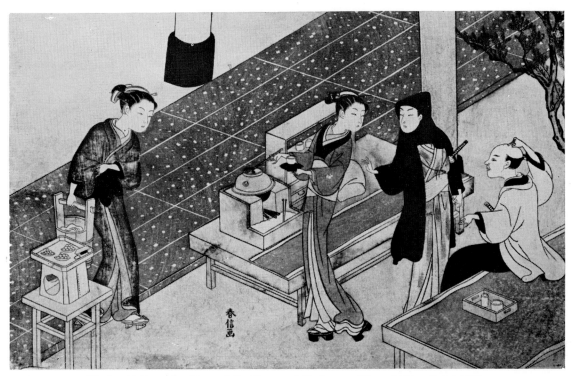

67. *Suzuki Harunobu:* Osen of the Kasamori Teahouse. *Aiban nishiki-e. Dated 1769.*

raised or embossed effects by means of unpigmented blocks. The leisured men who first created the designs and techniques for the making of such prints were known as *tsujin*, or men of taste, refinement, and great savoir faire. The notable *tsujin* groups included those led by Kikunoya Kyosen and Sukikotei Shakei, and surviving records indicate that both men played a part in the creation of the new type of print. And among the artists who produced paintings from drafts submitted by the *tsujin* was the genius of the age, Suzuki Harunobu (1725–70).

With the arrival of Harunobu, as the eighteenth-century writer Shokusanjin (Ota Nampo) tells us, single-color prints were abandoned, and polychrome prints took the center of the stage. Harunobu's first works in this genre were published in 1765, only five years before his death in early

middle age, but in that pitifully brief space of time he produced a considerable number of prints, among them the nine representative examples shown in this book (Figs. 21, 31, 46, 47, 66–69, 162). I think it is quite reasonable to speak of him as the artist of the *chuban*-size print (29.3 by 19 cm.). Of course he also produced masterpieces in the *o-nishiki-e* (39.3 by 26.3 cm.), *hashira-e* (66.7 by 12.1 cm.), *hosoban* (30.3 by 15.1 cm.), and other sizes, but his *chuban* prints are by far the most numerous, and possibly this size was the most appropriate for the expression of his genius.

Harunobu's polychrome prints well satisfied the fashions of the time and sold quite well, with the result that there soon appeared imitators and forgers. One of those who published forgeries of Harunobu was Shiba Kokan (1747–1818), originator of the mainstream of Japanese painting in Western

68. Suzuki Harunobu: The Evening Chime of the Clock *from* Eight Views of Interiors. *Chuban nishiki-e. Between 1764 and 1770.*

style. In a collection of his reminiscences, Kokan makes the following admission: "At this time Suzuki Harunobu excelled in depicting the feminine manners and morals of the day, but when he was not much over forty he was carried off by a sudden illness. I then set about creating pictures that resembled his and had them carved into wood blocks and printed. I imitated the originals so well that the public took me for Harunobu. But this misconception troubled my conscience, and I therefore adopted the name Harushige for my prints. Sometimes I painted the beautiful girls of our land by using the color techniques of such Chinese painters as Ch'iu Ying and Chou Ch'en." To be sure, Kokan-Harushige's polychrome prints (Fig. 70) are almost indistinguishable from Harunobu's, but close examination reveals not only a lack of that indefinably appealing quality that marks the work

of Harunobu but also a certain intellectual frigidity.

Kokan, who first pursued the sentimental and idealistic dream of Harunobu and then turned to the study of Chinese painting of the Ming dynasty (1268–1622), later became a realist who ardently admired Western-style painting. In his *Seiyoga Dan* (Chats About Western Painting), published in 1799, he writes: "As we often hear it said, a painting is without excellence if it is not true to life. In fact, it is not really worth the name of painting. Being true to life means that when one paints landscapes, flowers and birds, cows and sheep, trees and stones, and various kinds of insects, one must look afresh each time at the object and give life to every single element in the painting. This is impossible if it is not done in the Western way." It is also of interest to note here that Kokan produced copper

69. *Suzuki Harunobu: detail from* Whispering. *Chuban nishiki-e. Between 1764 and 1770.*

70. *Suzuki Harushige:* The Mosquito Net. *Chuban nishiki-e. Between 1764 and 1781.*

engravings and taught this technique to the artist Aodo Denzen (1747–1822).

Probably the artist who most faithfully followed the Harunobu style was Isoda Koryusai (Figs. 41, 73, 74), who flourished during the second half of the eighteenth century and was a representative ukiyo-e painter of the An'ei era (1772–81) in particular. In his works of the Meiwa era (1764–72), out of respect for Harunobu, he used such signatures as Haruhiro and Koryusai Haruhiro. The resemblance between these works and those of Harunobu is so great that the two artists have sometimes been identified as one and the same man—for example in a book of the late nineteenth century that states: "In his later years, Harunobu signed himself Koryusai."

After the death of Harunobu, Koryusai's paintings gradually freed themselves from his influence and at the same time lost the poetic tone that they had derived from the works of the old master. It is said that Koryusai achieved his first fame with his portrait of the courtesan Nagahashi done in the *hashira-e,* or pillar-print, format—that is, a long, narrow print (66.7 by 12.1 cm.) designed to be hung on one of the supporting posts of the traditional Japanese house. The American critic Ernest Fenollosa, writing in the late nineteenth century, observed that Koryusai, while he could not be called an utter genius, had a particular talent for creating pillar prints and that two-thirds of the extant prints of this type were his. Such prints were no doubt made in answer to the demand among the lower middle class for inexpensive objects to be used for interior decoration. Koryusai's forte lay in his handling of this format, within which he depicted the famous beauties of his day.

72. *Nishikawa Sukenobu: illustration for a popular-style book.
Sumizuri-e. Dated 1741.*

71. *Ippitsusai Buncho:* Osen of the Kagiya. *Hosoban nishiki-e. Between 1764 and
1789.*

His painting activity, however, was by no means limited to the production of underdrawings for woodblock prints. Toward the close of the An'ei era, perhaps around 1780, he was awarded the rank of *hokkyo*, an honor originally reserved for distinguished Buddhist priests and later accorded to artists, doctors, and other men of notable achievement, and it is thought that after this time he devoted himself mainly to the production of ukiyo-e paintings.

THE KATSUKAWA Harunobu must be regard-
SCHOOL ed primarily as a designer of
 prints of beautiful women.
The Edo-period book *Ukiyo-e Ruiko* (Reflections on Ukiyo-e) says of him: "People say that Harunobu never once painted pictures of Kabuki actors. 'I am a true Japanese painter,' he maintained. 'Why

should I paint pictures of such trash as Kabuki actors?' Such was his determination." Nevertheless, he produced a number of actor prints. Aside from creating these prints, which were influenced by those of the Torii school, Harunobu painted such actor portraits as that of Bando Shinsui in the role of a mendicant monk. It was only at a later stage that he devoted his energies to producing prints of beautiful women.

In contrast with Harunobu, Katsukawa Shunsho (1726–92; Figs. 48, 75, 76), a master who published a great number of excellent prints from about 1764 to about 1792, spent practically his whole artistic career in the designing of actor prints. Such prints were his primary concern from the time when he still had no friends or connections in the art world and lived off the wholesale dealer Hayashiya Shichiemon in Ningyo-cho in Edo until he died in 1792

73. *Isoda Koryusai: detail from* The Courtesan Itotaki of the Chojiya. *Oban nishiki-e.Between 1772 and 1781.*

74. *Isoda Koryusai:* Morning-Glories. *Nishiki-e in hashira-e format. Between 1764 and 1781.*

at the age of sixty-six. He achieved recognition as an artist in 1768 upon the publication of his portraits of five Osaka actors who were featured in a Kabuki play at the Nakamura-za in Edo. His deathbed poem, written in accordance with an ancient Japanese tradition, may reflect a certain wryness in his character:

> So I go withering away.
> It makes no difference now
> Whatever I might say.

The actor prints of the age of *benizuri-e* were far from being true likenesses of the actors, but in Shunsho's prints we observe for the first time an attempt to escape from the stereotyped and unpersonalized theater pictures that had developed since the advent of the Torii school and to portray the individual characteristics of the actors. Shunsho's

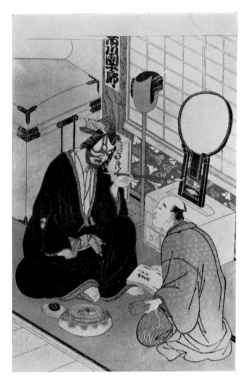

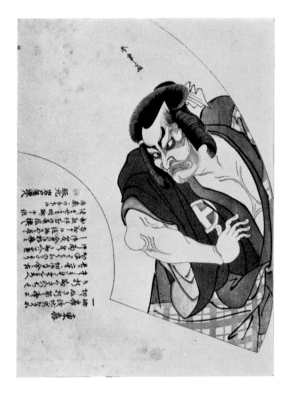

achievement in this respect gained the compliments of two popular writers of his time. Shikitei Samba (1776–1822) dubbed him as the "father of actor portraits," and Ota Nampo (1749–1823) declared: "It's Tsuboya for true likenesses." Tsuboya, of course, is Shunsho, and the name dated from the time when he was still an unknown artist and a dependent of the above-mentioned dealer Hayashiya. Since Shunsho had no seal of his own, he borrowed the one with which Hayashiya stamped his receipts—a seal shaped like a *tsubo,* or jar—and used it on his polychrome prints, thus becoming known as Tsuboya Shunsho.

Although he created a new genre of actor prints, Shunsho stated defensively in a book published in 1780 that he was fond of watching plays but had not the slightest social connection with actors. Nevertheless, in his *Ichikawa Danjuro V in the Greenroom* (Fig. 75) and other backstage portrayals of

actors, he indicates that on occasion he at least got as far as the greenroom door.

The greenroom print of Ichikawa Danjuro V is of *oban* size (45.4 by 75.7 cm.), but most of Shunsho's prints are of *hosoban* size (30.3 by 15.1 cm.). These *hosoban* prints were most probably sold at much lower prices than Harunobu's *chuban* (29.3 by 19 cm.) prints of beautiful women. In fact, evidence from contemporary writers suggests that a Harunobu *chuban* brought something like ten times the cost of a *hosoban.*

Shunsho also produced quite a number of prints of beautiful women, but his greatness as an artist is more clearly recognizable in his ukiyo-e paintings of the same subjects, in which he might well be considered to represent the highest pinnacle of the ukiyo-e genre. Kiyokata Kaburagi, whose opinion on the Kaigetsudo artists we have already noted, makes the observation that "if one compares the

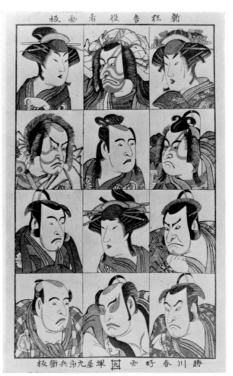

75 (opposite page, left). Katsukawa Shunsho: Ichikawa Danjuro V in the Greenroom. Oban nishiki-e. Between 1764 and 1790.

76 (opposite page, right). Katsukawa Shunsho: polychrome actor print designed for use on a fan. About 1788.

77. Katsukawa Shunko: portraits of actors at the beginning of a new season. Oban nishiki-e. About 1788.

women in Shunsho's pictures with the beauties painted by Kunisada or Eisen, the decline in Edo culture is graphically illustrated."

The artists who produced actor prints in the style of Shunsho were quite numerous, but the best of them were Shun'ei (c. 1762–1819; Figs. 78, 88) and Shunko (1743–1812; Figs. 38, 77). Shun'ei, who used the additional art name Kyutokusai, was a man of highly eccentric habits. He was quite oblivious of the way he dressed, and one story about him relates that a courtesan with whom he was familiar once said to him: "You look awful like that. Why don't you wear something more elegant?" and that the next time he visited her he appeared in the garb of a female *sarugaku* entertainer—that is, a performer in a popular type of vaudeville. According to another story, he returned home one day after a spree in great fear that the house had been sold during his absence and, standing at the gate, shouted: "Is this where Shun'ei lives?" His contemporaries commented that he behaved exactly like the celebrated fifth-century Chinese painter Ku K'ai-chih, who was also known to history for his eccentricities.

Of Shunko we know a good deal less. At the age of about forty-five he lost the use of his right hand through an attack of paralysis and, from that time on, worked as a left-handed painter. Since he used the same jar-shaped seal as Shunsho, he became known as Ko Tsubo, or Little Jar.

By this time the heroic *aragoto* style of the Ichikawa actor family had already become classic theater, and the playwrights of the age began to create new dramas of greater realism to suit the mood of society. Accordingly, the actors adopted more realistic techniques for the presentation of dramas that reflected everyday life rather than remote historical events. As a result, painters of theatrical sub-

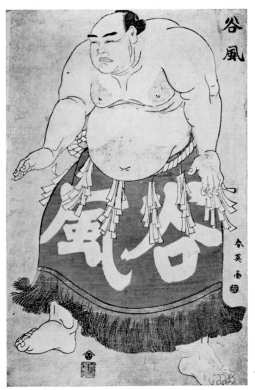

78. *Katsukawa Shun'ei:* The Sumo Wrestler Tanikaze. *Oban nishiki-e. About 1790.*

79 *(opposite page, left). Kitao Shigemasa:* Picture of Beauties of the ▷ East. *Oban nishiki-e. Between 1789 and 1801.*

80 *(opposite page, right). Kitao Masanobu:* Flowers of Yamashita ▷ *from* Contest of Sexual Charms Among Contemporary Beauties. *Oban nishiki-e. Between 1781 and 1789.*

jects were in turn obliged to become more realistic in their portrayals. Shun'ei, Shunko, and others of their school prepared the way for the ultimate master of actor portraits, Toshusai Sharaku.

THE KITAO SCHOOL A similar trend toward realism in the portrayal of beautiful women is evident in the works of Kosuisai Kitao Shigemasa (1739–1820; Figs. 79, 81). Shigemasa was a major figure in the world of ukiyo-e and came to be known by such names as Kitao no Oyabun (Boss of the Kitao) and Kitao Sensei (Master Kitao). A nineteenth-century record says of him: "Shigemasa was a master of modern ukiyo-e. After he died, the style of ukiyo-e became vulgar."

He has been variously identified as the first, second, or third son of Suhara Saburobei, owner of a bookshop in the Kodemma-cho district of Edo. Instead of succeeding his father in the family business, he left it in the hands of a younger brother and went to live in poverty in a slum district, later moving to the village of Negishi (now part of Tokyo). He was a serious and charitable man who devoted his life entirely to his art. By nature he was unselfish and coveted little. In fact, he usually left the matter of his fee up to the person who commissioned the work. One source tells us that he never earned very much, but another says that he did not worry about his fees because he already had quite a lot of money.

Shigemasa produced a large number of prints for cheap illustrated books, but his single-sheet *benizuri-e* and polychrome prints are extremely rare. He apparently also produced a sizable number of *uki-e,* or perspective pictures—that is, prints or

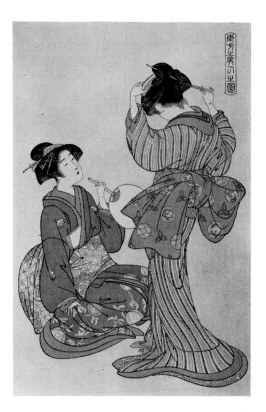 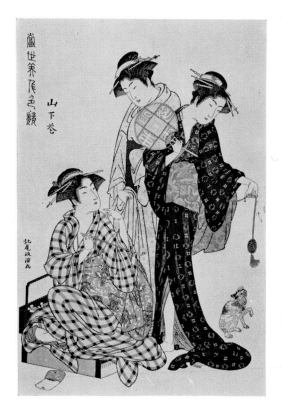

paintings influenced by Western techniques of perspective.

One of Shigemasa's pupils was Kitao Masanobu (1761–1816; Fig. 80), otherwise known as the writer and playwright Santo Kyoden. He first made his name as a painter rather than as a writer. As the novelist and poet Shokusanjin (Ota Nampo; 1749–83) says of him, "Kyoden was an assumed name. In fact, he was Masanobu, a maker of colored prints." In contrast with his teacher Shigemasa, who was so magnanimous about money, Kyoden (as we shall call him from now on) was by no means the typical Edo spendthrift who would never let tomorrow's sun rise on today's wages. He was a shrewd townsman of the sort who counted every penny.

His father, Denzaemon, was born in the province of Ise (the present Mie Prefecture) and, at the age of eight, accompanied his parents to Edo, where he was apprenticed to a pawnbroker in the Fukagawa district and later adopted into the pawnbroker's family. There is no doubt that Kyoden was a true son of Edo from the start. Since he was born into the family of a sharp-witted merchant from Ise, he soon learned how to run a pawnshop, which was one of the representative financial enterprises of his day. Of course there are other traditions about Kyoden's origins, including those that make him the bastard son of a daimyo or some other man of rank. It is also said that his father, Denzaemon, was the manager of a shipping agency in Fukagawa.

Kyoden was a great libertine but by no means a prodigal wastrel. He indulged his appetites without drowning himself in the stream of sensuality. In his comings and goings in the Yoshiwara he never squandered money but amused himself most eco-

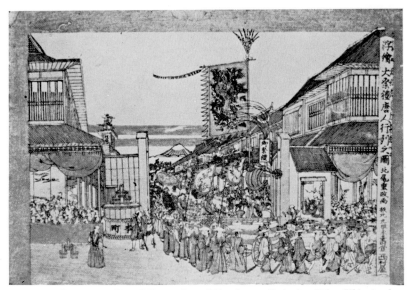

81. Kitao Shigemasa: Grand Procession of Foreigners Entering Edo. *Uki-e in oban nishiki-e format. Between 1772 and 1789.*

nomically and observed with a cool eye the customs and passions of the pleasure quarters. Although he steeped himself night and day in the affairs of this district, a record of the time notes that "he never lost a single thing that he or his parents possessed." With boundless enterprise, he also opened a shop in the Ginza area where he made use of his fame as a writer to sell new kinds of tobacco pouches and pipes in "Kyoden style," as he advertised them. At the same time he expanded the sales of his home-made pills, which he claimed were manufactured according to the formula of a famous Chinese Taoist sage, and did not hesitate to use his own literary works to advertise the products he was selling. His profits exceeded even those of long-established shops, and his monthly income was astonishingly large.

In 1776, his teacher Shigemasa, collaborating with Katsukawa Shunsho, published an illustrated book called *Seiro Bijin Awase Kagami* (A Mirror of Beauties in the Brothels), and in 1784 Kyoden followed suit with his *Yoshiwara Keisei Shin Bijin Awase Jihitsu Kagami* (A Mirror of the New Beauties Among the Yoshiwara Courtesans, with Poems in Their Own Handwriting), an album containing seven prints of *toku-oban* (somewhat larger than *oban*) size published by the well-known Tsutaya Juzaburo. Here Kyoden presented such celebrated prostitutes of the day as Segawa, Matsundo, Azumaya, Kokonoe, Komurasaki, Hinazuru, Chozan, Hitomoto, Tagasode, Utagawa, and Nanasato surrounded by their maidservants and child attendants. On each print was an old poem inscribed in the hand of one of the Yoshiwara beauties. The album was a luxury edition designed to meet the demands of high-class patrons of the pleasure houses.

In the work of Shigemasa, who likewise depicted the pleasure quarters and their inmates, there is a quality that is somehow disagreeable and rather ceremonious, but in the art of Kyoden there is a sense of something extremely polished and altogether refreshing. Still, in the beautiful women he pictures for us there is always a cold, intellectual

quality that perhaps reflects Kyoden's own character. Unlike Utamaro, he was ultimately incapable of portraying beautiful women who had merged themselves body and soul into the world of fleshly lust. It is a disappointment for admirers of Kyoden to learn that his single-sheet polychrome prints are extremely rare. For this reason we have to evaluate his art by way of his book illustrations.

The charm of illustrated books lies mainly in perfect coordination between author and illustrator. In this respect there were several author-artist teams that published superb works. There were also a number of cases in which the painter was himself an accomplished writer, with the result that text and illustrations complemented each other in a peculiarly individual manner that might be termed true storytelling. Kyoden himself, using the traditional Japanese theater as a simile, said: "The painter is like the performer, and the writer is like the shamisen player," and in my opinion Kyoden's illustrated storybooks contain some good performances of the type envisioned in his comparison.

But the mercenary Kyoden, as he became more and more famous and demands for his plays increased, gradually withdrew from painting. His withdrawal is also said to have been in some degree connected with his having been heavily fined for accepting the commission to illustrate a work by Ishibe Kinko based on a scandal involving the high government officer Tanuma Okitsugu. After his retirement as a painter, the illustrations for his works of fiction were largely undertaken by his teacher Shigemasa and his fellow student Masayoshi (later known as Kuwagata Keisai). From around 1799, Kyoden gave many commissions for illustrations to Toyokuni I. Their collaboration was initiated with the publication of *Kanadehon Mune no Kagami* (Mirror of the Heart: A Model Tale).

Masayoshi, who became as well known as Kyoden, made extraordinarily energetic progress in the world of illustrated fiction. In 1794 he was engaged by the daimyo Tsuyama as *o-kakae-eshi*, or painter-in-attendance, and in 1797 he adopted the name Kuwagata and became a member of the Kano Yosen-in school. Thereafter he abandoned the production of prints and concentrated on ukiyo-e paintings. His prints of beautiful women are exceedingly rare, but among them are such works as the twelve that compose the set *Onna Fukoku Hana no Utage* (Customs of Women: Flower-viewing Party).

CHAPTER FOUR

Masters of the Golden Age

TORII KIYONAGA Terms like *ukiyo-e zenseiki* and *ukiyo-e ogon jidai*, both of which mean "the golden age of ukiyo-e," are commonly used, but there still remains the problem of how to define this period exactly. A sensible answer would be to limit the period to the Kansei era (1789–1801). Nevertheless, I should like to view it as having begun somewhat earlier—that is, in the Temmei era (1781–89), during which time Torii Kiyonaga (1752–1815) and the so-called Kiyonaga style came to dominate the world of ukiyo-e.

In his preface to the first volume of his *Ehon Monomi ga Oka* (Picture Book: Observation Hill), published in 1785, Kiyonaga humbly states: "I am but an amateur at painting and one fearful of the criticism of later generations. I still grope for the way I cannot find, and I am unable to control the direction of my brushwork." Such modesty is perhaps becoming, but he was later to receive from his countrymen such accolades as "a master of the new age, worthy to be called the father of Edo *nishiki-e*" and "since the Genroku and Hoei eras [1688–1711] there has been no one to equal him." Indeed, throughout the Temmei and Kansei eras—years that witnessed the emergence of a succession of major artists—he towered above the rest. In the creation of actor prints, the specialty of the Torii school, Kiyonaga was of far from ordinary ability, but it is undeniable that his real province was the portrayal of beautiful women. Once he had established what one writer called "a school of *onna-e*

[pictures of women] in the modern mode," the so-called Kiyonaga style took the world of ukiyo-e by storm.

During his youth, Kiyonaga became a pupil of Kiyomitsu, the third-generation head of the Torii school, and gave his full attention to painting. From about 1769 to about 1776 he was much influenced by his teacher Kiyomitsu and Suzuki Harunobu and then, for some five years, by Kitao Shigemasa and Isoda Koryusai. In the following Temmei era he finally perfected a style of his own.

The period of Kiyonaga's activity was the period in which the artisan culture based on materialistic realism reached full maturity. It was the age in which the ukiyo-e print escaped once and for all from its subservience to the upper-class painting sponsored by the court and the aristocracy and attained the peak of its development. The magnanimity and elegance of Moronobu and Kiyonobu were lost, the charm and grace of Toyonobu and Harunobu began to disappear, and elements of bourgeois vulgarity and coarseness became all too evident. Still, in Kiyonaga's time the signs of decay were not so readily apparent. The ukiyo-e of this period may be characterized by the mood with which they are imbued: they remind one of early summer in Japan, when fresh winds blow through the new foliage of the trees.

The polychrome prints of Kiyonaga (Figs. 25, 33, 82–86, 89, 90, 160) are truly representative of Edo at this time. They are the creations of an age in

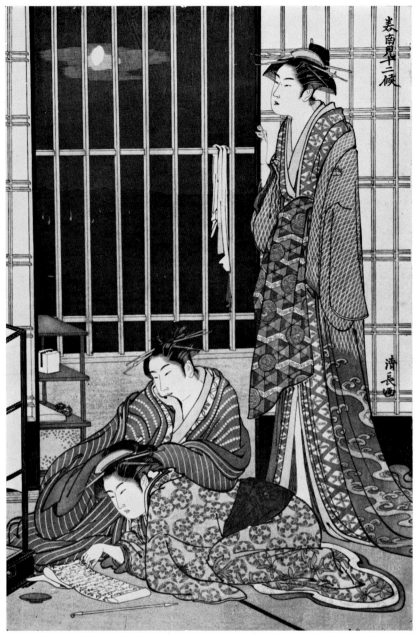

82. *Torii Kiyonaga: right-hand print of diptych* The Ninth Month *from* The Twelve Months in the South. *Oban nishiki-e. Dated 1784.*

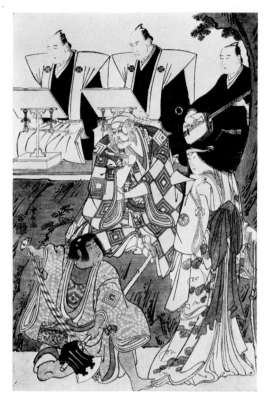

83. *Torii Kiyonaga:* Kabuki Scene. *Oban nishiki-e. Dated 1785.*

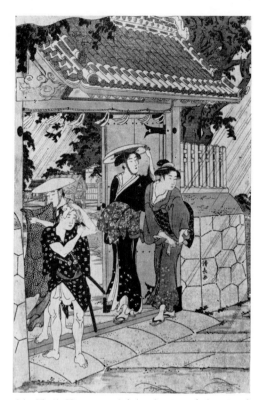

84. *Torii Kiyonaga: left-hand print of the triptych* Sudden Shower at the Mimeguri Shrine. *Oban nishiki-e. Dated 1787.*

which society was universally blessed by an increase in leisure time resulting from nearly two centuries of peace under Tokugawa rule, and they symbolize the mood of the people, no longer hard-pressed by circumstances and now ready to reject the products of bad taste and to seek only refinement. In their joy at liberation from old conventions, these people made light of everything in the world and demanded only what was openhearted and brilliantly clear in spirit. As mementos of this age, Kiyonaga's portrayals of beautiful women are the products of careful and accurate observation. The scent of healthy flesh seems to be wafted from them, and they brim with a sense of voluptuousness.

Three famous sets of Kiyonaga's polychrome prints in *oban* size are *Tosei Yuri Bijin Awase* (Present-Day Beauties of the Yoshiwara), *Fuzoku Azuma Nishiki* (Customs of Eastern Japan in Polychrome), and *Minami Juni Ko* (The Twelve Months in the South), the last of which is represented here by the print shown in Figure 82. Well-known examples of his triptychs include *Shijo-gawara Yusuzumi no Tei* (Enjoying the Cool of the Evening at Shijo-gawara), which pictures a scene in Kyoto and has often been praised for its faultlessly balanced composition and its harmonious coloring (Fig. 33), and the superbly designed *Mimeguri no Yudachi* (Sudden Shower at the Mimeguri Shrine), of which the left-hand print appears in Figure 84. Another delightful triptych that well displays the characteristic qualities of Kiyonaga is the cherry-blossom scene at Shinobazu Pond in the Ueno district of Edo (Fig. 89).

Kiyonaga was adopted by the Torii family and later succeeded his teacher and predecessor Kiyo-

mitsu as its fourth-generation head. It is said that in 1795, upon having accepted Kiyomitsu's seven-year-old grandson Shonosuke (later to become Torii Kiyomine) as one of his pupils, he forced his own son Kiyomasa to give up painting completely so that, after his death, there would be no problem concerning who would succeed to the headship of the Torii family. Kiyomasa, born in 1777, was eighteen years old at this time and had already displayed considerable talent in *chuban* and *oban* prints. It was undeniably cruel to force this promising young artist to abandon painting, but in the ukiyo-e world, which was no less permeated by feudalistic outlooks than the rest of society, this story was handed down as an instructive example of loyalty and self-sacrifice on the part of Kiyonaga.

Kiyomine (1787–1868), who as Shonosuke had been brought up under the kind tutelage of Kiyonaga, succeeded as fifth-generation head of the Torii school after Kiyonaga's death and adopted the name Kiyomitsu II. Although he enjoyed a long life of eighty-one years, his better works date from his youth. His *oban nishiki-e* in the set called *Azuma Nishiki Bijin Awase* (Beautiful Women of Eastern Japan in Polychrome) are possibly his best prints (Fig. 92).

In the portrayal of beautiful women, the Kiyonaga style was carried on to a considerably smaller degree by the Torii school itself than by the Katsukawa-school painter Shuncho, who flourished from the late 1770's to the end of the century (Figs. 87, 91). Shuncho entered the school of Kubo Shumman, where he studied under the master himself and took the name Kissado Shuncho, but he was never able to escape the weighty influence of Kiyonaga. Many of his prints, if one were to cover the signature, would be hard to distinguish from those of Kiyonaga himself. Shuncho was especially skillful in the portrayal of naked bodies, and among his pictures of beautiful women in the bath, or just emerging from it, there are some unforgettable masterpieces.

KITAGAWA UTAMARO

Kiyonaga sensitively captured the beauty of women as it actually was, and he had the artistic

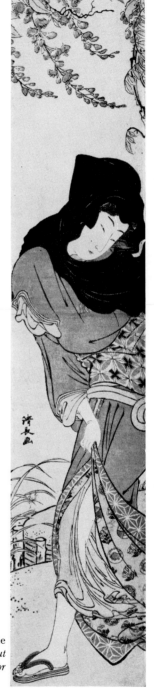

85. *Torii Kiyonaga:* The Wind. *Hashira-e. About 1780. (See Figure 25 for detail.)*

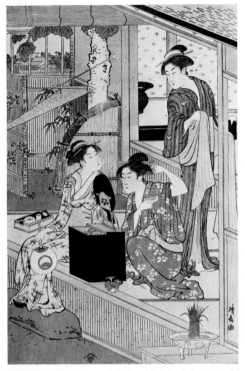

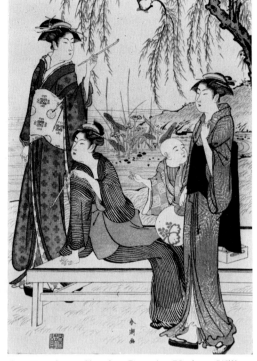

86. *Torii Kiyonaga: right-hand print of the triptych* Washing and Stretching Kimono. *Oban nishiki-e. Dated 1788.*

87. *Katsukawa Shuncho:* Beauties Under a Willow Tree. *Oban nishiki-e. Between 1775 and 1800.*

skill to endow it with a superior reality of its own, but he did not succeed in reaching the point where he could portray the representative beauties of his day as individual women. Attainment to the level of true portraiture was reserved for Kitagawa Utamaro (1753–1806; Figs. 1–3, 15, 20, 26, 29, 94–96, 100–104, 111, 164), who was only a year younger than Kiyonaga and began his career as an ukiyo-e artist around the same time.

In his portrayals of the beautiful women of his time, Utamaro managed not only to depict the bewitching charm of their faces, the softness of their flesh, and the satiny smoothness of their skins—and even to suggest the scent of their bodies and the incense with which they perfumed their clothes—but also to represent their qualities as actual persons: the individual ways in which they appealed to the senses of sight, touch, and smell. Although these women are conventionalized to the extent that we speak of them as Utamaro-style beauties, we can discover in each of them certain qualities that give them personalities of their own. Senior critics in the world of ukiyo-e scholarship have told us that this is not so and that Utamaro's women do not represent figures from real life, but if we look closely at a print like the one shown in Figure 104, we must admit there is clear evidence of an attempt by the artist at individual portrayal of the leading beauties of his age.

Utamaro studied under Toriyama Sekien, but in his youth he was strongly influenced by Shigemasa and, in the late 1780's, by Kiyonaga. It was only in the 1790's that he succeeded in establishing the imposing style that is truly his own. But toward the end of the century his prints declined in quality. Since he was a fashionable artist, his publisher pres-

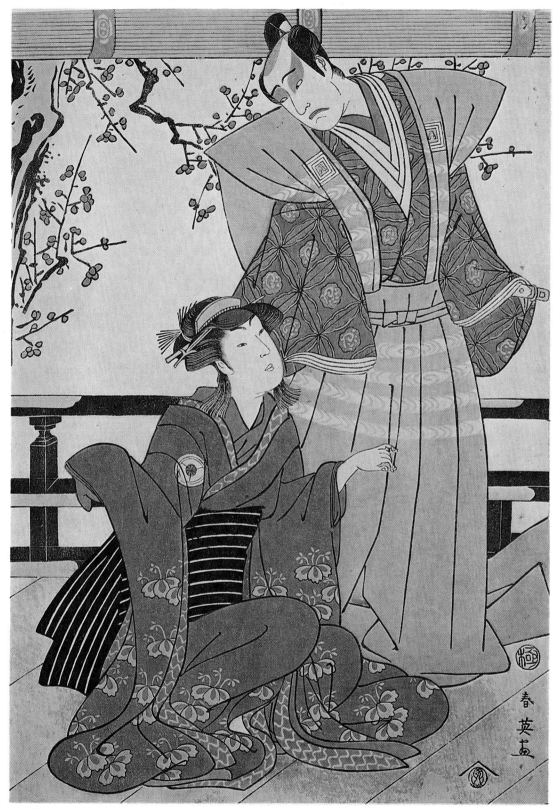

88. Katsukawa Shun'ei: The Actors Ichikawa Yaozo and Iwai Hanshiro. *Oban nishiki-e; height, 31.2 cm.; width, 22 cm. Between 1781 and 1789.*

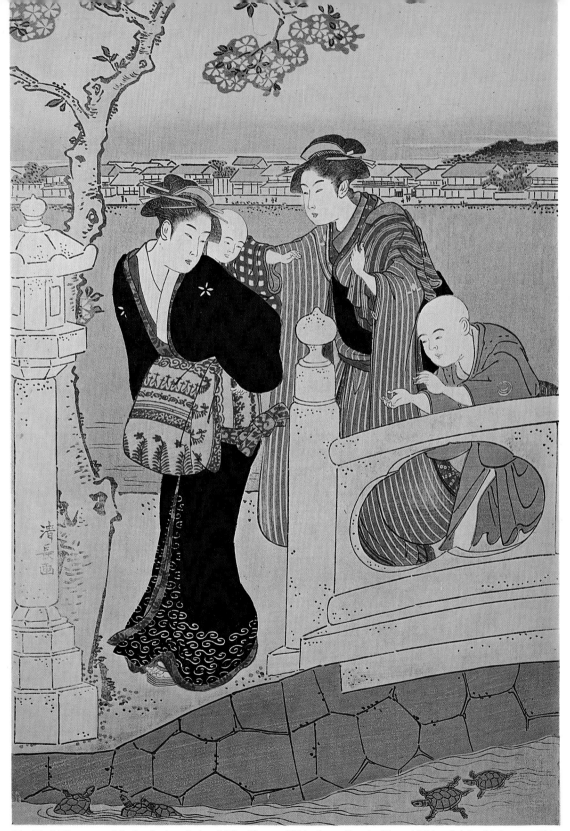

89. *Torii Kiyonaga: right-hand print of triptych* The Shore of Shinobazu Pond. *Oban nishiki-e ; height, 38.2 cm. ; width, 25.8 cm. Dated 1788.*

90. *Torii Kiyonaga:* The Bath. *Chuban nishiki-e ; height, 26.3 cm. ; width, 19.2 cm. Between 1779 and 1781.*

91. Katsukawa Shuncho: Parrot Komachi *from* Seven Ages of the Poetess Komachi. *Chuban nishiki-e; height, 22.5 cm.; width, 16 cm. Between 1804 and 1818.*

東
錦
美
人
合

清峯筆

92. Torii Kiyomine (Kiyomitsu): A Beauty of Eastern Japan *from* Beautiful Women of Eastern Japan in Poly-
chrome. *Oban nishiki-e; height, 37.5 cm.; width, 25.8 cm. Dated 1808.*

93. Chobunsai Eishi: right-hand print of triptych The Pleasure Barge. *Oban nishiki-e; height, 37.8 cm.; width, 25.2 cm. Between 1789 and 1801. (The entire triptych is shown in Figure 165.)*

94. Kitagawa Utamaro: Hour of the Rabbit *from* Day and Night in the ▷ Pleasure Houses. *Oban nishiki-e; height, 36.4 cm.; width, 23.5 cm. About 1795.*

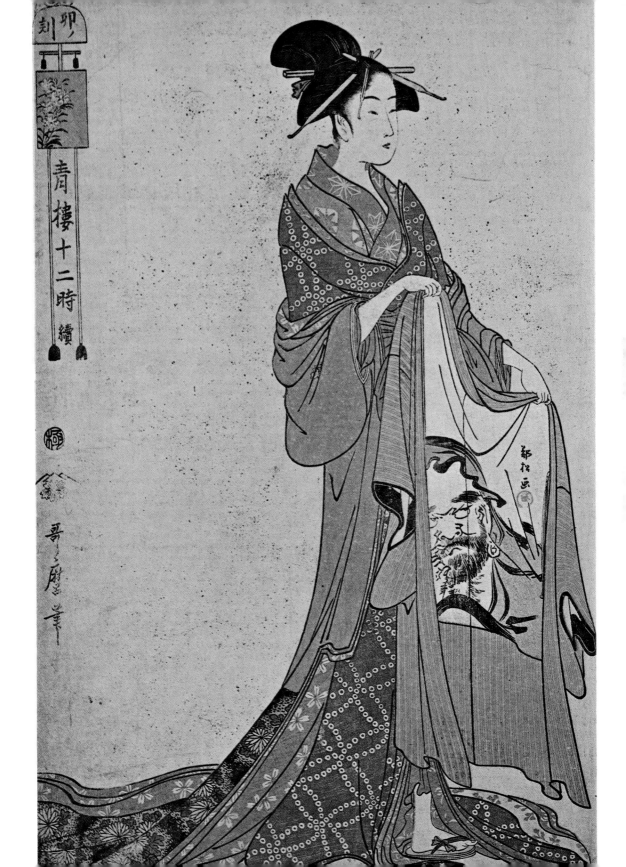

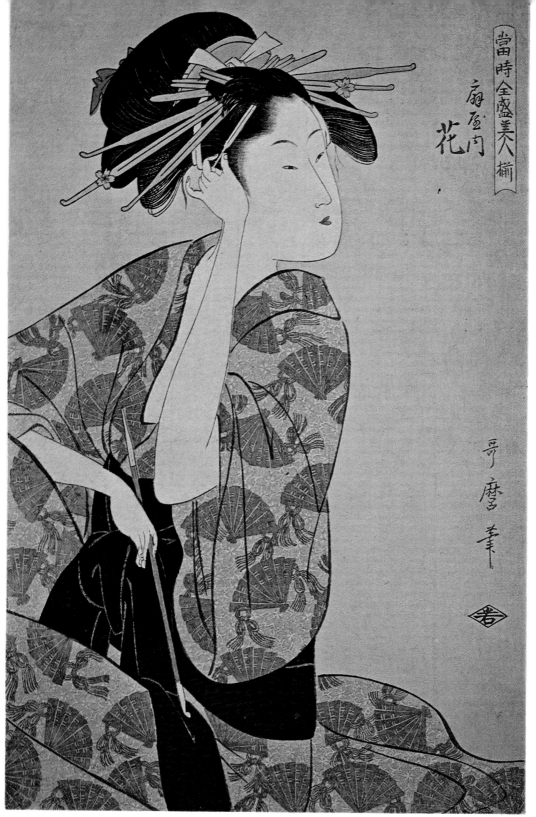

95. Kitagawa Utamaro: The Courtesan Hanaogi of the Ogiya *from* An Assemblage of Beauties of the Current Prosperous Age. *Oban nishiki-e; height, 38 cm.; width, 24.8 cm. About 1795.*

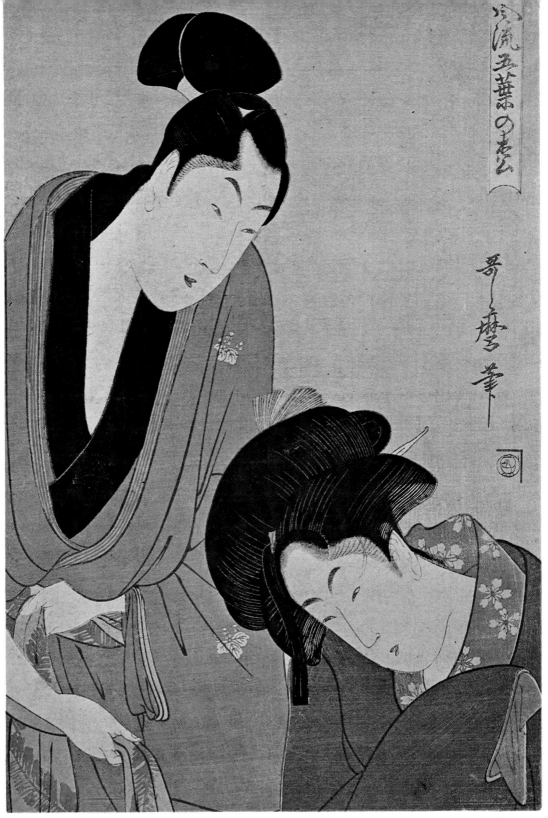

清
流
五
葉
の
吾

哥
麿
筆

96. *Kitagawa Utamaro:* The Morning After *from* Five Elegant Aspects of Life. *Oban nishiki-e; height, 37.7 cm.; width, 25.3 cm. About 1800.*

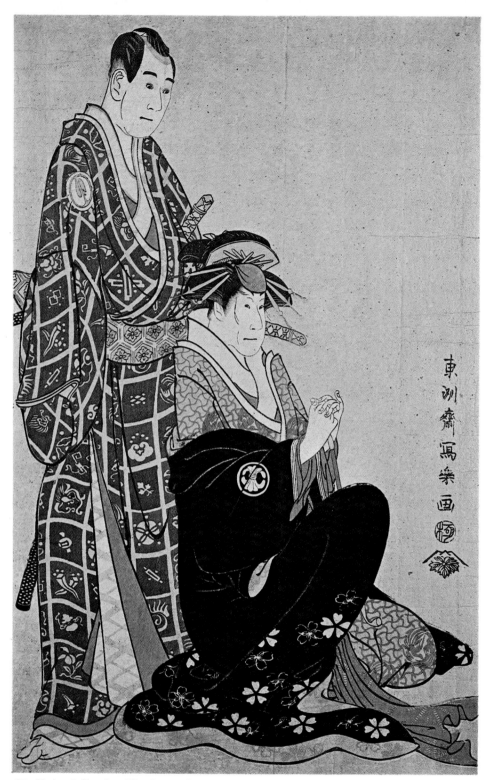

97. *Toshusai Sharaku:* The Actors Sawamura Sojuro III and Segawa Kikunojo III. *Oban mica nishiki-e height, 38 cm.; width, 24.6 cm. Dated 1794.*

98. *Toshusai Sharaku:* The Actor Kosagawa Tsuneyo as Sakuragi, Wife of Take- ▷ mura Sadanoshin. *Oban mica nishiki-e; height, 38.8 cm.; width, 25.8 cm. Dated 1794.*

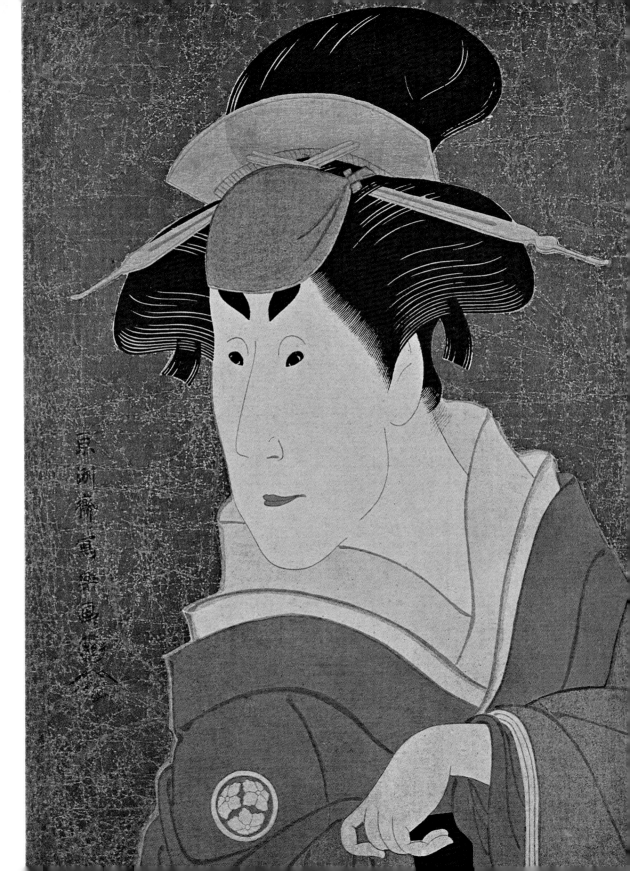

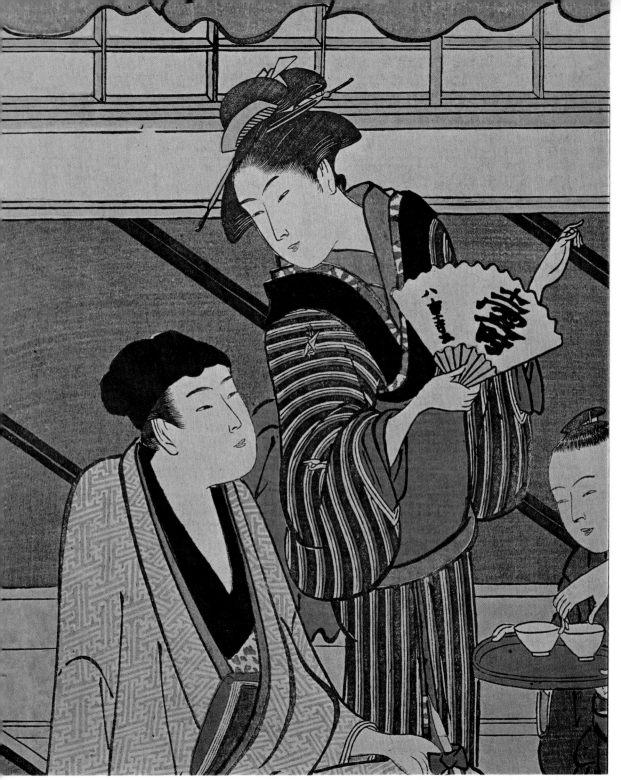

99. *Eishosai Choki: detail from left-hand print of triptych* At the Front of the Naniwaya Teahouse. *Aiban nishiki-e; dimensions of entire triptych (see Figure 106): height, 32.5 cm.; width, 67 cm. About 1795.*

100. Kitagawa Utamaro: detail from The Wanton *in* Ten Types of Women. *Oban nishiki-e. About 1790.*

sured him into overproduction. Moreover, his health began to fail, and as his arteries hardened, his art began to harden as well. His marvelously tall and slender beauties shrank in height and became fat, retaining only a superficial touch of glamor and losing their fleshly appeal.

Among Utamaro's pupils were Kikumaro (Fig. 105) and Utamaro II. The latter is variously identified as a doctor and as a nobleman who shaved his head in the manner of a Buddhist monk and lived in retirement. A contemporary record remarks that his polychrome prints were less skillful than those of his master, but there are a number of instances in which his work is scarcely distinguishable from that of Utamaro's last years.

EISHOSAI CHOKI Eishosai Choki (Figs. 99, 106, 161), who worked from the 1760's to the early 1800's, was another of the artists

101. Kitagawa Utamaro: The Courtesan Komurasaki and Her Lover Gompachi. Hashira-e. About 1801.

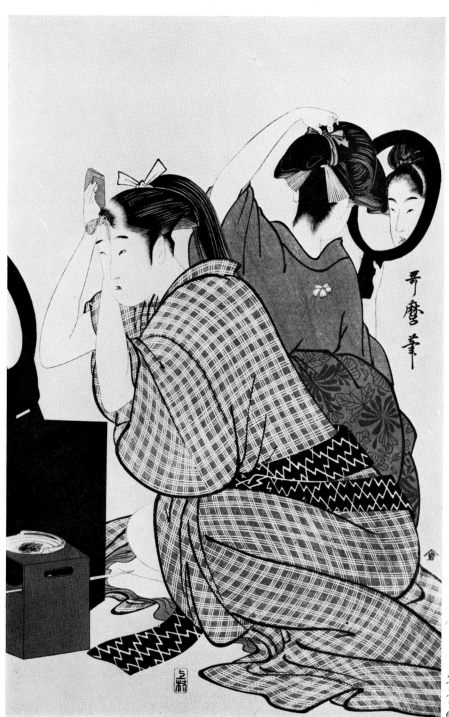

102. Kitagawa Utamaro: Two Beauties Dressing Their Hair. *Oban nishiki-e. Between 1789 and 1801.*

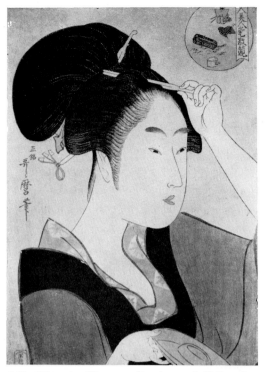

103. *Kitagawa Utamaro:* Suminoe of Shiba *from* A Comparison of the Charms of Five Beautiful Women. *Oban nishiki-e. About 1795.*

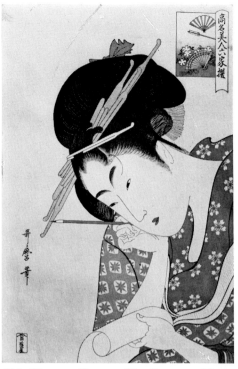

104. *Kitagawa Utamaro:* The Courtesan Hana-ogi of the Ogiya *from* A Selection of Six Famous Beauties. *Oban nishiki-e. About 1800.*

who graced the golden age of ukiyo-e with portrayals of beautiful women, although we must admit the inferiority of his work to that of Utamaro. The facts about Choki's life are obscure. According to one opinion, he was a samurai of the lowest rank. It is said that at some time in the Kansei era (1789–1801) he became the adopted son of a family who owned the teahouse Owariya on the main street of the Yoshiwara and that, not long afterward, he separated himself from this household and became the owner of a house in Kodemma-cho.

Choki is a peculiar artist. On the one hand, he has been extravagantly praised by such Western scholars of ukiyo-e as Julius Kurth, who found him to have the "greatness of a giant." On the other hand, a book of his own time remarks that "between 1789 and 1801 he painted *nishiki-e* and illustrations for popular books commissioned by the publisher Tsutaya, but since they were unskillful, they were not popular, and so after five or six years he gave up painting and turned to the craft of brushmaking instead." If the praise of critics like Kurth seems extravagant, the opinion just quoted seems unnecessarily severe. Moreover, there are errors of fact in the book. Choki's career as a painter was certainly longer than five or six years. He continued to produce illustrations for popular books from 1789 until about 1809. He also produced quite a number of excellent mica prints and other types of polychrome prints. Still, his work has less of the fleshly opulence and rich flavor that characterize Utamaro's, and even in his de luxe *nishiki-e* editions there is a certain sense of what is perhaps best described as "loneliness." Although both Choki and

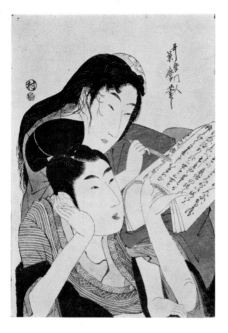

CHOBUNSAI EISHI AND HIS FOLLOWERS

Another painter who was active in the same era but who deserves a higher place in our estimation than Choki was Chobunsai Eishi (1756–1829; Figs. 34, 93, 109, 165). Eishi derived an annual income of five hundred *koku* (about 2,500 bushels) of rice from his respectable position as a retainer of Fujiwara Tokitomi, the eldest son of Danjo Tokiyuki, who was in turn a descendant of Hosoda Tokitoshi, lord of Tamba and shogunal finance administrator. As an employee of the shogunate, Eishi served as painter to the tenth Tokugawa shogun, Ieharu, who was himself partial to painting, and then to Ieharu's successor, Ienari. He also studied painting under Kano Eisen'in Sukenobu. He occupied his post as painter to the shoguns for only three years, being obliged by ill health to retire from it, and thereafter transferred the headship of his house to his heir Tokitoyo and proceeded to devote his attention to his long-cherished hobby of ukiyo-e. In answer to the demands of the polychrome-print wholesalers he produced a large number of underdrawings and, at the same time, painted on commission for members of the wealthy merchant class. His paintings of beautiful women do not express the personalities of his subjects, and many of them convey little more than an impression of delicate feminine beauty. Although he liked best to picture courtesans, geisha, and the customs of the pleasure quarters, his portrayals of beautiful women, for all the coarseness of their subject matter, somehow convey a sense of great dignity and grace. It is this very quality in Eishi's prints that deprives them, perhaps regrettably, of that flavor of the vulgar in which lies the essence of our fascination with ukiyo-e.

Among the galaxy of able men who made up the roster of Eishi's pupils, perhaps the most significant was Chokosai Eisho, who worked in the 1790's. His *Tosei San Bijin* (Three Beauties of the Present

Utamaro portrayed the beauty Okita of the Naniwaya house, for example, we get totally different impressions from the two portraits.

In one of Kunieda Kanji's novels, we catch a revealing glimpse of Choki attired in a once elegant but now worn and faded kimono and an out-at-the-seams obi of Hakata weave. He sits at the window of his small room in a tenement house, gazing at the darkening sky that promises an evening shower.

When we look at Choki's pictures, we cannot help feeling that in comparison with the proud and defiant Utamaro he is somehow a weak-spirited artist. Still, it is much more difficult to obtain prints by Choki than it is to buy those of Utamaro. When we have the occasion to examine Choki's most outstanding works—his mica prints or his half-length or three-quarter-length *oban* prints of beautiful women—the startling slenderness of the bodies in comparison with the faces—a slenderness like that of traditional Japanese *kokeshi* dolls—leaves us with a most forceful impression of femininity.

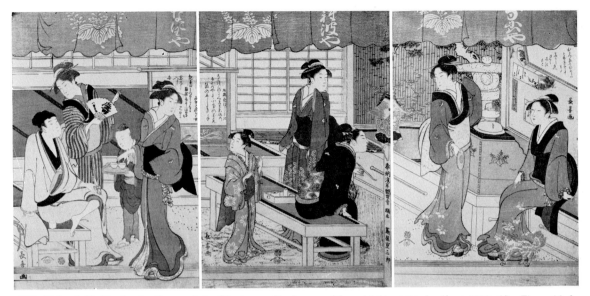

106. Eishosai Choki: At the Front of the Naniwaya Teahouse. *Aiban nishiki-e triptych. About 1795. (See Figure 99 for detail.)*

Time), *Tosei Bijin Awase* (Collection of Beauties of the Present Time), and *Kakuchu Bijin Kurabe* (Contest of Beauties of the Pleasure Quarters), the last of which is represented by the print in Figure 107, are superlative examples of his *okubi-e,* or bust portraits. The *Tosei Bijin Awase* includes a portrait of the streetwalker Otatsu, who frequented the Ryogoku district of Edo and was also made the subject of a print in the set *Sanka no Tsu Soka Bijin Awase* (Collection of Beauties of the Three Waterfronts) by Eisho's fellow pupil Eiri. It appears that Eiri's subjects for this set—Otatsu of Ryogoku, Oman of the Sanjo Sunaba district in Kyoto (Fig. 108), and Okane of the Dotombori district in Osaka—were highly acclaimed prostitutes of the time.

Eiri, whose work also dates mainly from the 1790's, is variously known as Chokyosai Eiri, Shikyusai Eiri, Kotsuyosai Eiri, and Rekisentei Eiri—all appellations that he used during the course of his career. Like Eisho, he produced a number of sets of *okubi-e,* including *Seiro Bijin Izutomi* (Collection of Beauties of the Brothels) and *Kakuchu*

Bijin Kurabe, which bears the same name as the set by Eisho mentioned above. Again like Eisho, who included among his *Edo no Hana: Kyobashi no Natori* (Flowers of Edo: Famous Artists of the Kyobashi District) a masterly portrait of Santo Kyoden seated at his work desk with a fan in front of him and a pipe in his hand, Eiri produced a fine portrait of the narrator Tomimoto Buzen seated at his lectern intoning the text of a *joruri* puppet drama.

In addition to Eisho and Eiri there were many other pupils of Eishi's school, including Ichirakusai (or Ichirakutei) Eisui, who produced many *okubi-e* of courtesans; Choensai Eishin, who is remembered for his *okubi-e* of a falconer; Chotensai; and Eijusai Eiju. We even find among Eishi's pupils a number of artists who used such coquettish names as Yujo (Courtesan) and Shinohara-me (Woman of Shinohara).

TOSHUSAI SHARAKU It is generally thought that *yakusha-e,* or actor prints, developed mainly because of their usefulness

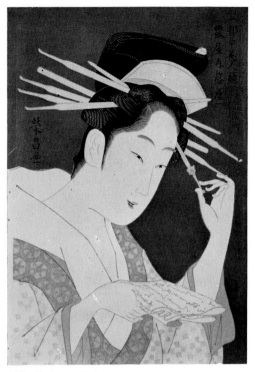

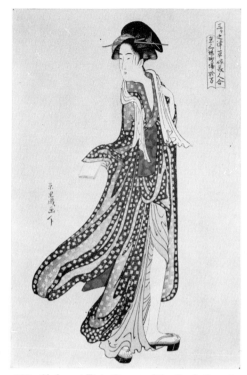

107. *Chokosai Eisho:* The Courtesan Shinohara of the Tsuruya *from* Contest of Beauties of the Pleasure Quarters. *Oban mica nishiki-e. About 1800.*

108. *Chokyosai Eiri:* Oman of the Sanjo Sunaba District *from* A Collection of Beauties of the Three Waterfronts. *Oban nishiki-e. About 1800.*

to actors and theatrical producers as an advertising medium. We know, for example, that the Edo Kabuki actor Nakamura Nakazo Shukaku made use of actor prints for this purpose. In 1787, Shukaku went to Osaka to perform at the theater of Nakamura Kumetaro. Among the roles he played there was that of the supernatural fox disguised as the warrior Tadanobu in the famous drama *Yoshitsune Sembonzakura* (Yoshitsune and the Thousand Cherry Trees). At this time one of his admirers in Edo sent him a hundred copies of a single-sheet print in which Rantokusai Shundo, a pupil of the previously noted Katsukawa Shunsho, had portrayed him in the fox-Tadanobu role at the point in the drama where the fox holds the magic hand drum in his mouth. Upon receiving the prints, Shukaku distributed them widely throughout Osaka.

Toshusai Sharaku (Figs. 19, 32, 97, 98, 112, 167, 170), whose artistic career covered the incredibly brief space of some ten months in the years 1794 and 1795, is the undisputed master of the actor print. Some critics rank him with Rembrandt and Velázquez as one of the world's three greatest portrait painters. His actor portraits, strikingly presented against black or white mica grounds, were published and sold in rather spectacular fashion by the famous Tsutaya Juzaburo, no doubt with the backing of theatrical producers and other interested persons. Up to this time, actor prints had been sold at generally moderate prices, and for this reason the publication in 1794 of a de luxe edition of single-sheet prints by an unknown amateur artist from the provinces was almost unthinkable, even for a publisher of the caliber of Tsutaya Juzaburo, who was

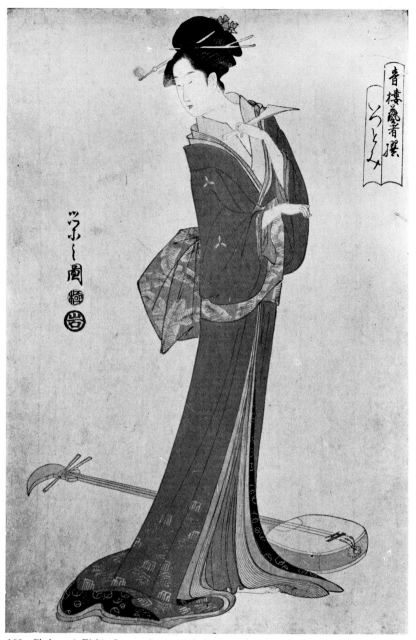

109. Chobunsai Eishi: Izutomi *from* A Selection of Geisha from the Pleasure Quarters. *Oban nishiki-e. About 1793 or 1794.*

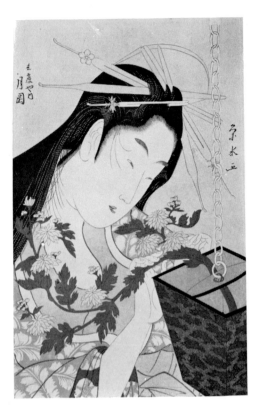
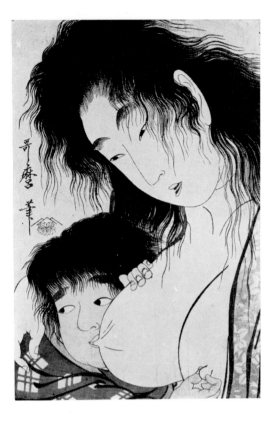

known to be bold and enterprising and not preoccupied with minor details. Without the support of theatrical producers the venture would have been virtually impossible.

Sharaku's actor prints represent the extreme limit of efforts made by painters since the time of Shunsho to free themselves from the realm of generalized theater pictures and to portray the individual personalities of Kabuki actors. Decidedly, Sharaku produced true likenesses of his actors, but Ota Nampo, in his *Ukiyo-e Ruiko* (Reflections on Ukiyo-e), an indispensable handbook for ukiyo-e scholars, tells us that "he was too realistic and produced pictures that were too exaggerated, with the result that his popularity was brief, and he stopped painting within one or two years." Similarly, the *Edo Enkaku* (Development of Edo), another book of

the time, states that Sharaku "was skillful at the depiction of their facial features and their habitual expressions, but he destroyed their appeal, and the actors came to resent him." It is understandable that the actors were offended at the startling exaggeration of their features and their quirks of expression, but it is almost certain that quite a number of Kabuki connoisseurs of the time applauded this caricaturing of personal characteristics. No doubt the publisher and capitalist Tsutaya Juzaburo took this last factor into consideration and made a financial arrangement with theater proprietors and others whereby he commissioned this painter from the provinces to produce at high speed a sizable number of large-size nishiki-e in luxurious mica editions.

The use of mica printing proved highly successful

110 (opposite page, left). Ichirakutei Eisui:
The Courtesan Tsukioka of the Hyogoya.
Oban mica nishiki-e. About 1800.

111 (opposite page, right). Kitagawa Uta-
maro: Kintoki and the Mountain Witch.
Oban nishiki-e. About 1800.

112. *Toshusai Sharaku:* The Actor Sawa-
mura Sojuro III as Kujaku Saburo *(left)*
and The Actor Kataoka Nizaemon VII
as Ki no Natora *(right). Hosoban nishiki-e.*
Dated 1794.

in the production of woodblock prints. In the previ-
ously cited *Hogokago* (Wastebasket), Hiraga Gennai
records that "Utamaro was the first to use printing
in gold and silver." It also appears that Utamaro
was the first to use printing in black and white mica.
Among his outstanding mica prints are those in the
set *Fujin Ninso Jippon* (Portraits of Ten Women) and
such half-length portraits as those of the teahouse
girls Ochie of the Koiseya poring over a picture
book, Okita of the Naniwaya serving tea, and Ohisa
of the Takashimaya with a fan in her hand.

Nevertheless, it was in the actor prints of Sharaku
that mica was used with the greatest success. These
prints seem to hound us with a sense of the uncanny
and the ominous, as though we had caught the re-
flection of a demon in a mirror. In fact, they have
evoked among critics such descriptions of their

effect as "like a thief abroad in the dead of night"
and "like a frenzied lunatic capering about in a
temple courtyard under the light of the moon."
Still, when Sharaku uses a yellow ground (*kizuri*)
instead of a mica ground, a good half of this demon-
ic quality is lost, and the prints seem rather ordi-
nary. Perhaps his greatest misfortune as a print
artist was the reimposition of a government ban on
luxuries and the resulting impossibility of publish-
ing further de luxe editions of prints. There are, of
course, some excellent works among his *hosoban*
(30.3 by 15.1 cm.) and *aiban* (33.3 by 22.7 cm.)
prints, but in these one should not expect to find
the spectral atmosphere that characterizes his *oban*
mica prints.

Among Sharaku's followers and imitators was the
artist Kabukido Enkyo (Fig. 113). Although the

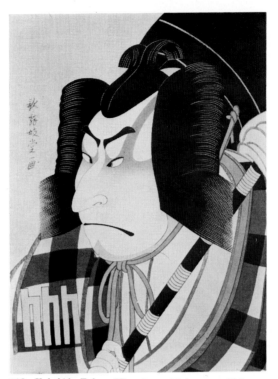

113. Kabukido Enkyo: The Actor Nakamura Nakazo II as Matsuomaru. *Oban nishiki-e. Dated 1796.*

scholar Julius Kurth believed that after 1795 Sharaku adopted the name Enkyo and produced pictures that catered to the popular tastes of the times, no one accepts this conclusion today. Until recently the facts about Kabukido Enkyo's life were obscure, but now, thanks to the research of Naoshige Ochiai, he has been identified as the Kabuki playwright Nakamura Jusuke II. Enkyo's actor prints were not commercial products but were published at the actors' own expense. They include such well-known prints as those of actors in the roles of Matsuomaru (Fig. 113), Umeomaru, and Sakuramaru in the "Pulling the Carriage" scene from the celebrated Kabuki drama *Sugawara Denju Tenarai Kagami* (The Illustrious Secrets of Sugawara's Calligraphy).

CHAPTER FIVE

Luminaries of the Closing Years

COERCION AND
SURRENDER

The art of the ukiyo-e, which had come to flower in an age when conventions were recklessly abandoned, began to sink into decadence under the shogunate's subsequent policy of enforcing thrift and diligence. In an attempt to halt developments that were shaking the feudal system to its very core, the government instituted a rigorously conservative policy that suppressed all manifestations of extravagant thinking and behavior, with the result that the arts of literature, drama, music, and painting came to assume eccentric forms of expression. The art of the ukiyo-e was no exception.

As we have already noted, the Kansei era of 1789–1801 is generally regarded as the golden age of ukiyo-e. Soon after the outset of that era, however, the world of ukiyo-e began to feel the early blast of a withering wind. The sumptuary edicts of 1790, which included measures for the control of picture books and illustrated popular literature, may well be said to have marked the beginning of the niggardliness that crept into ukiyo-e. In the following year, upon having published a novel by Santo Kyoden about the pleasure quarters, Tsutaya Juzaburo, the great genius of the publishing world who was at once the protector and exploiter of ukiyo-e artists, had to endure the confiscation of half his estate by way of punishment. The year 1792 brought the death of Katsukawa Shunsho, who had broken new ground in the field of portrait prints. Ippitsusai Buncho, who had collaborated with

Shunsho to create the pictures for *Ehon Butai Ogi* (literally, "Picture Book: Stage Fans"), a collection of actor portraits in fan shape, died in 1793. In 1797, Tsutaya Juzaburo died in his prime at the age of forty-seven.

Restrictions on polychrome prints became more and more severe. New sumptuary laws were promulgated in 1793 and 1796, and late in 1799 the office of the Edo magistrate Taruyoemon issued a decree to the effect that no print could be published until it had undergone inspection in finished form at the proper administrative office. Early in 1800 this decree was strengthened by another government order, and in the middle of the same year a still more forceful decree forbade the production of single-sheet de luxe prints and calendars as well as prints that might be detrimental to public morals. By the end of the Kansei era, prints with black or white mica grounds, which had made their first appearance only a few years earlier, were virtually no longer produced.

Although the retrenchment policies of the Kansei era rigorously limited the production of mica prints, they brought about an increase in the publication of *murasaki-e*, or purple prints. *Murasaki-e* were also known by the term *beni-girai* (literally, "avoiding red"), for they represented an attempt to avoid the ostentatious color of *beni* and to stress purple and thin black ink, to which was added a peach-blossom pink. Since these prints began to appear around the end of the Temmei era (1781–

89), we cannot attribute their origin directly to the Kansei-era prohibitions against de luxe single-sheet prints, but it is undeniable that they appeared in great numbers at this time. Among extant *murasaki-e* there are some that seem to have followed the retrenchment edicts in extremely literal fashion, avoiding even the use of purple and achieving the ultimate in simplicity with the single color of thin black ink. While these prints shunned sumptuous coloring and, on the surface, abstained from gorgeousness, a number of them displayed an intrinsic beauty of design and technique by no means inferior to that of the de luxe editions. Shumman, Eishi, and Toyokuni I produced some superlative *beni-girai* prints. Shumman's pictures of tea pickers, his triptych of night scenes in restaurants, and his *Mu Tamagawa* (The Six Tama Rivers), which is generally regarded as his masterpiece and of which one print is shown in Figure 129, are all *beni-girai* prints.

Changes in subject matter are also evident. At the same time, in an effort to fall in with government policy, artists took to embellishing their prints with lengthy moralistic inscriptions, as we have already noted in the first chapter of this book.

Among the artists who graced the golden age, Kiyonaga, after reaching his peak in the 1780's, gradually produced less and less superior work and, in the Bunka era (1804–18), concentrated solely on the Torii family profession of painting theater posters, with the result that his last years were years of extreme stagnation. Utamaro, who could boast in the 1790's that he was a self-made man, at the turn of the century began to display increasingly the ravages of arteriosclerosis. Choki, who in 1796 had changed his signature to Shiko, reverted to his old name after 1801, but his prints, which had always been less voluptuous than those of Utamaro, from this time on became more and more seedy. Santo Kyoden (Kitao Masanobu), who enjoyed growing fame as a writer, began to paint less and less.

At this time the one group that gradually succeeded in spreading its roots and putting forth branches was the Utagawa school. In fact, during the closing years of the Edo period, the world of ukiyo-e came to be almost entirely dominated by this school.

UTAGAWA TOYOHARU AND PERSPECTIVE PICTURES

Ichiryusai Toyoharu, founder of the Utagawa school, produced a quantity of ukiyo-e paintings (*nikuhitsuga*) of voluptuous women, but they are by no means of high quality. We regret the exaggerated make-up of the women, with its thickly daubed rouge and powder. They are nowhere near as fine as the beautiful women of Shunsho and very much inferior to those of Eishi. During the Meiwa era (1764–72) Toyoharu also produced a small number of prints of beautiful women and actors, but in the following An'ei era (1772–81) his main activity as a woodblock-print artist was the production of *uki-e*, or perspective prints (Fig. 130).

The term *uki-e* is used to describe woodblock prints created under the influence of Dutch copperplate prints, in particular, and designed according to Western concepts of perspective, as though made for use in a peep show. After the ban on Chinese books relating to Christianity had been lifted by the shogun Yoshimune in 1720, Japanese artists began to encounter Chinese pictures embodying Western ideas of perspective and to come under their influence. The new trend is evident in such works as Okumura Masanobu's scenes of the interiors of theaters, painted around the late 1730's and early 1740's; Nishimura Shigenaga's *Tojin Gyoretsu Zu* (Procession of Foreigners from the Continent), a depiction of the Korean emissary's entry into Edo in 1748; and portrayals of Nagasaki and the brothels of the Yoshiwara. These were generally very rough works in which the laws of perspective were only partially used, but Toyoharu's *uki-e* were finely executed works modeled directly on Dutch copperplate engravings. In these prints he not only depict-

114. Keisai Eisen: The Courtesan Hitomoto of the Daimonjiya *from* Contemporary Scenes in the Pleasure Quarters. ▷
Oban nishiki-e; height, 37 cm.; width, 25.3 cm. Between 1804 and 1844.

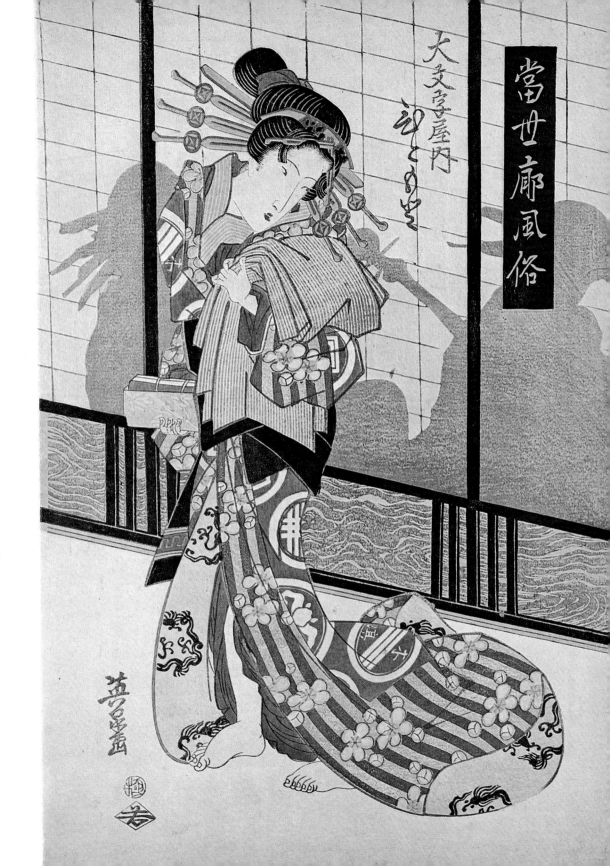

當世廓風俗

大文字屋内
江□の□

115. Utagawa Toyokuni: Takashima Hisa. *Chuban mica nishiki-e; height, 26 cm.; width, 19 cm. About 1795.*

116. Utagawa Toyohiro: right-hand print of triptych Garden of Blossoming Plum Trees. *Oban nishiki-e; height, 38.3 cm.; width, 25 cm. Between 1804 and 1830. (The entire triptych is shown in Figure 166.)*

117. *Gototei Kunisada:* The Courtesan Nakayubi of the Shimanouchi District in Osaka *from* Famous
Scenes of the Floating World. *Oban nishiki-e; height, 38 cm.; width, 24.8 cm. Between 1818 and 1844.*

118. *Gototei Kunisada: detail from two-piece vertical print* Return from the Bath. *Oban nishiki-e;* ▷
dimensions of entire print (see Figure 140): height, 72 cm.; width, 24.8 cm. Between 1818 and 1844.

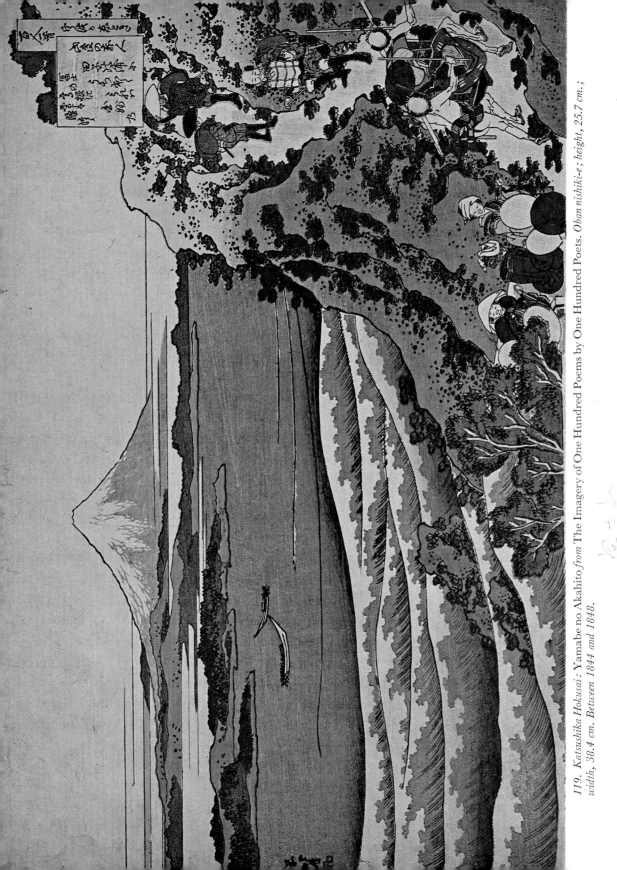

119. *Katsushika Hokusai*: Yamabe no Akahito *from The Imagery of One Hundred Poems by One Hundred Poets. Oban nishiki-e; height, 25.7 cm.; width, 38.4 cm. Between 1844 and 1848.*

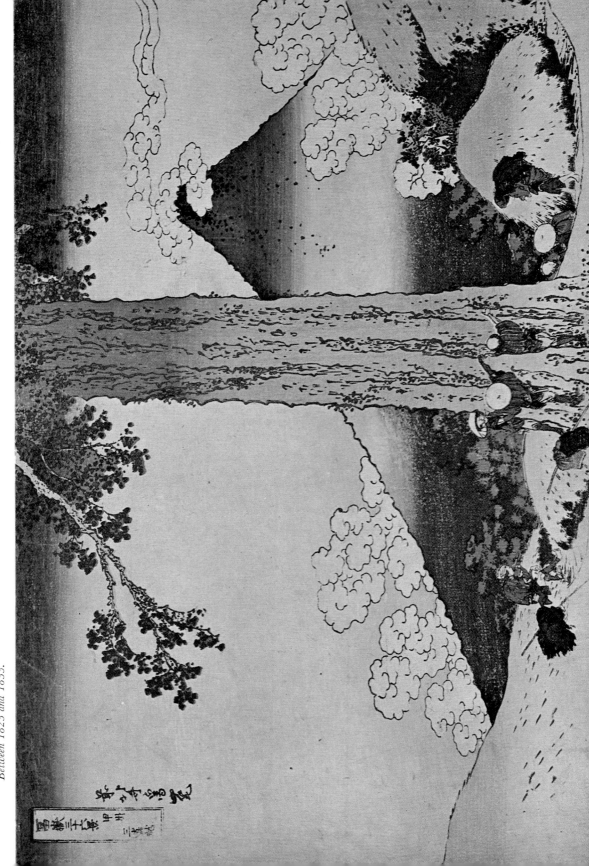

120. Katsushika Hokusai: Mishima Pass in Kai Province from Thirty-six Views of Mount Fuji. Oban nishiki-e; height, 25.5 cm.; width, 37.7 cm. Between 1823 and 1833.

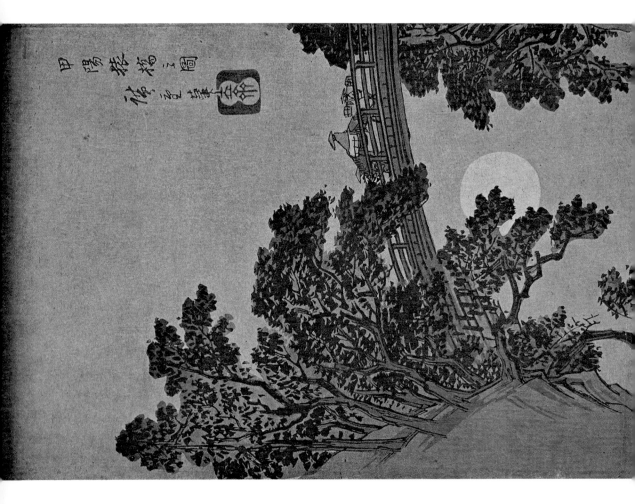

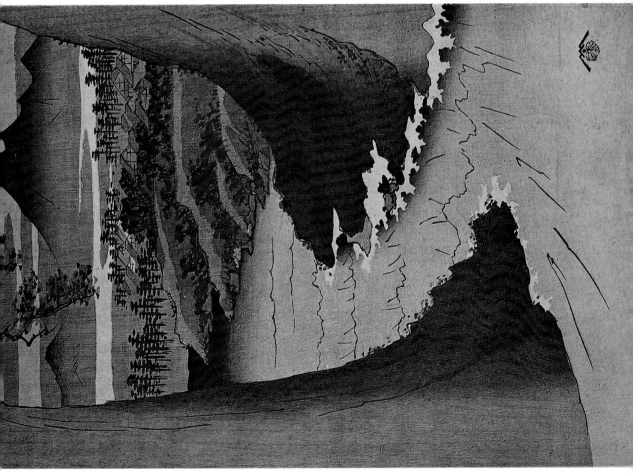

121. *Ichiryusai Hiroshige*: The Monkey Bridge in the Koyo District. *Nagaban two-piece vertical nishiki-e ; height, 73 cm.; width, 25 cm. About 1840.*

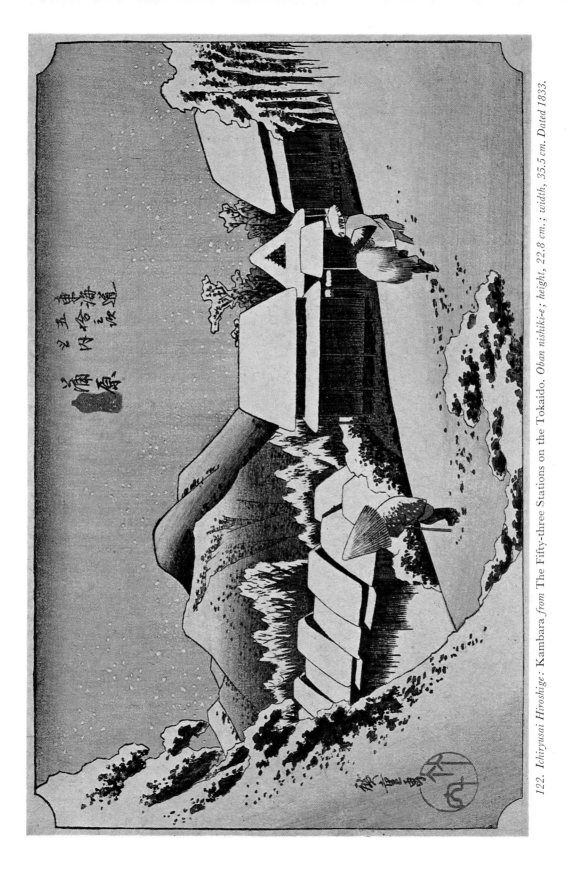

122. *Ichiryusai Hiroshige*: Kambara *from* The Fifty-three Stations on the Tokaido. *Oban nishiki-e; height, 22.8 cm.; width, 35.5 cm. Dated 1833.*

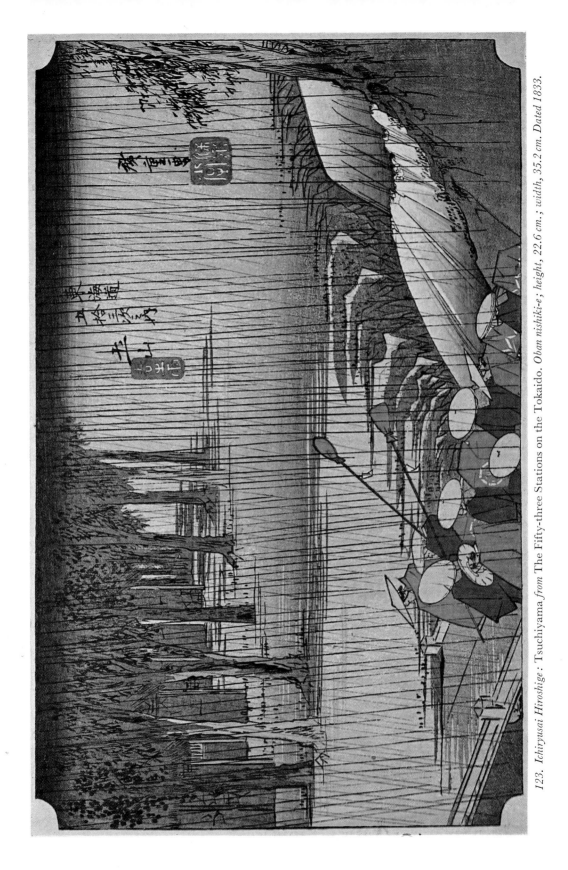

123. *Ichiryusai Hiroshige*: Tsuchiyama *from* The Fifty-three Stations on the Tokaido. *Oban nishiki-e; height, 22.6 cm.; width, 35.2 cm. Dated 1833.*

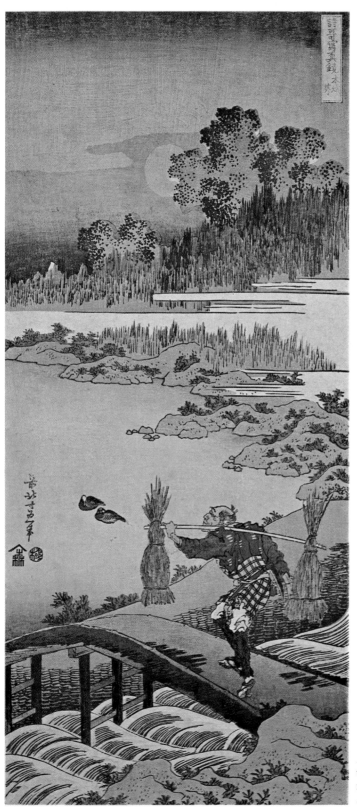

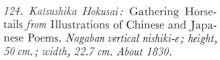

124. Katsushika Hokusai: Gathering Horse-
tails *from* Illustrations of Chinese and Japa-
nese Poems. *Nagaban vertical nishiki-e; height,
50 cm.; width, 22.7 cm. About 1830.*

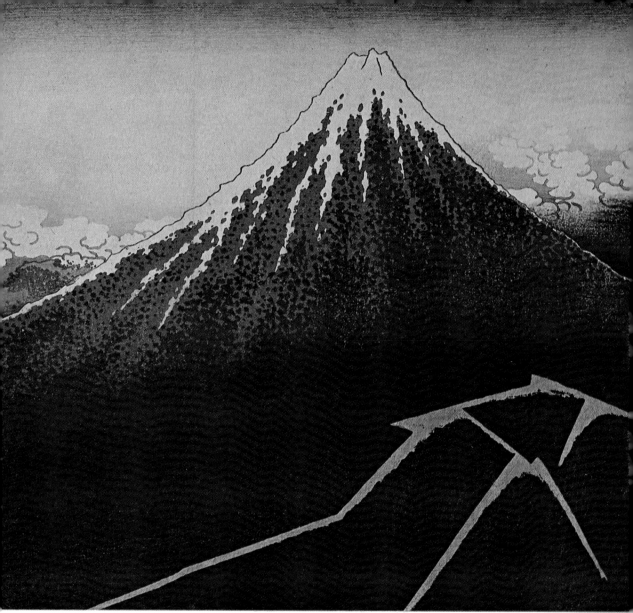

125. Katsushika Hokusai: Rainstorm Below the Mountain *from* Thirty-six Views of Mount Fuji. *Oban nishiki-e; height,
25.1 cm.; width, 37.7 cm. Between 1823 and 1833.*

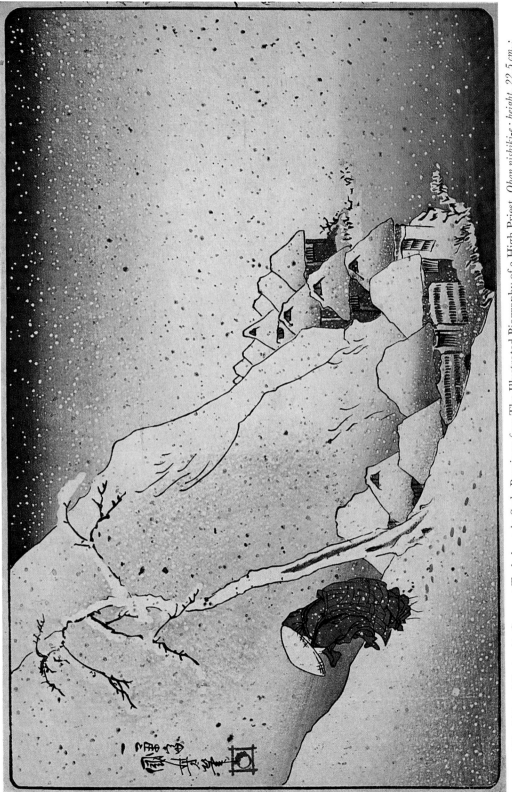

126. *Ichiyusai Kuniyoshi*: Snow at Tsukahara in Sado Province *from* The Illustrated Biography of a High Priest. *Oban nishiki-e; height, 22.5 cm.; width, 34.7 cm. Dated 1831.*

127. *Ichiyusai Kuniyoshi*: Evening Cool at Ryogoku *from* Celebrated Places in the Eastern Capital. *Oban nishiki-e ; height, 24.7 cm. ; width, 36.3 cm. About 1832.*

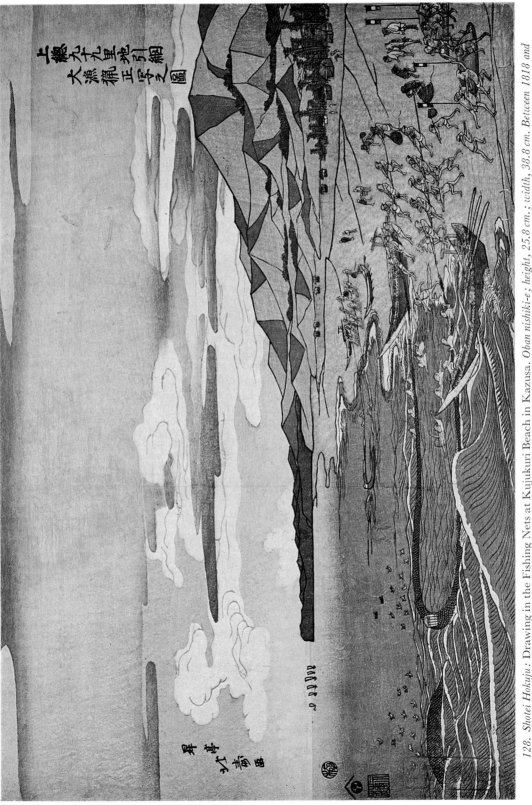

128. *Shotei Hokuju: Drawing in the Fishing Nets at Kujukuri Beach in Kazusa. Oban nishiki-e; height, 25.8 cm.; width, 38.8 cm. Between 1818 and 1830.*

ed Edo and other famous places in Japan but also copied Dutch originals and even went on to such subjects as the ruins of ancient Rome and a celebrated battle in Taiwan. Again, he created *uki-e* out of such favorite themes of the ukiyo-e artists as the legendary love affair between the medieval hero Yoshitsune and the princess Joruri. In a word, Toyoharu's *uki-e* covered a wide range of subjects and, in addition, incorporated such a variety of linear and coloring techniques that one is tempted to wonder if all these can be the work of a single artist.

Leaving aside the question of whether these works are successful or not, we must note that the technical mastery of this founder of the Utagawa school extended to prints of beautiful women, theater prints, and landscape prints. In the first of these two genres, this mastery was transmitted to his pupil Toyokuni I and reached the peak of its maturity in Toyokuni III. In landscape prints, it was passed on by way of Toyohiro to Hiroshige I, in whom it came to final perfection.

Like Toyoharu, Kitao Shigemasa played a part in the production of *uki-e*. So too did the great masters Kiyonaga and Utamaro, no less than the painters of the Katsukawa, Kitao, and Utagawa schools. Indeed, almost all ukiyo-e artists painted at least some *uki-e*. Moreover, painters other than ukiyo-e artists gradually began to produce underdrawings for *uki-e*. Eventually, single-sheet *uki-e* and such *uki-e* albums as the *Azuma Miyage* (Souvenir of Eastern Japan) were bought in large numbers by sightseers from the provinces, old and young, male and female alike, and taken back to their home towns in the country as gifts. Woodblock prints were light in weight and easily portable, and in an age when transportation facilities were poorly developed they were greatly prized, especially as souvenirs of Edo.

Nevertheless, by the 1790's, the *uki-e* too had already revealed a tendency toward deterioration through the overproduction of low-quality works, and superior pictures like those of the 1770's appeared less and less frequently. In fact, *uki-e*, which had actually originated as pictures for children's peep-show boxes, tended in general to be-

129. *Kubo Shumman:* The Tama River at Koya *from* The Six Tama Rivers. *Oban beni-girai. About 1791 or 1792.*

come an even cheaper commercial product than ukiyo-e.

Okyo (1733–95), founder of the Maruyama school of painting and contemporary of Toyoharu, used Western techniques to paint what came to be called *megane-e* (eyeglass paintings) of such scenes in and around Kyoto as the Sanjo Bridge, people enjoying the cool of evening at Shijo-gawara, the floats of the Gion Festival, and the Ishiyama Temple in Otsu. Some of these were later published as monochrome prints, either in black ink alone or in two tones of black ink. Certain scholars place particular stress on the influence of Okyo's *megane-e* (Fig. 132) on the new *uki-e* of Toyoharu.

130. Utagawa Toyoharu: Picture of Mimeguri. Uki-e in oban nishiki-e format. Between 1772 and 1781.

TOYOKUNI I AND TOYOHIRO It was probably in the late 1770's that Toyoharu accepted as one of his pupils the son of a friend of his who lived in the Shiba district of Edo (as Toyoharu himself did) and worked as a carver of wooden puppets. This boy, named Kurahashi Gorobei, was later to play a significant role in the world of ukiyo-e as Toyokuni I (1769–1825; Figs. 115, 133–36, 169). Through his keen observation of popular tastes and his skillful expression of their flavor in his pictures, Toyokuni broadened the stream that began with Toyoharu into the full-flowing river of the Utagawa school.

In the early 1790's Toyokuni painted beautiful women in the manner of Utamaro. There is a tendency to regard these paintings as nothing more than pure imitations of Utamaro and to dismiss them as having no artistic charm whatever, but one must admit that they have a certain unique quality that is not found in the works of either Utamaro, Eishi, or Shuncho or of Toyokuni's teacher Toyoharu. It is said that he first achieved popularity around 1795, and during the second period of his development, which began at this time, he engaged in the continuous production of actor prints. In these portraits we can recognize not only the influence of Shun'ei but also, to a certain extent, an imitation of Sharaku. Nevertheless, when we look at the large number of actor prints that Toyokuni produced between about 1794 and 1795—particularly such works as his masterpiece, *Yakusha Butai no Sugata-e* (Portraits of Actors on the Stage), of which three prints are shown in Figures 135, 136 and 169

131. *Katsukawa Shunsen:* The Benzaiten Shrine in Shinobazu Pond. *Uki-e in oban nishiki-e format. Between 1804 and 1818.*

—we find it impossible to pass over him as merely a clever but unimaginative technician and an uncreative plagiarist. The various postures, movements, and facial expressions of actors onstage are depicted in a candidly realistic fashion with a brush that has both strength and finesse.

Regrettably, however, the attractive qualities of Toyokuni's work fade considerably at the turn of the century and, after about 1805, degenerate into complete decadence. Toyokuni himself seems not to have noticed the decline in his style. He was surrounded by no fewer than twenty-eight pupils and enjoyed immense popularity. One contemporary record reports of him: "People who want his underdrawings follow one upon the heels of another. He has no time to receive them, for he is worked to death merely trying to find excuses for extending the deadlines on their orders." He lived an unusually happy life for an ukiyo-e artist, being blessed with a comparatively large income. He took up traditional-style dancing and practiced such vocal forms of theater music as *nagauta* and *jiuta*. His love of sakè and his predilection for geisha were both noted in a humorous novel of 1806 by Shikitei Samba, who wrote of him that he was "loud in his cups" and that his buying the favors of geisha, like Samba's, was "by no means something that began only yesterday." When he was forty, he married a girl of fifteen. One of his disciples, later to be known by the art name of Utagawa Kunihiro, was Ishikawa Hiuga no Kami, daimyo and castle lord of Kameyama in Ise Province, with an annual income of some 250,000 bushels of rice. All in all, Toyokuni's success was reflected in the long life of

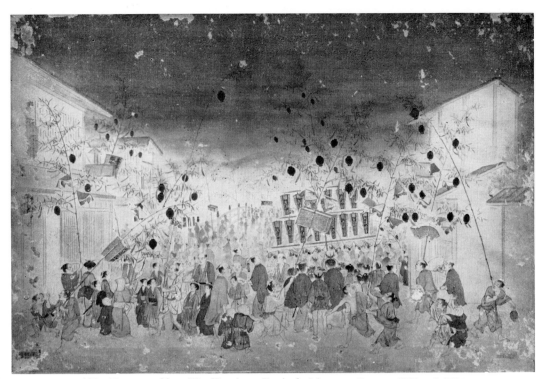

132. Maruyama Okyo: The Tanabata Festival. *Megane-e. Between 1751 and 1764.*

the Utagawa school, which survived until the Meiji era (1868–1912).

Another painter who was known as one of the great disciples of Toyoharu was Ichiryusai Toyohiro (1773–1828; Figs. 116, 138, 166). In his *Mumei O Zuihitsu* (Essays of a Nameless Old Man), the ukiyo-e artist Keisai Eisen (1790–1848) notes: "Some people have said that Toyokuni's pictures are far from matching those of Toyohiro in excellence of technique, but Toyokuni, even though his artistry may be inferior, is miraculously successful in capturing the attention of the common people and falling in line with the fashions of the entertainment districts." No doubt Eisen is right in saying that Toyohiro did not equal Toyokuni in fame because he did not make a specialty of actor prints,

which at that time had great popular appeal, and thus was unable to achieve much success in going along with contemporary vogues. What is more important, however, is that Toyohiro was some four years younger than Toyokuni and, being a junior pupil under the same master, was always obliged to follow in Toyokuni's footsteps. One can therefore assume that this was largely the reason for his lack of popularity. The scholar Iijima Kyoshin recorded of him that genre paintings of beautiful women were not his forte, but this opinion seems unreasonable if we are to judge by his extant prints and paintings in this particular field. In fact, as a painter of beautiful women, he is now more widely respected than Toyokuni. He also produced such sets of landscape prints as *Edo Hakkei* (Eight Views

133. Utagawa Toyokuni: Putting On Lipstick. *Fan print. Between 1818 and 1825.*

of Edo), *Toto Hakkei* (Eight Views of the Eastern Capital), and *Omi Hakkei* (Eight Views of Omi), all of which have a delightful simplicity about them.

There was a feud of long standing between Toyohiro and Toyokuni, but a reconciliation was brought about through the efforts of Shikitei Samba, particularly through Samba's undertaking to publish the work *Ittsui Otoko Hayari no Utagawa* (Two Popular Men of the Utagawa School), of which the first six volumes were illustrated by Toyokuni and the remaining six by Toyohiro. In the same year Toyohiro apprenticed his son Kinzo (later known as Toyokiyo) to Toyokuni. The playwright Tsuruya Namboku (1755–1829) congratulated this young man on his future prospects by writing a poem for him, but unfortunately Toyo-

kiyo preceded his father to the grave, dying in 1820 of an illness at the early age of twenty-two.

There is some fine work by Toyohiro among the triptychs in the sets he produced jointly with Toyokuni, as represented by the prints shown in Figures 116, 138, and 166. The ukiyo-e critic Shizuya Fujikake observes of the jointly produced set called *The Twelve Months* that it contains some superlative work by Toyohiro—work so excellent, in fact, that it is even said that Toyokuni was transformed by the influence of Toyohiro's style. Although Toyohiro's pictures often contain rather disordered groups of human figures, there is somehow a sense of quietness about them: a suggestion of sadness, even, like that of *shamisen* music heard on an autumn evening. It was under Toyohiro's tutelage

that the gentle and nature-loving art of Hiroshige was nurtured.

TOYOKUNI II Toyokuni I had a son named Naojiro, but this boy seems to have been a wastrel. Although he became a carver, it appears that he ruined himself through dissipation and lived as a vagrant. According to the novelist Kyokutei Bakin (1767–1848), Toyokuni therefore adopted one of his pupils to be the future Toyokuni II (1777–1835; Fig. 137). There is a story to the effect that this pupil, whose name was Ichiryusai Toyoshige, ingratiated himself with Toyokuni's widow after the master's death in 1825, married her, and then assumed the name of Toyokuni II, thereby incurring the hostility of the entire Utagawa school, but this tale has been shown to be completely false. It was about 1824 that Toyoshige became the adopted son of Toyokuni I, and upon his master's death in the spring of 1825 he legitimately succeeded to the title Toyokuni II. With the backing of Toyohiro, Sakuragawa Jihinari (a writer and comic-storytelling performer), and Santo Kyozan (younger brother of the previously noted artist-writer Santo Kyoden), he announced his succession to the name of Toyokuni by giving a grand banquet at the Mampachitei, a restaurant in the Yanagibashi district of Edo.

If what Bakin says in one of his letters is true, it was for financial reasons that Toyokuni I adopted a rather low-ranking disciple of his as his son. What of the ability of this problematical artist Toyokuni II? Many have concurred in the past with Bakin's opinion that his work was greatly inferior to that of his master, but there are now scholars who disagree with this evaluation. In his pictures of beautiful women, at least, he achieved no more than a formalized and slavish imitation of his master's later work. Here he clung to the style of Toyokuni's worst period and may be considered to have created no style at all of his own. Quite a number of his sets of prints in this genre survive, but there is not a single masterpiece among them. There are some admirers who praise his *Saru* (Monkey) from the set called *Furyu Azuma Sugata Junishi* (Aspects of Elegance in Eastern Japan Pictured Under the

134. Utagawa Toyokuni: Kabuki Scene. *Naga-e. About 1795.*

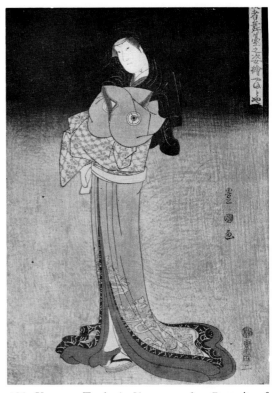

135. *Utagawa Toyokuni:* Tachibanaya *from* Portraits of Actors on the Stage. *Oban nishiki-e. About 1795.*

136. *Utagawa Toyokuni:* Yamatoya *from* Portraits of Actors on the Stage. *Oban nishiki-e. About 1795.*

Twelve Signs of the Oriental Zodiac), but this is actually not a very significant work. In the print market today such landscape scenes of his as *Oyama Yau* (Evening Rain on Mount Oyama), which appears in Figure 137 and is from the set *Meisho Hakkei* (Eight Views of Celebrated Scenic Spots), command higher prices than his prints of beautiful women. This print is said to have been much influenced by Hokusai's *Red Fuji* (Fig. 22).

GOTOTEI KUNISADA (TOYOKUNI III) Despite the fact that there had already been a Toyokuni II, who was also called Genzo Toyokuni and Hongo Toyokuni and used the additional art names of Ichieisai and

Gosotei, a decade or so after his death another artist assumed the name Toyokuni II. This was Kunisada, who had been a senior disciple of Toyokuni I and who is generally known today as Toyokuni III (1786–1864; Figs. 117, 118, 139–42).

It is recorded that the original Toyokuni II died in the late autumn of 1835 at the age of fifty-eight, but this information has never been verified. Early in 1844, Kunisada announced his succession to the name of his former teacher Toyokuni I and changed his name to Toyokuni II. We are told that this development took place through the agency of one Tachikawa Emba II and the mother of the publisher Igaya Kan'emon. On the folding fans distributed as announcements of the succession, there

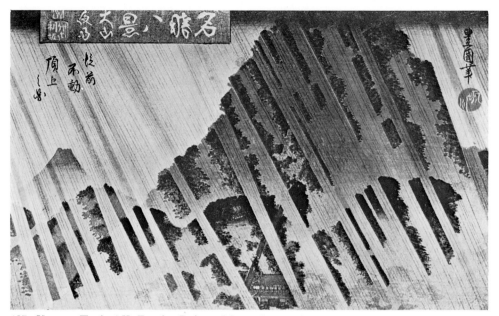

137. *Utagawa Toyokuni II:* Evening Rain on Mount Oyama *from* Eight Views of Celebrated Scenic Spots. *Oban nishiki-e. Between 1818 and 1825.*

was a congratulatory poem from the writings of Shida Yaha (1663–1740) along with a picture of a boy garbed in ceremonial costume and a girl with her hair done in formal *shimada* style. In *Gesaku Hana no Akahon Sekai* (Flowers of the World of Cheap Fiction), written by Honchoan Kosamba (son of the novelist Shikitei Samba) and published in 1856 by Tsutakichi, there is a picture of the announcement ceremony along with a speech made on this occasion, which runs as follows: "Now, what is most important is that Master Utagawa Kunisada disliked the idea of bringing shame upon the name of his former teacher and was most hesitant to take this step. Since it was proper, however, that his master's name should be inherited by a senior disciple rather than by an unknown junior disciple, and since, if there was to be a successor, it would be a matter of filial duties and something very right and proper [for Kunisada to become that successor], and since he is more suitable than any other of

Toyokuni's family and has been urgently recommended to take this course, he has, by your grace, changed his name to Toyokuni. The change of his own respected name and the enriching succession to the name of his master we feel in all sincerity to be an act of true respect to his master. Although the master did not himself request that this be done, we have full confidence in the rectitude of this course and have thus come to make this announcement." It is interesting to note, in addition to this, that Toyokuni's pupils Kunimasa, Kunimaro, Kunimichi, and Kuniaki appear in the above-noted picture. Of these five, only Kuniaki has an unshaven forelock, signifying that he had not yet come of age.

The work produced by Toyokuni III when he was still known as Gototei Kunisada is generally considered to be better than his later work. It is said, incidentally, that the name Gototei, which can be translated as Pavilion of the Fifth Ferry, was

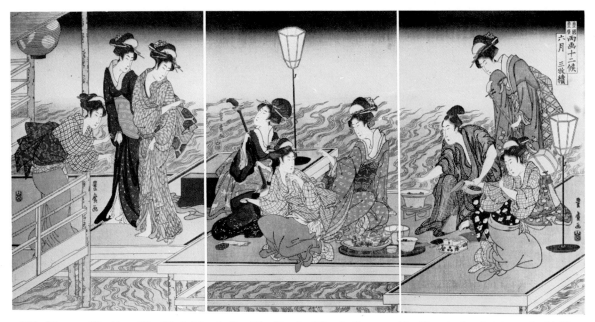

138. *Utagawa Toyohiro:* The Sixth Month *from* The Twelve Months Portrayed by Two Artists *(a joint work with Toyo-kuni). Oban nishiki-e triptych. Between 1789 and 1804.*

chosen for him by the novelist Shokusanjin because his father owned shares in the No. 5 ferry at Honjo in Edo or that it was derived from Kunisada's having lived in the vicinity of that ferry. In any event, this artist, whom we shall refer to as Kunisada from now on, for the most part produced very fine work over a long period, although after about 1818 it became extremely rough. Probably no other ukiyo-e artist equaled him in commercial success. Such works of his as the *Yakusha Mitate: Tokaido Gojusan Eki* (Selection of Actors, with Scenes of the Fifty-three Stations on the Tokaido Highway) were advertised by means of paper lanterns on poles outside the publisher's shop. We are also told that the prints in this set were praised in a popular song of the time with words to the effect that Kunisada's actor portraits were to be prized as highly as the flavor of Asakusa seaweed (a famous delicacy of the time) and that his pictures of the fifty-three Tokaido post stations were the "flowers of Edo."

As the writer Robun Kanagaki (1828–92) noted, there was once a time when "the word ukiyo-e meant only one thing: Kunisada." Certainly Kunisada's polychrome prints express in a subtle style the overripeness of an age in decline. I myself find in these prints a highly decadent charm. They seem to convey a feeling like that of sobering up under the red lanterns of a brothel while listening to the sound of scattered autumn leaves striking the window in an icy wind. Still, even among the works that are considered to be his masterpieces, there are many that disillusion us if we look at them for any length of time, for they ultimately exceed the natural limits of charm and splendor and end up by breaking the spell that they first imposed.

The most outstanding prints of beautiful women that Kunisada produced during the fifty-seven years or so of his career as a woodblock-print artist are probably those published between about 1811 and 1818. After the period when he was known as

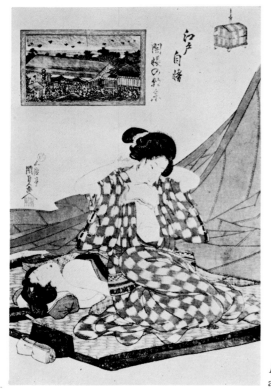

139. *Gototei Kunisada:* Getting Up Early for a Morning Visit to a Temple *from* Edo Pride. *Oban nishiki-e. Between 1804 and 1844.*

Gototei, through the period when he used the name Kochoro, and then during the years after he assumed the name Toyokuni, his work showed a steady decline. When we look at the prints of beautiful women made during his late years—women whom the dramatist and critic Shoyo Tsubouchi (1859–1935) described as "dwarfish and stoop-shouldered"—we have the impression of observing the stunted and misshapen quality of the Edo-period merchant-townsman culture as it withered under feudal pressure and failed to achieve a healthy development.

Kunisada died toward the end of 1864 at the age of seventy-eight. Among his last recorded words were these: "Leaving all in the hands of Amida Buddha, I have set my mind at rest, and there is nothing now but the prayer 'Namu Amida Butsu' [Glory to Amida Buddha]" and "My brush is

worn out, and I think this year will be my last."

In 1845 he had selected the twenty-two-year-old Baido Kunimasa to marry his daughter Suzu and had designated him as Kunisada II. After the master's death, however, Kunisada II adopted the name of Toyokuni. But this man, who had assumed a celebrated name, was from the beginning an artist of mediocre talent and, in his later years, was so disabled by palsy that he could no longer make free use of his brush. During his master's lifetime he was known by the nickname of Kobozu (Little Rascal), while the master himself was nicknamed Obozu (Big Rascal), but in his role as the new master of the Utagawa school he became a target of ridicule and was saddled with such nicknames as Yoiyoi Toyokuni and, in shorter form, Yoi Toyo, both of which mean Trembling Toyokuni. He died in the summer of 1880 at the age of fifty-seven. There is

140. Gototei Kunisada: Return from the Bath. *Two-piece oban nishiki-e. Between 1818 and 1844. (See Figure 118 for detail.)*

not a single print of his that merits our attention, and such works as his twelve-print *Tokyo Bijo Soroi* (A Collection of Beautiful Women of Tokyo) are particularly preposterous.

OTHER DISCIPLES OF TOYOKUNI I Toyokuni I had a considerable group of talented disciples, including the particularly able Ichijusai Kunimasa (1773–1810; Fig. 143), who produced a number of excellent prints and was an expert in the creation of *okubi-e* (bust portraits) of actors. Having come under the influence of Toyokuni's earlier and better work, he eventually gained the reputation of a pupil who had surpassed his master, and Toyokuni himself is said to have praised Kunimasa's actor portraits as being superior even to his own. Since Kunimasa died at the relatively young age of thirty-seven, it may be said that he thereby avoided the decadent style into which his teacher lapsed in his later years. Aside from his actor prints he left very few single-sheet works, but there are some rather fine examples among his pictures of beautiful women, including the one of a young lady at the *kotatsu* (foot warmer) talking delightedly to a kitten.

At one time there was a trio of the first Toyokuni's disciples who were known by such collective nicknames as Samba Karasu (The Three Crows) and Sampukutsui (The Triptych). These men were Ichiyosai (or Ichiensai) Kuninao, Ipposai Kuniyasu, and Ichiensai Kunimaru. Kunimaru, who died aroung the age of twenty-nine during the late years of the Bunsei era (1818–30), left the deathbed poem "Ephemeral needles of frost, rustling as they form." Kuniyasu died in the summer of 1832 at the age of thirty-eight. Kuninao survived until the summer of 1854, when he died at the age of sixty-

one, but he seems to have given up painting at a rather early date in his career.

ICHIYUSAI KUNIYOSHI

As the senior and junior members of his school fell away, Kunisada (Toyokuni III) gradually built up a name for himself, but he eventually ran up against a quite unexpected rival. This dark horse was Ichiyusai Kuniyoshi (1797–1861; Figs. 126, 127, 144–45), fellow pupil of his and more than ten years his junior, who established the Genyadana branch of the Utagawa school as a rival of Kunisada's own Kameido branch school.

Toyokuni I, recognizing the talents of Kuniyoshi, had apparently enrolled him among his disciples in 1811, when Kuniyoshi was fourteen years old. For some time Kuniyoshi lived at the house of his senior fellow pupil Kuninao as a de-pendent and assisted him with his work. Around 1820 he won some acclaim with his triptych portraying a legendary tale about the ghost of the medieval warrior Taira no Tomomori, the prints being published by the wholesale dealer Kinshudo Azumaya Daisuke of Bakuro-cho in Edo. Then, around 1827, he produced a set of prints portraying five celebrated heroes from the Chinese novel *Shui Hu Chuan,* modeling their features on a group of wooden statues of the Five Hundred Arhats (Buddhist saints) at a temple in Edo. These prints, published by Kagaya Kichiemon of Yonezawa-cho in the Ryogoku district, proved to be more popular than had been anticipated—so much so that Kuniyoshi became increasingly confident and published a succession of similar works, with the result that he finally became known as Musha-e no Kuniyoshi (Kuniyoshi of the Warrior Prints) in contrast with

141 (opposite page, left). *Gototei Kunisada*: Yagembori Kompira *from* Various Scenes of Contemporary Edo. *Oban nishiki-e. About 1818.*

142 (opposite page, right). *Gototei Kunisada*: Spring Morning *from* An Assemblage of Beautiful Women. *Oban nishiki-e. Between 1818 and 1844.*

143. *Utagawa Kunimasa*: The Actor Ichikawa Ebizo in the Kabuki Drama "Shibaraku." *Oban nishkiki-e. About 1800.*

Kunisada, the painter of beautiful women and actors. Of these two artists it was said that "one depicts the hard [Kuniyoshi] and one the soft [Kunisada], but both have advanced equally into the realm of the exquisite, and truly they make a fitting pair." To the present-day viewer, Kuniyoshi's warrior prints seem to be greatly lacking in artistic taste, but they appear to have been extremely popular in his own time, no doubt because they were exactly attuned to the troubled conditions of the late Edo period, an age already pregnant with the seeds of revolution.

Long after Kuniyoshi had begun to enjoy a wide sale of his prints, Kunisada continued to treat him as a junior colleague and to refer to him as Yoshi. A satirical song of the day contained the words "Kokoronaku yoshi ni sao sasu watashimori," or "The ferryman heartlessly plunges his pole into the reeds." Here the word *yoshi* (reeds) means Kuniyoshi, while *watashimori* (ferryman) is a metaphor for Gototei (Pavilion of the Fifth Ferry), which, as we have noted, was an appellation used by Kunisada in the days before he adopted the title Toyokuni III. Later, as Kuniyoshi's prints became more and more popular, people said, in the words of a well-known comic poem: "As the reeds grow thicker, they become a menace to the ferryman."

It has been said that the warrior prints of Kuniyoshi, the prints of beautiful women and actors by Kunisada, and the landscape prints of Hiroshige represent a three-part division of the latter-day world of ukiyo-e. Today, however, Kuniyoshi's warrior prints are the lowest priced of his works, while his prints of beautiful women fetch somewhat higher prices, and his landscape prints are the most expensive of all. There are some works of surpris-

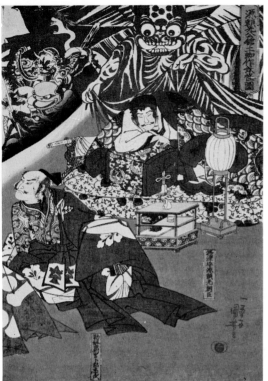

144. *Ichiyusai Kuniyoshi: right-hand print of triptych* Minamoto Raiko and the Demon Spider. *Oban nishiki-e. Dated 1843.*

145. *Ichiyusai Kuniyoshi:* The Brave Woman Oken of Omi ▷ Province. *Oban nishiki-e. About 1831.*

ingly high quality in his *Toto Meisho* (Celebrated Places in the Eastern Capital), a series of horizontal prints of large size published by the Kagaya and represented by the print shown in Figure 127. The same is true of his *Toto Naninani no Zu* (Pictures of All Sorts of Places in the Eastern Capital), published by the Yamaguchiya and represented here by the plate shown in Figure 146.

From about 1854, Kuniyoshi suffered increasingly from palsy. He died in 1861 at the age of sixty-four, leaving behind a large number of disciples. As an artist, he was not satisfied to do nothing more than follow the style of his master Toyokuni but attempted to study everything there was to be studied. One is reminded here of an observation by the modern artist Kiyokata Kaburagi to the effect that it would be hard to conceive just what Kuniyoshi might have produced had he lived, like Hoku-

sai, to the age of almost ninety. The genius of Kuniyoshi indeed defies conjecture, but the absence of elegance in his works is a major flaw. One of his contemporaries, in fact, described his pictures as resembling the work of "a common artisan, garbed in a bellyband like any everyday workman."

KATSUSHIKA HOKUSAI Kuninao, whose hospitality Kuniyoshi enjoyed in his younger days, had a deep respect for the painting style of Katsushika Hokusai (1760–1849; Figs. 7, 8, 11, 14, 22, 119, 120, 124, 125, 147–49, 172, 176), and Kuniyoshi himself, from the early years of his career, patterned himself after Hokusai. By the time of Yoshitoshi Tsukioka, a disciple of Kuniyoshi's who became the great illustrator of the Meiji era, the influence of Hokusai was more marked, and among the artists of the Utagawa

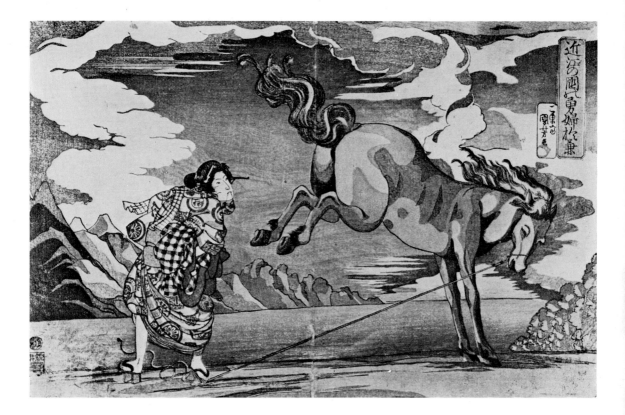

school, who tended to dominate the closing years of the ukiyo-e world, not a few were influenced by Hokusai.

In the ukiyo-e of the preceding years a certain degree of influence from Chinese and Western painting is undeniably evident, but in the work of Hokusai the impact of imported painting appears to have become much more obvious. Indeed, one has a strong feeling that Hokusai, through his outstanding talent, forcefully turned the uniquely Japanese art of ukiyo-e in the direction of Chinese and Western painting.

"Hokusai was a man who was constantly growing. Whatever his age, he remained young at heart. There are many of his pictures that have the quality of the first gray streaks of dawn. There is no one quite like him," says the modern novelist Saneatsu Mushanokoji in his *Hokusai Zakkan* (Miscellaneous Impressions of Hokusai). Although there are probably those who doubt that Hokusai's pictures reflect a perennially youthful zest for life, no one will deny that he continued to grow as an artist for a longer time than any other ukiyo-e painter.

In his *ehon* (picture book) of 1836, the *Katsushika Shin Hinagata* (New Designs by Katsushika), Hokusai says with both humility and plain arrogance: "Fortunately, heaven made me stupid. Moreover, since I am illiterate, I am not fettered by ancient techniques. Regretting last year and feeling ashamed of yesterday, I leave everything to the will of fortune, and I am free to do as I please in my painting. Although I am getting close to my eightieth year, my eye and my brush are no less strong than those of a man in his prime. I hope to live to be a hundred and to achieve complete independence." Indeed, it does seem that as he grew older his

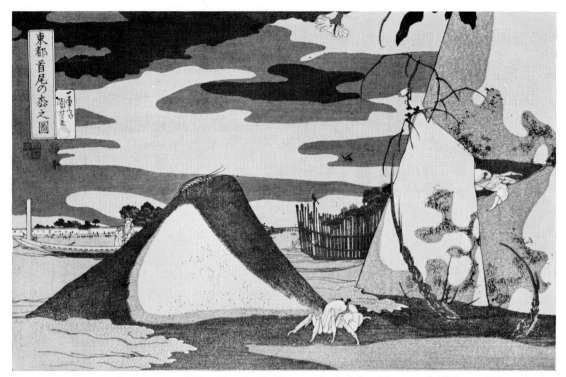

146. *Ichiyusai Kuniyoshi:* The Shubi Pine Tree in the Eastern Capital *from* Pictures of All Sorts of Places in the Eastern Capital. *Oban nishiki-e. About 1831.*

imagination grew increasingly fertile and his brush yet more vigorous. Still, the misty quality like that of dawn in spring is more often found in the works of his early years, when he was known as Shunro (Spring Brightness).

Hokusai became a pupil of Katsukawa Shunsho in 1778 at the age of eighteen and, before long, adopted the school name of Katsukawa and the artist name of Shunro, which contained one of the characters (*shun*, or spring) of his master's name. At this stage he painted pictures for illustrated stories of the popular type. The works he produced during the period when he was known as Shunro impress us as having less of the quirky stubbornness of his later works and more of the ingenuousness that characterized the Katsukawa school. Later, however, after he had taken up with the descend-

ants of the Kano school and had further acquired a smattering of Western painting techniques, his work became quite far removed from ukiyo-e. The novelist Kafu Nagai (1879–1959) notes that among the masterpieces of Hokusai's mature period we often find prints that seem un-Japanese.

Probably the best known of Hokusai's polychrome prints are those in his *Fugaku Sanjurokkei*, or *Thirty-six Views of Mount Fuji* (Figs. 22, 120, 125, 148, 172). This series, all in the horizontal format called *oban yoko-e*, was issued over a period of some seven or eight years, beginning around 1823 and ending not long after 1830. Together with the so-called *Ura Fuji* (Fuji from the Rear), a ten-print supplementary set featuring views of Mount Fuji from the interior rather than from the coastal regions, it makes up a masterwork of forty-six prints.

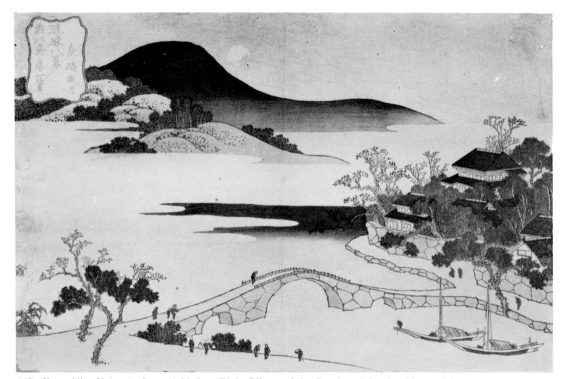

147. *Katsushika Hokusai*: Izumisaki *from* Eight Views of the Ryukyu Islands. *Oban nishiki-e. Between 1828 and 1832.*

It is often said that this work established Hokusai's reputation as a landscape painter, but there are critics like Kazuma Oda who maintain that the decreased attention to detailed drawing and the typical insistence on fantastic compositional devices are painfully obvious and that the work is an inferior product of the painter's old age, totally lacking in charm.

Hokusai painted ceaselessly for seventy years, from the 1770's to the 1840's, including even advertising signs and posters for marionette performances among the products of his brush. In 1849, at the age of eighty-nine, he died in the Edo district of Asakusa at one of the countless temporary residences he had maintained during his lifetime. His deathbed poem, making a touching play on the word *hitotama*, which means both "soul" and "will-o'-the-wisp," reads: "The summer fields, and the diversion of having my spirit leave this life like a will-o'-the-wisp." In the course of his long life as a painter, an extremely large number of artists studied under him. Of all his disciples, the one who best upheld the tradition on his master's painting in Western style was Shotei Hokuju (Fig. 128). The Hokusai-school artists Ryuryukyo (or Ryukaen) Shinsai, Totoya Hokkei, and others also produced a considerable number of landscapes.

ICHIRYUSAI HIROSHIGE As we move from Hokusai to Hiroshige (1797–1858; Figs. 6, 23, 24, 28, 121–23, 150–53, 173–74), the traces of Chinese and Western influence seem to disappear from ukiyo-e landscape prints, and we become vividly aware of the re-emergence of pure

148. Katsushika Hokusai: The Riverbank at Oumaya and Sunset over the Ryogoku Bridge *from* Thirty-six Views of Mount Fuji. *Oban nishiki-e. Between 1823 and 1833.*

Japanese painting. It was Hiroshige who unwittingly revived the ukiyo-e of the late Edo period, which had lapsed into extreme licentiousness and degeneracy, and endowed it with a fresh spirit and new forms. Although he learned primarily from direct observation of nature, he also studied the techniques of ukiyo-e and the styles of the Kano school, the *nanga* artists (painters in the southern Chinese style), and the Shijo school of so-called realistic painting. At the same time he made use of the laws of perspective observed in Western painting. All this he absorbed and expressed in Japanese fashion, infusing his work with a rich sense of the character of Edo and the emotions of the Japanese people of his time.

It has long been said that many of Hiroshige's

masterpieces are depictions of the moon, snow, or rain. Dealers in prints call these the "three star performers" and suchlike names. In the work that made him famous, his first and finest version of the *Tokaido Gojusan Tsugi* (The Fifty-three Stations on the Tokaido), published by Hoeido, the most widely admired prints include those of the full moon rising over the Kano River at Numazu, the town of Kambara buried under an evening snow (Fig. 122), the bamboo groves at Shono lashed by a driving rain (Fig. 6), the castle of Kameyama under clearing skies after a snowfall, and the post station of Tsuchiyama in a springtime shower (Fig. 123). His *Honcho Meisho* (Celebrated Places in Japan) includes a particularly fine print depicting the rain-soaked pilgrims' path up Mount Akiba in Enshu (in

149. Katsushika Hokusai: Pheasant and Snake. Oban fan print. Between 1830 and 1844.

the present Shizuoka Prefecture). Other favorites among his prints are those of geisha at the gate of the snow-covered Gion Shrine in Kyoto, from *Kyoto Meisho* (Celebrated Places in Kyoto), and of midnight rain pouring down on the Karasaki pine tree, from *Omi Hakkei* (Eight Views of Omi).

Other highly admired prints by Hiroshige include *Autumn Moon on the Tama River, Night Rain in the Woods at Azuma,* and *Evening Snow at Asukayama,* all from the set called *Edo Kinko Hakkei* (Eight Views in the Suburbs of Edo), and *Nihombashi in the Rain* and *Evening Snow in the Compound of the Kameido Temman Shrine* from his *Toto Meisho* (Celebrated Places in the Eastern Capital), published by the house of Kikakudo. The *Kiso Kaido Rokujukyu Tsugi* (The Sixty-nine Stations on the Kiso Highway),

the famous highway series that followed his *Fifty-three Stations on the Tokaido,* contains three prints that have long been ranked among his masterpieces: *Seba* (Fig. 152), *Nagakubo,* and *Miyanokoshi,* all of which are moonlight scenes. It should be noted, incidentally, that the *Kiso Kaido* set actually consists of seventy prints, of which twenty-four are the work of Eisen.

Among his vertical two-piece prints is *The Monkey Bridge in the Koyo District* (Fig. 121), which has brought the highest price paid to date for any single Hiroshige print. Here he depicts the full moon hanging beneath the arch of an extraordinary wooden bridge over the Katsura River in Kai Province (the present Yamanashi Prefecture). His untitled snow landscape, another two-piece vertical

150. Ichiryusai Hiroshige: The Strait of Naruto in Awa Province. *Oban nishiki-e triptych. Dated 1857.*

print, is also a superior work. Two other widely favored prints come from his *Gyosho Tokaido,* a later series of scenes along the Tokaido highway—so named because the titles of the prints are inscribed in the semicursive style of writing called *gyosho.* These two favorites are *Ejiri,* a sunlit landscape under newly fallen snow, and *Ishiyakushi,* in which we see men and horses struggling forward in a blinding snowstorm. In his *Reisho Tokaido*—still another Tokaido series, in this case so named because the titles are written in *reisho,* or official style —such prints as *Mariko,* picturing the lonely post station under quietly falling snow, and *Hodogaya,* another snow scene, are much more highly valued than the other prints in the set. *Moon over the Sumida River,* from his *Edo Meisho* (Celebrated Places in Edo), published by the Aritaya, and *Snow on the Sumida River,* from his other series by the same name, published by the Sen'ichi house, are also popular works.

In the great series of his last years, the *Meisho Edo Hyakkei* (One Hundred Views of Famous Places in Edo), the print that brings the highest prices is *Sudden Shower at Ohashi* (Fig. 24). The next most prized in the series are the snow scenes *The Lumberyard at Fukagawa, Suzaki in Fukagawa* (Fig. 28), *The Kiryu Temple in Asakusa, Yabukoji at the Foot of Atago Hill,* and *Sunset over the Hills at Taikobashi in Meguro,* and the moonlight scenes *Evening View of Saruwakacho, The Bamboo Yard at Kyobashi,* and *Misaki by Moonlight.* Among his finest works in the triptych format are the snow scene *Mountains and Rivers Along the Kiso Highway* and the moonlight scene *Night View of the Eight Beauty Spots of Kanazawa in Musashi Province.* It is an interesting fact that among Hiroshige's masterpieces there are a great many that feature the moon, snow, or rain, while among those of his prints in which the moon does not shine and neither the rain nor the snow falls there are few that are considered masterpieces.

151. *Ichiryusai Hiroshige:* Sparrows and Camellias in Snow. *Large tanzakuban nishiki-e. About 1830.*

152. *Ichiryusai Hiroshige:* Seba *from* The Sixty-nine Stations on the Kiso Highway. *Oban nishiki-e. Between 1837 and 1842.*

HIROSHIGE II AND HIROSHIGE III

Hiroshige died in the autumn of 1858, leaving his forty-year-old second wife, Oyasu, and his twelve-year-old adopted daughter Otatsu. In the following year, when she was only thirteen, Otatsu married one of Hiroshige's disciples, the thirty-three-year-old Shigenobu, who now took the family name of Ando and acquired the title Hiroshige II (1826–69; Fig. 175). Having assumed his master's mantle, he went on to paint a large number of landscapes that faithfully followed the Hiroshige style. Probably the most noteworthy of his works is the series *Shokoku Meisho Hyakkei* (One Hundred Views of Celebrated Places in Various Provinces), which was published between 1859 and 1861 by the Uoei house in Shitaya and is represented here by the print shown in Figure 175.

The work was begun soon after his succession to his master's name. Leaving aside the question of the artistic skill displayed in this series, we may note that it is a work of extremely wide scope, ranging in subject from the print called *Hotogahama*, which pictures a scene in northern Honshu, to *The Jusei Dance at Kaimondake in Makurazaki*, in which the locale is southernmost Kyushu.

In 1865, because of domestic troubles, Hiroshige II left the house of his master's family and thereafter painted under the name of Kisai Ryusho. At one time he lived in Yokohama, where he painted pictures for the decoration of tea chests designed for export, and this occupation gained him the nickname of Chabako Hiroshige, or Tea Chest Hiroshige. He died a solitary death in 1869 at the age of forty-three. Interestingly enough, certain great

153. Ichiryusai Hiroshige: Evening Snow at Uchikawa *from* Eight Views of Kanazawa. *Oban nishiki-e. About 1835 or 1836.*

painters of the West found valuable suggestions in such plain and humble pictures as the tea-chest designs of Hiroshige II.

No sooner had Hiroshige II left the Ando household than his junior colleague Shigetora (also known as Shigemasa) married Otatsu and assumed the name of Hiroshige II. This is the same artist whom later generations were to call Hiroshige III. He was twenty-three years old at the time.

In the autumn of 1879, Otatsu died at the age of thirty-three, and in the spring of 1894 he followed her to the grave, leaving the deathbed poem "Faster than the steam train is the game of *sugoroku* played during the journey as fifty-three stations go flying by," a rather complicated metaphor for life involving the steam railway, which was then still new to Japan; the fifty-three stations on the Tokai-

do highway, past which a railway was soon to run; and the old Japanese game of *sugoroku,* in which the players progress toward a goal, as travelers on a journey do. There is also a reflection here of his own travels. His specialty was landscapes, and we are told that he toured Ise, the Nara district, Osaka, and Kyoto and made sketching trips to Hitachi and Shimo-osa (the present Ibaraki and Chiba prefectures), "endeavoring to become the leading light of his generation." He failed, however, in his ambition to become a leading light, and it would probably not be wrong to say of him that his destiny as an artist was to reflect in his work the vulgarity of the new "culturally awakened" Japan—that is, the Japan that was so preoccupied with Westernizing itself after the Meiji Restoration. He used a great deal of crimson in his prints, and one has the sense

that this unquiet and garish color expresses the restlessness of the age in which he lived.

THE KIKUKAWA
SCHOOL

After Utamaro's death in 1806, the succession was carried on by Kikukawa Eizan (1787–1867; Fig. 154), whose activities included the manufacture of artificial flowers. It is no surprise that his prints were, for the most part, of inferior quality, but among them there are many superior pictures of beautiful women. His father Eiji is said to have studied under the artist Kano Tosha and to have painted ukiyo-e. Since Eiji, however, produced no prints, his son Eizan is generally regarded as the founder of the Kikukawa school. Eizan first studied painting with his father, then became one of the artist Suzuki Nanrei's students, and later changed over to the school of Hokusai's disciple

Hokkei, under whom he managed to absorb some of the style of Hokusai. From the time of his youth he published a large number of gorgeous pictures of beautiful women. He was successful with fan paintings and *kakemono-e* (hanging-scroll paintings), and he made a great deal of money for Mikawaya Den'emon, a wholesale dealer in illustrated storybooks in the Kojimachi district of Edo. Together with Toyokuni I, he often accepted commissions from various feudal lords to produce sketches of formal gatherings, much as a photographer would be commissioned today. In his later years, however, he fell into misfortune and obscurity. Lonely and worn out, he took refuge with his disciple Hikobei, who had established himself as a nurseryman in Takada. He died in 1867 at the age of eighty. Although he published a great deal of work during the first three decades of the nineteenth century, his

154 (*opposite page, left*). *Kikukawa Eizan:* A Beauty *from* A Collection of Fashionable Beauties. *Oban nishiki-e. Between 1804 and 1830.*

155 (*opposite page, right*). *Keisai Eisen:* Hairdressing *from* Forty-eight Customs of the Floating World. *Oban nishiki-e. Between 1818 and 1844.*

156. *Keisai Eisen:* Sixth Month: Dressing for the Tenno Festival *from* Calendar of Beautiful Women in the Floating World. *Oban nishiki-e. Between 1830 and 1844.*

later production was limited to such tasks as furnishing the illustrations for a popular encyclopedia published in 1863. Of his numerous disciples, only Eisen deserves mention.

Keisai Eisen (1790–1848; Figs. 114, 155–56, 158–59), once a lodger at the home of Eizan's father, was the most eccentric artist of his time. He studied painting under Kano Hakkeisai, the leading disciple of Kano Eisen'in, and later, through his own determination, gained an official post, only to lose it through slander and thus to become a vagrant. Then, bemoaning the way things were going with him in the world, he turned to the painting of ukiyo-e. He had been a student of the playwright Shinoda Kinji I (later known as Namiki Gohei II) and had succeeded to the name of Chiyoda Saiichi, but he finally became a dependent in the house of Eizan's father. Kikukawa Eiji.

He lived an extravagant and Bohemian life until marriage and the fathering of a baby girl persuaded him to settle down and devote his energies to woodblock prints. He worked day and night without leaving the house and, over a period of some ten years, produced a great quantity of picture books and polychrome prints. From his youth he had been fond of the Sung-dynasty painting of China, and his passion for calligraphy had caused him to burn much midnight oil. He concentrated on discovering new techniques of color printing and, at the same time, followed the style and techniques of Hokusai and developed from them a style of his own. He had an abundance of pupils, and his studio was prosperous. Nevertheless, in his autobiography he writes: "It is indeed lamentable that with all my efforts I was not able to realize my aspirations." Few of his pupils merit our attention.

157. *Yoshitoshi Tsukioka:* Teasing the Cat *from* Thirty-two Aspects of Manners and Customs. *Oban nishiki-e. Dated 1888.*

158 (*opposite page, left*). *Keisai Eisen:* Rejected Geisha *from* ▷ Passions Cooled by Springtime Snow. *Nishiki-e book illustration. Dated 1824.*

159 (*opposite page, right*). *Keisai Eisen:* Atago Hill *from* Twelve ▷ Views of Modern-Day Beauties. *Oban nishiki-e. Between 1830 and 1844.*

Eisen died in 1848 at the age of fifty-eight. The parting verse carved on his gravestone was thoughtfully composed to embrace all of the four seasons, so that it would be appropriate regardless of the time of year when he died.

So great was Eisen's delight in painting pictures of courtesans that he at one time operated a brothel in the Nezu district of Edo. Some scholars list Eisen together with Harunobu, Kiyonaga, and Utamaro as one of the four great painters of beautiful women, but numerous other scholars challenge this view. There are a number of masterpieces among the prints in such *okubi-e* (bust portrait) series of his as *Bien Sennyo Ko* (The Scent of Bewitching Nymphs), *Imayo Bijin Kurabe* (A Comparison of Contemporary Beauties), *Tosei Kobutsu Hakkei* (Eight Views of Present-Day Favorites), *Jisei Rokkasen* (Selection of Six Beauties of the Present Age), *Edo no Matsu Meiboku-zukushi* (a rather untranslatable title that literally means "An Exhaustive Collection of Edo's Famous Pine Trees" and uses the pine trees as a metaphor for the beautiful women portrayed), *Ukiyo Fuzoku Bijin Kurabe* (Manners of the Floating World: A Comparison of Beauties), and *Imayo Bijin Juni Kei* (Twelve Views of Modern-Day Beauties), the last of which is represented by the print shown in Figure 159.

As a painter of landscapes, Eisen was Hiroshige's senior. The previously noted *Sixty-nine Stations on the Kiso Highway* was originally commissioned from Eisen by the house of Hoeido but is thought to have been turned over to Hiroshige when it was less than half completed. As is usually noted, it is not the sort of undertaking that can be called a joint work. Of

the total of seventy prints that it comprises, twenty-four are by Eisen and forty-six by Hiroshige. It is possible to suppose that some kind of unpleasant difficulty arose between Eisen and the Hoeido, with the result that the commission was transferred to Hiroshige. When the series was finally completed and was sold as a whole, the wrapper bore a label reading "Painted by the late Keisai Eisen and the present Ichiryusai Hiroshige: A Series of Pictures of the Sixty-nine Stations on the Kiso Highway." Among the extant Eisen prints from this series, a great many bear no signature, and prints signed either "Eisen" or "Keisai" are extremely hard to come by. Some scholars explain the lack of a signature by saying that the negligent Eisen probably forgot to sign the prints, but such conjectures are the fault of persons who have been quite misled by

later editions. In the first edition the signature (either Keisai or Eisen) is generally not omitted.

UKIYO-E PRINTS AFTER THE MEIJI RESTORATION As we have already noted, Hiroshige I, Kuniyoshi, and Toyokuni III, who have been called the three great ukiyo-e painters of the late Edo period, died in 1858, 1861, and 1864, respectively. In the Meiji era (1868–1912) their successors, the so-called Three Masters of Ukiyo-e, made their appearance. These were Yoshitoshi Tsukioka (1839–92; Fig. 157), Yoshiiku Ochiai, and Kunichika Toyoharu.

The woodblock prints that appeared during the Keio era (1865–68) and the early years of the Meiji era carried to extremes the expression of brutality, disorder, and gloom, as is particularly evident in

such bloodthirsty creations as Yoshitoshi's *Biyu Sui-koden*, portraying heroes of the Chinese epic novel *Shui Hu Chuan*; his *Eimei Nijuhachi Shuku* (Illustrations for Poems by Twenty-eight Illustrious Persons), which he produced jointly with Yoshiiku; and his *Kaidai Hyaku Senso* (One Hundred Selected Examples of Powerful Men). After ten years or so, such works began to disappear, and more bright and cheerful prints emerged in large numbers: an indication, perhaps, that the new structure and the new order of Meiji society had at last become firmly grounded.

After the Meiji Restoration, ukiyo-e prints of actors, beautiful women, and landscapes were gradually faced with overwhelming competition from lithographs and photographs. It appeared that the resources of the ukiyo-e artists were suitable only to topical pictures (*jikyokuga*) and cartoons. The event that provided the ukiyo-e with an opportunity to revive in the midst of its declining fortunes was the Sino-Japanese War of 1894–95. With the outbreak of this conflict, innumerable war pictures were published, and the world of the polychrome print was suddenly infused with new life. According to a contemporary newspaper report, ukiyo-e craftsmen who had been living in poverty and obscurity on the outskirts of Tokyo converged as one man upon the great Shinto shrines to offer thanks by decorating them and offering sacred wine to the gods with shouts of "Long live the nation! Long live our trade!" With the coming of peace, however, the demand for prints fell off drastically, and the cost of

living rose, thus forcing the ukiyo-e into a further decline. Despite the outbreak of the Russo-Japanese War in 1904, ukiyo-e prints were no longer in demand except in such formats as that of the picture postcard, and they never again saw a boom like that of ten years before.

At the outset of the Taisho era (1912–26) efforts were made to encourage extensive research in the vanishing art of the ukiyo-e and to revive the traditional art of the woodblock print. Certain painters, in the hope of creating a new era in the history of this genre, tried to assimilate Western ideas and techniques in order to provide the ukiyo-e with fresh spirit and form. This effort is represented by the prints of such artists as Goyo Hashiguchi, Hasui Kawase, Koka Yamamura, Hiroshi Yoshida, and Shunsui Ito. The work of all these artists relied on the ukiyo-e print tradition in which much was left to the discretion of the carvers and the printers.

The new prints of the present day, however, have abandoned the traditional system of the division of labor. Many artists have invaded the several areas of print production and now undertake the painting, the carving, and the printing entirely by themselves. Aside from the creation of original prints, the crafts of reproducing and copying old ukiyo-e prints are now widely practiced, aided by the skills of carvers and printers: the last successors of the Edo-period craftsmen. And their work, at least, contributes to our appreciation of the grace and charm of the traditional prints of the vanished days of Edo.

CHAPTER SIX

Genre Prints and Prints of Beautiful Women

THE EARLY PERIOD As we have already noted, ukiyo-e-prints appealed to the tastes of the Edo townsmen first and foremost as portrayals of the manners and customs of the pleasure quarters. Figures 4 and 50 are both prints from a set in *oban* size by Hishikawa Moronobu entitled *The Style and Substance of the Yoshiwara*. Figure 50 depicts the kitchen of a pleasure house. All the servants are busy: one drawing water, one scaling a fish, one washing an octopus to prepare it for cooking, one grinding yams into a paste, one preparing to cut up a fish, one shaving dried bonito for soup stock, and one polishing lacquer trays and dishes, not to mention a dog on the lookout for scraps. The scene reminds one of the prosperity of the Yoshiwara as described by the contemporary writer Ebian Nanchiku in his *Waga Koromo* (My Garments): "Choice delicacies from all over the country are brought to this district, the prime market for such things, and every house is permeated by exotic odors." In this picture, however, no beautiful women appear. Light colors were applied by hand to the original printing in black ink. The print was produced in 1678 and published by the wholesale dealer Yamagataya, who specialized in the publication of *joruri* (puppet theater) texts and was located in Toriabura-cho in Edo.

Prints of this kind were marketed either as black-ink prints or as hand-colored prints. The purchaser would either color the black-ink prints himself or request someone with artistic taste to do so. Some surviving sets of prints like these have appended instructions for coloring them.

Ukiyo-e artists who regarded their work as a revival of ancient artistic traditions often selected classical themes and modernized them in their prints. Examples of such themes are the Six Tama Rivers, the Six Greatest Poets, the Seven Ages of the Poetess Komachi, and themes from such literary works as *Tales of Ise*, *The Tale of Genji*, and *One Hundred Poems by One Hundred Poets*. Torii Kiyomasu, in imitation of the ancient Chinese painting theme of the Eight Views of the Hsiao and the Hsiang (two rivers whose point of confluence is a celebrated scenic spot in China) and its Japanese counterpart, the Eight Views of Omi (Omi Hakkei), produced a set of prints called *Yoshiwara Hakkei* (Eight Views of the Yoshiwara), of which the *Ageya-cho no Shugetsu* (Autumn Moon at Ageya-cho) is shown in Figure 44.

The next step after the black-ink print and the hand-colored print was the development of color printing with a limited range of colors, at first largely the red known as *beni* and used in the *beni-zuri-e*. A representative work from this period is *Hana Oke* (Flower Pail), the large-size *hashira-e*

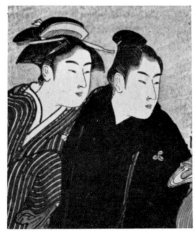

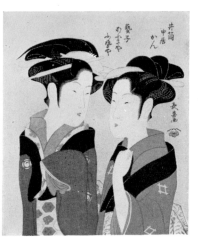

160. Torii Kiyonaga: detail from diptych Snow at Matsuchiyama. Oban nishiki-e. Dated 1785.

161. Eishosai Choki: detail from The Geisha Fuseya of the Ogiya and the Maid Kan of the Izutsuya. Oban mica nishiki-e. Between 1789 and 1801.

(pillar print) by Ishikawa Toyonobu shown in Figure 43. Here a courtesan, portrayed with almost divine elegance, is seen reading a poem card attached to a branch of plum blossoms.

For portrayals of beautiful women in the age of the true polychrome print, one must look first at the work of Suzuki Harunobu. One of his masterpieces is the set entitled *Zashiki Hakkei* (Eight Views of Interiors), which is modeled on the two themes mentioned above—the Eight Views of the Hsiao and the Hsiang (a favorite theme in Chinese painting from as far back as the Northern Sung dynasty) and the Eight Views of Omi—and treats these themes in metaphorical fashion. The set consists of *Kotoji no Rakugan* (Descending Geese of the Bridges of the Koto), in which the imagery of the title involves the bridges of the *koto,* or Japanese zither; *Tenuguikake no Kihan* (Returning Sails on a Towel Rack); *Ogi no Seiran* (After the Storm of Fans); *Nurioke no Bosetsu* (Evening Show on a Lacquered Tub); *Kyodai no Shugetsu* (Autumn Moon in the Dressing-Table Mirror); *Daisu no Yau* (Evening Rain at the Lacquer Stand); *Tokei no Bansho* (The Evening Chime of the Clock); and *Ando no Sekisho* (Evening Glow on a Paper-covered Lamp)—all of which are actually parodies of the traditional scenic themes. The print from this set entitled *The Evening Chime of the Clock* is shown in Figure 68. Here the

mood of the original scene (actually an aural rather than a visual effect)—the sound of temple bells carried on the evening breeze—is conveyed by Harunobu's picture of two young women on a veranda listening to the chime of a clock. One of them, probably just out of the bath, sits with bared shoulders and has not bothered to put on her obi.

Harunobu designed the prints of the *Zashiki Hakkei* according to the plan of a certain comic-verse adept who distributed them as gifts to his friends. They turned out to be so popular that they were soon published and marketed by the house of Shokakudo. The first edition of the series has comparatively light coloring and bears the signature "Kyosen" together with either the double seal "Josai Sanjin" and "Kyosen" or the single seal "Kyosen no in" (seal of Kyosen). Later editions were unsigned, and finally the signature of Harunobu came to replace that of Kyosen, while the colors became thicker, possibly to please the taste of the general public. As it went through one edition after another, the *Zashiki Hakkei* series became increasingly inferior in artistic quality.

Examples of Harunobu's work presented in color in this book are *Second Month* (Fig. 21) and *Mid-autumn* (Fig. 46) from the series *Fuzoku Shiki Kasen,* or *Furyu Shiki Kasen,* as some of the prints are inscribed (Elegant Poetry of the Four Seasons), and

One *Chrysanthemum* (Fig. 47). The work of his follower Isoda Koryusai is represented in color by *Sunrise* (Fig. 41), which comes from the set called *Furyu Mittsu no Hajime* (Three Elegant Beginnings) and pictures the early-morning departure of a guest who has spent the night in the pleasure quarters.

Prints of beautiful women by the Kitao-school artists Shigemasa and Masanobu are shown in Figures 79 and 80. The *oban* print by Shigemasa (Fig. 79) is entitled *Toho Bijin no Zu* (Picture of Beauties of the East), and the name probably signifies that the two women portrayed were beautiful courtesans from the Fukagawa pleasure district of Edo. The print by Masanobu (Fig. 80), called *Yamashita no Hana* (Flowers of Yamashita), is from the *oban-nishiki-e* series *Tosei Bijin Iro Kurabe* (Contest of Sexual Charms Among Contemporary Beauties). It is thought that the women pictured here are *kekoro*: unlicensed prostitutes who plied their trade in broad daylight in the Shitaya Hirokoji district, collecting only the smallest of fees for their services and invariably to be identified by their sitting on half-size *tatami* mats to advertise their charms. They flourished during the 1780's but apparently disappeared from the scene after the reforms of the Kansei era (1789–1801).

THE GOLDEN AGE The golden age of ukiyo-e was also the golden age of *bijinga*: pictures of beautiful women. Among the representative masterworks of this age are such prints by Kiyonaga as his splendid triptych *Shinobazu Chihan* (The Shore of Shinobazu Pond), the right-hand print of which is shown in Figure 89. The scene of the triptych is Shinobazu Pond in the Ueno district of Edo. The season is spring, and the cherry trees are in bloom. In the right-hand print we see an apparently well-to-do matron (probably a merchant's wife) with her baby on her back, a young woman, and a shaven-headed boy, all standing at the foot of a stone bridge and enjoying the sight of young turtles swimming at the edge of the pond. In the central print, two women stand in front of an itinerant juvenile goldfish vendor who is resting under a profusely blooming cherry tree. The left-hand print pictures a high-ranking maidservant

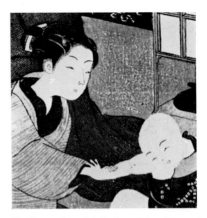

162. *Suzuki Harunobu: detail from* The Mosquito Net. *Chuban nishiki-e. Between 1765 and 1770.*

from the shogun's retinue mincing along as she holds up the skirt of her kimono, while two maidservants of lower rank follow her. High or low, wealthy or poor, all are enjoying springtime in the great city of Edo.

Two other noteworthy works by Kiyonaga, produced before the above-noted Shinobazu triptych, are *The Bath* (Fig. 90), from his *chuban*-size series called *Iro Kurabe Empu Sugata* (Comparison of the Charms of Enticing Women), published around 1780, and the unquestioned masterpiece called *The Wind* (Figs. 25, 85), which is one of his pillar prints.

Kiyomitsu, who studied painting under Kiyonaga and later became the fifth-generation head of the Torii school, also left some superlative prints of beautiful women. Among these is the one shown in Figure 92—a work dating from the period when he was still known as Kiyomine.

The artist who was most greatly influenced by Kiyonaga was Katsukawa Shuncho, from whose series *Nana Komachi* (Seven Ages of the Poetess Komachi) the print called *Omu Komachi* (Parrot Komachi) is reproduced in Figure 91. Here the scene derives its inspiration from a poem by the tenth-century poetess Ono no Komachi, and the poem itself is inscribed on the print.

After Kiyonaga, the next great artist is Kitagawa Utamaro. Figure 94 reproduces his *U no Koku*

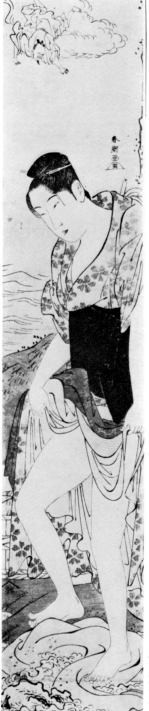

(Hour of the Rabbit), which comes from the series in *o-nishiki-e* size entitled *Seiro Juniji* (Day and Night in the Pleasure Houses), a masterpiece published by Tsutaya Juzaburo around 1800. Under the old-style division of the hours of the day and the night, the hour of the rabbit was the time between five and seven in the morning. In the scene depicted here by Utamaro a night of pleasure is over. A courtesan brings her lover his *haori* coat, the lining of which carries a picture of the Zen patriarch Daruma (Bodhidharma). Daruma seems to glare critically at the owner of the coat. Even more interestingly, perhaps, Utamaro has signed the Daruma picture with the name of Rinsho, an artist of the Kano school who was famous for his paintings of the great Zen patriarch. Utamaro also pictures an early-morning departure from the pleasure quarters in *The Morning After* (Fig. 96), an *oban nishiki-e* print from the series *Furyu Goyo no Matsu* (Five Elegant Aspects of Life).

Among Utamaro's prints of representative beauties of the 1790's there is a set entitled *Komei Bijin Rokkasen* (A Selection of Six Famous Beauties). Here his subjects are geisha, courtesans, and teahouse girls, and there is evidence of his intention to portray them as individual personalities. The set is represented in this book by the print shown in Figure 104, which pictures the courtesan Hanaogi (Flower Fan) of the establishment called the Ogiya. In the cartouche at upper right, next to the title of the set, Utamaro has used a rebus to identify her: fan (*ogi*), arrow (*ya*), flowers (*hana*), fan (*ogi*)—that is, Ogiya no Hana-ogi, or Hanaogi of the Ogiya. (It should be noted, however, that the *ya* of the name Ogiya means "house" rather than "arrow," although the words are homonyms in Japanese.)

The Ogiya, or Gomeiro Ogiya, to give it its full name, appears to have been a large and rather elegant brothel. The late-seventeenth-century writer Yomo Sanjin tells us that it was located in Edo-machi in the Shin (New) Yoshiwara, that it was of tall structure, and that it had a latticework facade of lacquered wood. The owner was one Uemon, and he and his wife, Inake, were students of calligraphy under the well-known scholar-teacher Kato Chikage. Uemon used the artist name of Bokuga

163. Katsukawa Shuncho: The Legend of the Wizard Kume and the Beauty Washing Clothes. Hashira-e. Between 1804 and 1818.

(River of Ink) in his role as calligrapher. Hanaogi and Takigawa, who was also frequently depicted by Utamaro (Fig. 15), were both famous courtesans of the time and both inmates of the Ogiya. Hanaogi had her quarters in the front part of the house, while Takigawa monopolized three rooms in the back. Like the master and his wife, both girls were students of calligraphy, Hanaogi under Sawada Toko and Takigawa under the above-mentioned Kato Chikage.

It was the practice at the Ogiya, once a month, to rate the courtesans according to the number of patrons they entertained and to reward them with appropriate prizes. Takigawa was often outpaced by Hanaogi; so the shrewd brothel owner Uemon devised a plan to encourage her to greater efforts. He would purposely have gifts of the finest quality (ostensibly from patrons of the establishment) delivered to Takigawa and then immediately send a servant to her rooms to inform her that they should have gone to the front room (Hanaogi's quarters) and to take them back. Thus challenged, Takigawa worked harder than ever, with the result that, as the contemporary book *Kumo no Itomaki* (The Spider's Web) tells us, "the two courtesans both shone with a radiance like that of jewels." Sadly enough, the writer Buyo Inshi, in his *Seji Kembunroku* (A Record of Observations on Contemporary Affairs), relates that in later years an epidemic of measles at the Ogiya carried off no fewer than some 120 courtesans and their girl attendants. He also remarks indignantly that the tragedy resulted from the neglect of proper hygiene at the Ogiya.

The print shown in Figure 95, which is from Utamaro's *Toji Zensei Bijin-zoroi* (An Assemblage of Beauties of the Current Prosperous Age), also portrays Hanaogi. The inscription on the print, however, identifies her only as "Hana of the Ogiya" (upper right, at left of cartouche), leaving the *ogi* (fan) pattern of her kimono to suggest the remainder of her name.

In Figure 20 we see Utamaro's portrait of Okita of the Naniwaya, one of the famous teahouse-girl beauties of the time. She appears again, along with five other beauties, in his triptych *Fujin Tomarikyaku no Zu* (Women Guests for the Night), which is

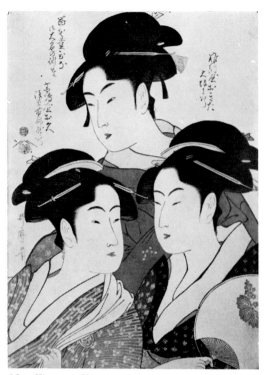

164. *Kitagawa Utamaro:* Three Beauties of the Kansei Era. *Oban nishiki-e. About 1790.*

shown in Figure 26. Here the women are preparing for bed, some of them already inside the overhanging mosquito net, some standing outside it. In addition to Okita, they include such highly regarded beauties as Ohisa of the Takashimaya, Tomimoto Toyohina, and Izutomi.

Utamaro's pupil Kikumaro is represented here by the print called *Lessons* (Fig. 105), a work in the *aiban-nishiki-e* size. Kikumaro later adopted different characters for the *kiku* of his name, then changed his name to Tsukimaro, and after about 1818 became known as Kansetsu.

The *aiban*-size triptych by Eishosai Choki shown in Figure 106 and represented by the detail in Figure 99 pictures a scene at the front of the Naniwaya teahouse and probably features the same six beauties who appear in the Utamaro triptych described

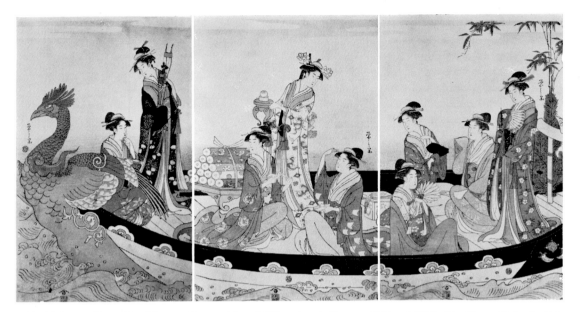

165. *Chobunsai Eishi:* The Pleasure Barge. *Oban nishiki-e triptych. Between 1789 and 1801. (See Figure 93 for detail.)*

above. Here they are joined by a male guest, a boy serving tea, and a young girl.

In the untitled triptych by Chobunsai Eishi shown in Figure 165 (a detail appears in Figure 93) nine beautiful women in a variety of costumes are enjoying a New Year's function aboard a boat with a prow in the form of a *geki*, a legendary bird that was reputed to fear neither wind nor waves. Pleasure barges and the like were often constructed in this fashion in old Japan.

Eishi is also represented in this book by his *Izutomi* (Fig. 109) from the *Seiro Geisha Sen* (Selection of Geisha from the Pleasure Houses), a set of *oban-size* prints that can well be called a masterpiece. In this portrait the geisha Izutomi has put her *shamisen* aside and stands in a graceful pose, holding the plectrum in her left hand. She is truly a Kansei-era beauty of ideal proportions, and we may note of her that she was portrayed by a fairly large number of other ukiyo-e painters. She was a prominent *tomimoto* geisha—that is, a geisha who played and sang

tomimoto-bushi, or songs in ballad-drama style. During her time, the *tomimoto-bushi* school of musical entertainment was at the height of its popularity, and the narrator-singer Buzendayu II enchanted the whole city with his superb natural voice and his deft handling of melody. Another outstanding perfomer of music in this style was Itsukidayu, who later changed his name to Kiyomoto Enjudayu. Although *tomimoto-bushi* was essentially music of the theater, it was also frequently performed at private entertainments like those held in the establishments of the Yoshiwara, where the talents of Izutomi and such other famous geisha as Toyohina were greatly in demand.

Figure 34 reproduces Eishi's triptych called *Good Spirits and Bad Spirits*, with the right-hand print shown in larger size to reveal more clearly the spirits named in the title as well as the male guest at right, who is thought to be Eishi himself enjoying the company of the courtesan Kisegawa at the Matsubaya pleasure house. Also among the festive

154 · GENRE PRINTS AND BIJINGA

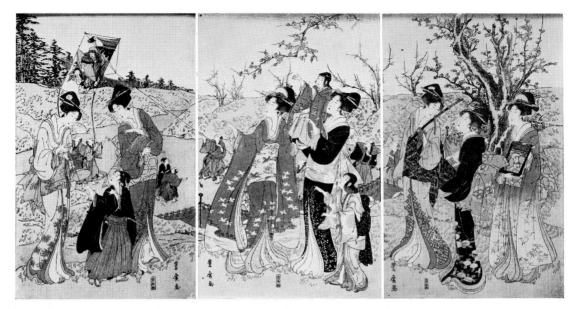

166. *Utagawa Toyohiro:* Garden of Blossoming Plum Trees. *Oban nishiki-e triptych. Between 1804 and 1830. (See Figure 116 for detail.)*

company are such people as the geisha Izutomi and the male geisha Tokichi, who was a performer of music in the *ogie-bushi* style. Of the era reflected here, it was said that "the people one meets in the world nowadays are playboys, snobs, prostitutes, and swindlers." Eishi's triptych, employing a theme originally expressed in a book by Santo Kyoden that was illustrated by Kitao Masayoshi and published in 1790, amusingly pictures the good spirits who urge the revelers to go home and the bad spirits who encourage them to stay on.

THE CLOSING YEARS Prints of beautiful women by artists of the Utagawa school are represented here first by Toyokuni I's *Takashima Hisa* (Fig. 115). Hisa (or Ohisa, as she was more commonly called) was the daughter of Takashima Chobei, who was both the owner of a teahouse and a maker and purveyor of rice crackers for the shogunate. His establishment was located in the Ryogoku district of Edo. He was a man of con-

siderable wealth and is reputed to have owned all the land on which the entertainment business in that district was carried on. Hisa married a man from the suburban area of Kameido and bore him two sons, Chojiro and Naokichi. She is said to have died at an early age.

Toyokuni's rival, Ichiryusai Toyohiro, was also a painter of beautiful women. A superlative example of his work is the triptych *Ume Saku Sono* (Garden of Blossoming Plum Trees), which appears in Figure 166 and from which a detail is shown in Figure 116. The prints are in *oban-nishiki-e* size.

The age of decline and decadence in the ukiyo-e is typified in the prints of beautiful women by Gototei Kunisada (Toyokuni III) of the Utagawa school and Keisai Eisen of the Kikukawa school. Kunisada's *Return from the Bath*, a vertical two-piece print, is shown in Figures 118 and 140 and his portrait of the Osaka courtesan Nakayubi in Figure 117. The latter print, one of a series in *oban-nishiki-e* size called *Ukiyo-e Meisho Zue* (Famous Scenes of the

Floating World), carries the title *Naniwa Shimanou-chi Nakayubi*. Naniwa is an old name for Osaka, while Shimanouchi was one of the city's celebrated pleasure quarters, and Nakayubi, as we have noted, was one of its famed courtesans. Similarly, Eisen portrays a courtesan in the print reproduced in Figure 114: *Hitomoto of the Daimonjiya*. This work is from the *oban-nishiki-e* series *Tosei Kuruwa Fuzoku* (Contemporary Scenes in the Pleasure Quarters).

Kunisada's *Yagembori Kompira* (Fig. 141), from a series called *Jisei Edo Kanoko* (Various Scenes of Contemporary Edo), is thought to have been published around 1818. The title of the print combines the names of a canal called the Yagembori and the nearby Kompira Shrine. According to the *Nihombashi-ku Shi* (A History of Nihombashi Ward), boats loaded with rice destined for the Yanokura storehouse formerly traveled by way of a canal that ran between the Sumida River and Yonegawa-cho. After the warehouse was relocated in the Tsukiji district in 1698, the canal was gradually filled in, although the main part of the work was not undertaken until 1771, when the job was finally completed. The name of the canal, Yagembori (Druggist's Mortar Canal), probably derived from the fact that many physicians lived in the area, which continued to be known as Yagembori even after the canal had been filled in. The Kompira Shrine was built in this area in 1783. It is said that the work *kompira* originally meant "alligator," but in this case it is the name of the guardian deity of sailors, whose faith in him was strong.

The woman in Kunisada's print is washing a cotton kimono (*yukata*) of the type worn at local festivals. The anchor pattern of the garment provides the only link between this attractive laundress and the Yagembori Kompira Shrine pictured in the circle in the upper-left corner of the print. We know, however, that the Kompira Shrine held a major festival every autumn and a minor festival on the tenth of every month. The woman's face expresses the proud and plucky spirit of the Edokko, the Edoite born and bred. Although the lines are somewhat stiff and unrefined, this woman is not so shrunken in stature as Kunisada's later beauties are, nor are her feet made ugly by the exaggeratedly high insteps that came to characterize these beauties.

Figure 159 reproduces Eisen's *Atago Hill* from his *Imayo Bijin Juni Kei* (Twelve Views of Modern-Day Beauties). His subject here may have been a girl from one of the teahouses either at the foot or at the top of Atago Hill, a scenic spot in Edo that is pictured in the hand scroll at upper left in the print. Eisen's beauties, when portrayed in full length, are often curiously broad-shouldered and dwarfish in height. They give the impression of hussies from back-street tenements who have undergone a thorough polishing after having been sold to pleasure houses. At the same time they resemble the rather moronic beauties of Eizan, with perhaps a dash of the Edokko spirit added in. During his more than forty years of activity as a painter, Eisen dashed off countless prints of beautiful women, and many of these works can still be found in the shops of print dealers today.

Actor Prints and Sumo Wrestler Prints

ACTOR PRINTS Hishikawa Moronobu, the progenitor of ukiyo-e prints, had included Kabuki scenes among his creations, but it was only with the emergence of the Torii school that the ukiyo-e genre became more closely linked with the actor print. Figure 45 reproduces a *beni-e* by Torii Kiyonobu I portraying the actors Ichikawa Danzo I as Soga no Goro and Fujimura Handayu as the courtesan Shosho in *Kissho Naotori Soga,* a drama based on the celebrated vendetta of the Soga brothers and performed at the Nakamura-za in Edo in 1721. Danzo made a specialty of the roles of villains and swashbuckling heroes of the *aragoto* (bombastic) style of acting. The bold white bar added to his family crest of three concentric rice measures (lower right in the print) dates from 1715, when he broke off relations with the Ichikawa actor family because of a quarrel with Ichikawa Danjuro II, son of his former teacher Danjuro I. The writer Haiyudo Muyu, in his *Santo Yakusha Yoyo no Tsugiki* (Successive Generations of Actors in Three Cities), notes of Danzo that "he makes a big hit every year with his performance as Soga no Goro."

Danzo made up his differences with the Ichikawa family in the winter of 1731, when he performed with Danjuro Hakuen at the Nakamura-za for the first time in eighteen years in the historical drama *Bankoku Wago Ichiji Taiheiki* (Chronicle of the Great

Peace in All the Provinces). At this time he abandoned the crest with the white bar and once again adopted the original Ichikawa family crest of the three rice measures. The last role of his career was again that of Soga no Goro, which he played in the spring of 1740 just before his death at the age of fifty-six.

Fujimura Handayu, the other actor who appears in Kiyonobu's print, was a prominent *onnagata,* or female impersonator, in the Kabuki theater of the day. A *hokku* poem of his appeared under the pen name of Hampu in *Kokon Yakusha Hokku Awase* (A Collection of Hokku by Actors Past and Present), which was published in 1756: "A night in spring, and my wooden pillow feels hard. An age has gone by." He died in the summer of 1745.

The *oban*-size pillar print by Okumura Masanobu in Figure 57 is also a *beni-e*. It pictures Bando Hikosaburo II as the youth Kichisaburo in a performance of the play *Hoshiai Genji-guruma* at the Ichimura-za in the summer of 1758. Hikosaburo II inherited and first used his father's name in a performance at the same theater in the winter of 1751, and by 1764 he was rated among the most outstanding of contemporary actors, being especially popular with women. Unfortunately, he died in the early summer of 1768 at the age of only twenty-seven.

The youth Kichisaburo, whom Hikosaburo portrays in Masanobu's print, was the lover of the tragic Oshichi, the fifteen-year-old daughter of a greengrocer in the Hongo district of Edo. In the spring of 1683, Oshichi was burned at the stake on the execution ground at Suzugamori for having committed the crime of arson as a consequence of her love affair with Kichisaburo, who was then a temple page. It is said that after her death Kichisaburo became a priest so that he could pray for the repose of her soul and that he died in 1737 at the age of about seventy. The romantic tragedy of Oshichi and Kichisaburo was dramatized for the Kabuki stage by Azuma Sampachi under the title *Oshichi Utazaimon* and made a tremendous hit when it was staged at the Arashi San'emon-za in Osaka in 1706. In midwinter of the next year another dramatization of the story, *Keisei Arashi Soga*, was staged in Edo as one of the opening performances of the newly formed theatrical troupe of the Nakamura-za. From that time on, the story frequently served as a vehicle for Edo playwrights, appearing under a variety of titles and involving numerous versions of the original facts. Its theme is reflected in the anonymous and rather vulgar poem inscribed on Masanobu's print, in which the double meanings of the words *koi* (love, carp) and *kosho* (page, pepper) make possible the two readings "Oh, my, what a poisonous mixture, love and a page!" and "Oh my, what a poisonous mixture, carp and pepper!"

One of Masanobu's pupils, Okumura Toshinobu, produced a hand-colored print in *hosoban* size portraying the actor Sanjo Kantaro in the role of Kichisaburo, and from the succeeding age of the *benizuri-e* there remain some prints picturing the actor Chusha Ichikawa Yaozo II in the same role. Popular female impersonators who played the role of Oshichi included Arashi Kiyosaburo, Segawa Kikujiro, and Segawa Kikunojo II.

Figure 39 reproduces a *beni-e* by Okumura Toshinobu in which we see a dramatization of a scene from Ihara Saikaku's celebrated novel *Koshoku Ichidai Otoko* (The Life of an Amorous Man). Here the actor Masugoro (later to become Ichikawa Danjuro III) plays the role of Yonosuke, an eight-year-old Don Juan who perches on the roof of an arbor and peers through a telescope at Sodesaki Kikutaro, who plays the role of a beauty engaged in taking a bath. We must note with some regret that Masugoro, after he had succeeded to the name of Danjuro III, died in 1742 at the tragically early age of twenty-one.

A work from the succeeding age of color printing appears in Figure 42: a *hosoban* print by Kiyomitsu, third-generation artist of the Torii line and son of the second-generation artist Kiyomasu. The subject is Bando Hikosaburo II in the role of Shiba no Kotaro in the play *Katakiuchi Mogami Inabune*, a drama of revenge that was presented in the spring of 1759 at the Ichimura-za. Here Shida no Kotaro stands under a willow tree, his face averted from the light of the lantern in the background. As we have noted above, Hikosaburo II died at an early age. The artist Kiyomitsu died in the spring of 1785 at the age of fifty-one.

Another example from the early age of color printing is Ishikawa Toyonobu's *Okiku and Kosuke* (Fig. 27), a *benizuri-e* in the *oban* size. Here we see the star-crossed lovers Okiku and Kosuke in a scene from *Kikuzakaya Shinju* (The Love Suicides at Kikuzakaya), which was presented at the Ichimura-za in the summer of 1751 as the second number on a Kabuki program that featured the play *Sasaki Saburo Fujito Nikki* (The Diary of Sasaki Saburo at Fujito). The role of Okiku's lover Kosuke was played by the actor Kamezo I, who in 1762 inherited the title of his father, Ichimura Uzaemon VIII, and was known from that time on as Uzaemon IX. He became the proprietor of the Ichimura-za and lived until 1785.

Okiku was played on this occasion by the Kyoto *onnagata* Nakamura Kiyosaburo, who had come to Edo the previous year. He was born in 1721 and died in Osaka in the summer of 1777. A stage rival of the Edo actor Segawa Kikunojo II, he had made the transition from the rank of *iroko* (catamite) actor to that of young female impersonator at the Ebisuya Kichirobei-za in Kyoto in 1735. He had a beautiful figure and a fine voice, and it appears that he was more popular in *sewamono* (dramas of contemporary everyday life) than in *jidaimono* (historical dramas).

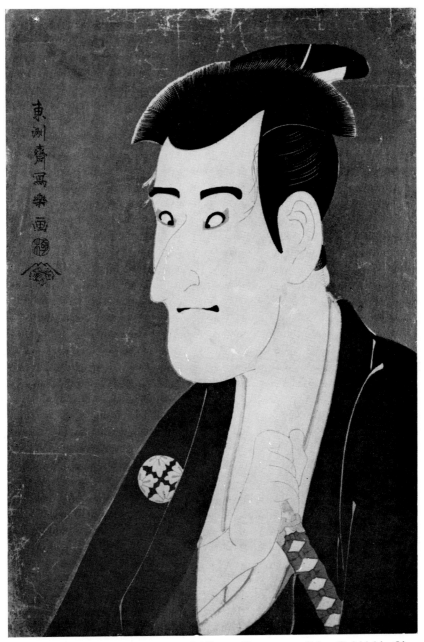

167. *Toshusai Sharaku:* The Actor Ichikawa Komazo as Shiga Daishichi. *Oban mica nishiki-e. Dated 1794.*

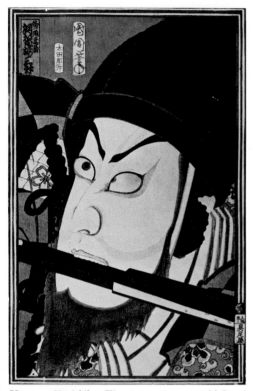

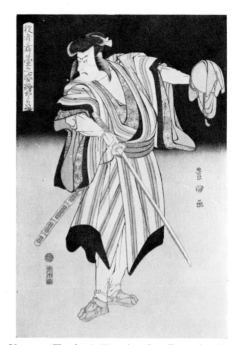

168. Utagawa Kunichika: The Actor Kawarazaki Sansho as Sato Masakiyo. *Oban nishiki-e. Dated 1869.*

169. Utagawa Toyokuni: Koraiya *from* Portraits of Actors on the Stage. *Oban nishiki-e. About 1795.*

The above-mentioned Kamezo made his debut in the winter of 1731 under the name of Manzo. In the spring of 1745, however, when the newly born second son of the shogun Tokugawa Ieshige was given the name Manjiro, the first character of which was the same as that of the name Manzo, he took the name of Kamezo to avoid any implication of lèse majesté. Since *kame* means "tortoise," perhaps he was inspired by the popular belief that the tortoise lived to the age of ten thousand years.

In the actor prints of the *benizuri* age the names of the actors were ostentatiously displayed, but the faces bore no resemblance to those of the actors themselves. Toyonobu's *Okiku and Kosuke* is no exception in this respect. It is not designed to portray

Kiyosaburo and Kamezo as individuals but to display the attractions of a typical beauty and a typical handsome man of the times. The mood of the print is reflected in the words of a contemporary song in which clever use is made of the fact that the name Okiku means "chrysanthemum": "Okiku of Kaga is a wine merchant's daughter. Her face is as white as white chrysanthemums, and her kimono is patterned with red chrysanthemums. She's a fine girl, a fine girl, this little chrysanthemum."

One can safely say that the portrayal of the personal characteristics of Kabuki actors began in the age of polychrome prints with the work of Katsukawa Shunsho. Figure 48 reproduces a print of *aiban-nishiki-e* size in which Shunsho pictures the

actors Ichikawa Danjuro V (left) and Iwai Hanshiro IV (right) in a historical drama. Danjuro V, who later changed his name to Ebizo, retired from the stage in 1796 to live in seclusion in Ushijima, where he then took the name of Naritaya Shichizaemon. He was fifty-five at the time. His fellow actor in this print, Hanshiro IV, was a celebrated *onnagata* who died in the spring of 1800 at the age of fifty-three. The artist Shunsho died in 1792 at the age of sixty-seven.

Shun'ei, one of Shunsho's outstanding pupils, is represented by the print shown in Figure 88: a work in *aiban-nishiki-e* size picturing Ichikawa Yaozo II (right) and Hanshiro IV (left). Yaozo II enjoyed enormous popularity among women, whose devotion to him is the theme of a story about his appearance in the title role of the famous play *Sukeroku*. We are told that after the final scene of the play, in which the hero Sukeroku conceals himself for a time in a vat filled with water, his female fans rushed onstage to fill sakè bottles with water from the vat, took the water home, boiled it, and then used it for medicine. After his death in the summer of 1777 at the age of forty-two, there was a weird and widespread rumor to the effect that his ghost had taken to haunting the streets of the Yoshiwara.

The print shown in Figure 38, of *oban-nishiki-e* size, is an *okubi-e* (bust portrait) of the actor Sakata Hangoro by Shunsho's leading disciple, Shunko. Not many of these large-size *okubi-e* survive, and they are not only Shunko's masterpieces but may also be numbered among the very best of all actor prints. Sakata Hangoro III, whom Shunko has portrayed here, was accorded the highest rank among actors for his performance of the roles of villains. He died in the summer of 1795 without having yet reached the age of forty.

The *Ehon Butai Ogi* (Picture Book: Stage Fans), produced jointly by Shunsho and Ippitsusai Buncho, is represented by the *hosoban* print in Figure 49: a portrait by Buncho of the actor Ichikawa Komazo, who was later to become Matsumoto Koshiro V. In another version of this print that I have seen, the actor's shadow appears on the *shoji* (sliding paper window) behind him, but the shadow is too dark, and the print gives an unpleasant impression.

Buncho made such frequent use of *shoji* in prints that he came to be known as "shoji no gaka," or "the shoji painter."

After Shunsho and Buncho, the artist who most distinctively emphasized the personal characteristics of actors was Toshusai Sharaku, to whom we have given considerable attention earlier in this book. In Figure 19 we see Sharaku's *oban*-size micaground portrait of Ichikawa Ebizo in the role of Takemura Sadanoshin. Even among his own superlative actor prints this one is particularly famous, and it leaves countless other actor prints in the shade. It appears to have won a great reputation at the time of its first publication, with the result that various editions of it survive even today.

The Kabuki play represented by this print, *Koi Nyobo Somewaka Tazuna*, is best known for the act in which the woman Shigenoi is forced to part from her child at an inn in Minaguchi. It is in the act just before this one that the character portrayed by the actor in Sharaku's celebrated print appears. He is Shigenoi's father, the Noh actor Sadanoshin, and the act reaches its climax when he commits *seppuku* (harakiri) inside the great bell used in the Noh play *Dojo-ji*. His suicide is an act of supplication for the life of his daughter, whose misconduct with the man Date no Yosaku has been discovered and is about to be punished by her death. Shigenoi is thereby saved and goes on to acquire the respectable position of wetnurse to an infant princess.

In this print Sharaku has captured precisely the qualities of Ichikawa Ebizo in his portrayal of the strong character of the Noh actor Sadanoshin. Ebizo was a man of fine physique, expert in the roles of both heroes and villains, and Sharaku, with great economy of line and color and an enormous audacity of expression, has caught him here at an intensely dramatic moment on the stage.

Figure 98 reproduces Sharaku's portrait of the actor Kosagawa Tsuneyo II in the role of Sakuragi, Sadanoshin's wife, in the same Kabuki play. Tsuneyo II was elevated to the highest rank in the actor hierarchy in 1808 and died in the summer of the same year at the age of fifty-five.

Sharaku produced many other portraits of actors in this play when it was performed at the Kawara-

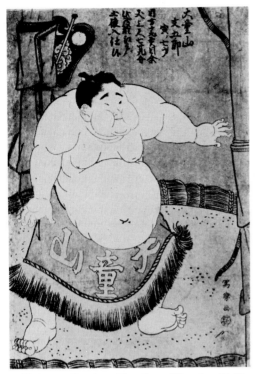

170. *Toshusai Sharaku:* The Boy Wrestler Daidozan Entering the Sumo Ring. *Oban nishiki-e. About 1794 or 1795.*

zaki-za. These include his portraits of Otani Oniji as the footman Edohei; Iwai Hanshiro as Shigenoi; Ichikawa Monnosuke as Date no Yosaku; Tanimura Torazo as the villain Yaheiji, younger brother of Washizaka Kandayu; Bando Hikosaburo III as the mediator Sagisaka Sanai; Iwai Kiyotaro as Sanai's wife, Fujinami; Bando Zenji as Kandayu's wife, Ozasa; and Ichikawa Omezo as the young servant Ippei.

The Sharaku print shown in Figure 97 pictures two actors who can be positively identified as Sawamura Sojuro III (left) and Segawa Kikunojo III (right). Formerly there were differences of opinion concerning the play and the roles represented in this print, but today there is little doubt that the play is *Keisei Sambon Karakasa* (The Courtesan's Three Parasols) and that the roles are those of

Nagoya Sanza and the courtesan Katsuragi. The play was staged at the Miyako-za in the summer of 1794, when Sojuro was forty-one and Kikunojo was forty-three. As one might expect, Kikunojo's face shows unmistakable wrinkles. Sojuro died in the spring of 1801 at the age of forty-eight and Kikunojo in the winter of 1810 at the age of fifty-nine.

As the comic novelist Jippensha Ikku noted in 1817 in his *Yakusha Nigao Hayageiko* (A Short Course in the Drawing of Actor Portraits), portraits of Kabuki actors had become so popular in Edo that "even children take time out from throwing stones at dogs in order to draw Matsumoto Koshiro's big nose." The tastes of such an age were well satisfied by Utagawa Toyokuni I, who became the most popular artist of the day. Perhaps his greatest masterpiece is the *Yakusha Butai no Sugata-e* (Portraits of Actors on the Stage), a series in *oban-nishiki-e* format. The series is represented here by *Yamatoya* (Fig. 136), *Tachibanaya* (Fig. 135), and *Koraiya* (Fig. 169), the titles being the house names of actor families. *Tachibanaya* pictures Ichikawa Yaozo III in the role of a servant in *Haru no Akebono Kaomise Soga*, a play on the favorite theme of the Soga brothers performed at the Miyako-za in the spring of 1794. The play was actually a parody of the famous Kabuki drama *Kagamiyama*, which also employs the theme of revenge, as the dramas of the Soga cycle do. Mica is used here and there in original editions of the print, and the red eye shadow used in all the first-edition prints of the series was applied by hand.

This series by Toyokuni I represents the last of the great stage portraits, and subsequent actor prints show a steady decline in quality. Kunisada (Toyokuni III) left countless actor prints, but few of them indeed can be called masterpieces. Under the so-called reforms instituted in 1792 by the shogun's adviser Mizuno Tadakuni, actor portraits, like portraits of courtesans and geisha, were banned. Although they enjoyed a revival around 1846, they displayed little or no improvement in quality. The movement for reform in the theater that arose during the Meiji era in response to the demands of the new age had no effect on Kabuki prints, and actor prints eventually came to be replaced by photographs.

SUMO WRESTLER PRINTS

Sumo wrestling, which was no less a popular form of entertainment than Kabuki, also served as a subject for ukiyo-e. In the Meiwa era (1764–72), when the wrestler Shakagadake Kumoemon from Izumo Province acquired fame as the "seven-foot boy who became a champion at the age of sixteen," Kiyonobu II and Ippitsusai Buncho lost no time in producing portraits of him. Similarly, no sooner had the great wrestler Tanikaze Kajinosuke won the acclaim of all Edo than Katsukawa Shunsho portrayed him in the ring against a panoramic *uki-e* (perspective picture) view of the tournament area and then went on to picture him in the ring with his opponent Onogawa Kisaburo and the referee Kimura Shonosuke and, again, to picture him and the wrestler Uzugafuchi in the ring together. Katsukawa Shun'ei's portrait of Tanikaze appears in Figure 78. At the same time, Katsukawa Shuncho produced a number of *okubi-e* portraying Tanikaze together with the contemporary Edo beauty Okita of the Naniwaya teahouse, while Shunko pictured him in the company of the wrestlers Ayakawa and Yamawake and, in another print, called *Edo no Sampukutsui* (Edo Triptych), in the company of a prominent courtesan and the actor Hakuen Ichikawa Danjuro costumed for the play *Shibaraku*. Utamaro also used Tanikaze as a subject, showing him engaged in a tug of war with the legendary boy warrior Kintoki while three beautiful women encourage them with cheers.

Another celebrity of the sumo world was the boy prodigy Daidozan Bungoro, who at the age of seven was almost 4 feet tall, measured about 42 inches around the hips, and weighed about 183 pounds. After he had come to Edo from his native village in the Tohoku region of northern Japan, Sharaku pictured him in his ceremonial entrance into the sumo ring (Fig. 170) and, in another print, showed him using a *goban* (board for the game of *go*) as a fan to snuff out a candle. He also served as a subject for Eishosai Choki, who comically pictured him as a guest at someone's house stealthily gobbling up cakes from a serving table, and for Shunsho's pupil Shunzan, whose print showing him in the sumo ring at the age of six was published by the

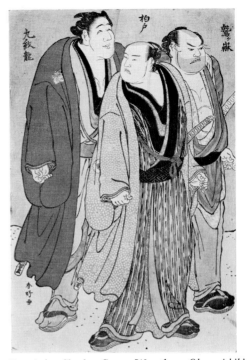

171. *Katsukawa Shunko:* Sumo Wrestlers. *Oban nishiki-e. Between 1789 and 1801.*

house of Yamaguchiya Chusuke of Bakuro-cho.

Sharaku also produced a number of *hanshita-e* (underdrawings for prints) showing great sumo wrestlers of his day in pairs, notably Kumonryu and Wadagahara, Tatsugaseki and Hidenoyama, Raiden and Kachozan, Semiyama and Kagamiiwa, Jimmaku and Iwaigawa, Kashiwado and Arauma, Sendagawa and Inazuma, Washigamine and Miyagino, and Tamagaki and Ryumon. These *hanshita-e* were in the collection of the late Bunshichi Kobayashi but were unfortunately burned to ashes in the great Kanto earthquake and fire of 1923.

After their heyday in the last two decades of the eighteenth century, both actor prints and sumo wrestler prints deteriorated in quality and, during the artistically decadent Bunka and Bunsei eras (1804–30), ceased to have any aesthetic value.

CHAPTER EIGHT

Landscape Prints and Other Types

The predecessors of uki-yo-e landscape prints were the *uki-e*, or perspective pictures, which owed much of their inspiration to Dutch copperplate engravings. The *uki-e* genre is well represented by Utagawa Toyoharu's *Picture of Mimeguri* (Fig. 130), a print of *o-nishiki-e* size published by the house of Eijudo in the 1770's. The Mimeguri Inari, a Shinto shrine dedicated to the god of the harvest, stood in the midst of the rice fields at Koume village and was therefore also known as the Tanaka Inari, or Inari in the Rice Fields. In the eclectic manner of religious institutions in Japan it was a branch establishment of the Emmei-ji, a temple of the Tendai sect of Buddhism. It was also one of the scenic spots of Edo most frequently depicted by ukiyo-e artists.

In Toyoharu's print the cherry trees are in full bloom, and a large number of people are either paying homage at the shrine or enjoying outings in the fine spring weather. Others are busy at their work: a girl is selling tea at the stone *torii* (ceremonial gateway) of the shrine, a farmer is plowing his inundated rice field, fishermen cast their nets from boats on the Sumida River, and raftsmen ply their long poles. Across the river, smoke from the Imado pottery kilns trails in the spring breeze. Even the herons in the rice field and the gulls floating on

the river are drawn in astonishingly careful detail.

As we have previously noted, a great many other artists produced *uki-e* prints. Among them were Kitao Shigemasa and Katsukawa Shunsen, examples of whose work are shown in Figures 81 and 131, respectively.

HOKUSAI AND
HIROSHIGE In the realm of the ukiyo-e landscape print, Hokusai and Hiroshige are universally acknowledged as the two greatest masters. Although Hokusai, as a painter of the fifty-three stations on the Tokaido, is slightly inferior to Hiroshige, he decidedly surpasses Hiroshige in his depiction of that other mutually shared theme, the thirty-six views of Mount Fuji. Hiroshige's two versions of the thirty-six views, in fact, compare most unfavorably with Hokusai's version.

Hokusai's *Thirty-six Views of Mount Fuji*, as we have noted, is actually a set of forty-six prints, including ten supplementary views of the mountain as seen from the landward side. The crowning masterpiece of the set is the print entitled *Gaifu Kaisei* (Southerly Wind and Fine Weather), commonly called *Aka Fuji*, or *The Red Fuji* (Fig. 22). Here the almost perfectly conical peak, printed in red ocher, soars majestically into a mackerel sky. The print is said to have greatly excited the French impression-

ists, and it enjoys astonishing popularity among foreigners in general. The shades and gradations of color, however, vary considerably with different editions, reflecting the different degrees of skill on the part of the printers.

Hardly less of a masterpiece among Hokusai's *Thirty-six Views of Mount Fuji* is *Sanka Hakuu* (Rainstorm Below the Mountain), which is shown in Figure 125. In this print the sacred mountain, still crowned in early summer with lingering snow, rises above thunderheads piled up like white cotton, while downpours of rain drench the foothills and lightning flashes across the foreground. There are also versions of the print in which we see groves of pine trees illuminated by the lightning, but these are apparently later editions.

Equally famous is *Kanagawa Oki no Namiura* (The Waves off Kanagawa), in which Mount Fuji is seen far in the distance through the troughs of swelling seas (Fig. 172). The composition of this print is certainly extraordinary, but one cannot escape the feeling that it is a bit melodramatic: a somewhat too dazzling display.

Another masterpiece from the same set is *Koshu Mishima-goe* (Mishima Pass in Kai Province), which is shown in Figure 120. Here a gray Fuji, its summit tinged with indigo, towers up at the right side of the composition. White columns of cloud rise around it, and the clouds surrounding the very peak are blown by the wind into a trailing girdle. In the foreground a single gigantic tree rises straight up, its branches seeming to scrape the sky. Three travelers, out of curiosity, have joined hands in an effort to encircle the massive trunk, but it seems that three or four more are needed to complete the circle. The man in the left foreground sits quietly smoking his pipe and displays not the slightest interest in what is going on. In the right foreground, men and women, perhaps travelers or local villagers, ascend and descend the pass. The print is colored in indigo, light and dark green, gray and gray-black tones of *sumi* (ink), and a bit of brown. Editions in which the sedge hats are colored in yellow and the shaven heads in light brown may be taken as later editions. It can be assumed that Hokusai crossed the Mishima Pass in the course of a journey through Kai Province, which is the present-day Yamanashi Prefecture, but I have been quite unable to discover its location in that prefecture.

A great work of Hokusai's last years is the ten-print set of vertical prints named *Shiika Shashin Kagami* (Illustrations of Chinese and Japanese Poems), which draws its themes from classical poetry. This series as a whole is not highly regarded by present-day ukiyo-e scholars, but one of the prints manages to avoid the excessive display of knowledge of the classics that characterizes the others and, at the same time, expresses a degree of emotion that is rather rare in Hokusai. In fact, it is generally regarded as one of his masterpieces. It is the *Tokusakari* (Gathering Horsetails), shown in Figure 124. Hokusai may have been inspired here by Zeami's Noh play *Tokusa* or perhaps by Kineya Shojiro's *Tokusakari*, composed for the Kabuki theater and performed by the actor Iwai Hanshiro IV as one of seven dances presented for the first time at the Miyako-za in the autumn of 1797. In Hokusai's print an old man who has been gathering horsetail rushes makes his way homeward across an earthen bridge over a mountain stream. The poem illustrated here, written by Minamoto no Nakamasa and included in the fourteenth-century anthology *Fuboku Wakasho*, can be translated as follows:

> Behind the trees on Mount Sonohara,
> Where I have been gathering horsetails,
> A brightly polished autumn moon
> Ascends the evening sky.

The evening atmosphere of the upland pond and the rushing mountain stream is admirably conveyed. Two wild ducks are swimming in the pond. In the first edition of the print the rising full moon is blurred by thin clouds, but in later editions it casts a bright light over the scene because the printer neglected to apply the thin ink shading.

Another work of Hokusai's late years is a series of prints illustrating the poems in the celebrated anthology *Hyakunin Isshu* (One Hundred Poems by One Hundred Poets). The series is represented here by the print in Figure 119, which bears as its title the name of the poet Yamabe no Akahito (eighth century), whose verse inspired it:

172. Katsushika Hokusai: The Waves off Kanagawa *from* Thirty-six Views of Mount Fuji. *Oban nishiki-e. Between 1823 and 1833.*

Coming out onto the beach at Tago,
I saw the high peak of Mount Fuji
Glistening with pure white snow.

The sight of Mount Fuji across the breakers of Tago Bay is reputed to be the best of all views of the mountain from the seacoast side. Only twenty-eight prints of this series were published, but the collection of Ernest Hart, an Englishman who visited Japan around 1888, is said to have included forty of Hokusai's underdrawings for the series, four of which were published in 1921.

Hokusai had many pupils. Among them was Shotei Hokuju, who was much influenced by his master's handling of the Western style and is represented here by his *Drawing in the Fishing Nets at Kuju-kuri Beach in Kazusa* (Fig. 128).

After Hokusai the next great landscape-print artist to appear was Hiroshige, whose first demonstration of his skill is perhaps best seen in his *Toto Meisho* (Celebrated Places in the Eastern Capital), a set of ten horizontal prints in *oban* size published by

Kawaguchiya Shozo in 1831. This set, generally known as the *Ichiyusai-gaki Toto Meisho* to distinguish it from the later set called *Toto Meisho*, was produced when Hiroshige was about thirty-four. The most famous print from the set is *Ryogoku no Yoizuki* (Evening Moon at Ryogoku), which depicts the rising full moon half hidden by the pilings of a wooden bridge (Fig. 173). This print is said to have influenced the American-born British painter Whistler when he pictured London's Battersea Bridge veiled in evening mist in his *Nocturne in Blue and Gold.*

The indigo-printed versions of this series are believed to be later editions, although there are those who claim them to be first editions. In any case, the series retains some of the freshness that Hiroshige displayed in his work when he began to emerge as a landscape painter. This quality is evident in the extraordinarily beautiful crimson clouds that trail across the landscapes in all ten of the prints. I have the feeling that these prints with crimson clouds represent the first edition.

173. Ichiryusai Hiroshige: Evening Moon at Ryogoku *from* Celebrated Places in the Eastern Capital. *Oban nishiki-e. Dated 1831.*

Kambara (Fig. 122) and *Tsuchiyama* (Fig. 123) are two prints in the series that constituted Hiroshige's first major success: the *Hoeido-ban Tokaido Gojusan Tsugi,* as it is called—that is, the Hoeido edition of *The Fifty-three Stations on the Tokaido. Kambara* pictures the snow-mantled landscape of the lonely post station at nightfall. Two men ascend the slope, one in a straw coat and a broad straw hat, while another, leaning on his stick and holding his paper umbrella half closed against the wind, plods wearily down the slope. The snow falls soundlessly and ceaselessly. In some editions of the print the dark-to-light shading of the sky is applied from the top downward and in some from the horizon upward. There are also editions in which the distant mountains are shaded in light blue. I have even seen later editions printed entirely in indigo, and I must report that they are hideous.

The other print, *Tsuchiyama,* shows us a landscape drenched in springtime rain. In some editions the color shading of the rapids of the Tamura River (lower right in the print) is applied from the top down and in others from the bottom up. The best editions are those that successfully convey the soft, hazy atmosphere around the rain-soaked Tamura Temple in the background at upper left.

Hiroshige's famous two-piece vertical print called *The Monkey Bridge in the Koyo District* (Fig. 121) is thought to have been produced around 1841, when he was forty-four. It was published by Tsutaya. Until recent years, when contrary opinions have been expressed, it was widely considered to be his finest work. It reflects what he saw for himself on his journey to Kai Province (the present Yamanashi Prefecture) in the spring of 1841. The full moon hangs beneath the arch of a wooden bridge built high above the clear waters of the Katsura River, which flows through the mountain valley below.

Having started his career as a landscape painter with the above-mentioned *Ichiyusai-gaki Toto Meisho,* Hiroshige went on to establish his reputation as a traveling painter and in his last years made it his greatest enterprise to produce the *Meisho Edo Hakkei* (One Hundred Views of Famous Places in Edo).

174. Ichiryusai Hiroshige: The Yodo River *from* Celebrated Places in Kyoto. *Oban nishiki-e.* Dated 1834.

One has the feeling that he found some truth in Shokusanjin's humorous poem: "Mountain villages are lonely places in winter, and cities, after all, are more lively and comfortable." The *Meisho Edo Hakkei* series was published over a period of two years beginning in 1856 by Uoei (Uoya Eikichi), a former fish seller who had established himself as a publisher in the Shitaya district. The prints, in vertical format of *oban* size, actually make up a total of 118, of which three are forgeries by Hiroshige II —namely, *Yamashita in Ueno, The Hachiman Shrine in Ichigaya,* and *Bikuni Bridge in the Snow.* The total reaches 120 if we include *Paulownia Grove at Akasaka on a Rainy Evening,* which is signed by Hiroshige II, and a table-of-contents print entitled *Ichiryusai Hiroshige Issei Ichidai Edo Hakkei* (One Hundred Views of Edo by Hiroshige I). The series won great acclaim and ran to many editions. In editions published around 1869, the "Edo" of the title was changed to "Tokyo" in recognition of the fact that the city had been renamed after the Meiji Restoration of 1868. There was also an edition on crepe-textured paper.

The finest print in the series, as everyone will no doubt agree, is *Sudden Shower at Ohashi* (Fig. 24), which was published in 1857. One version of this print has two boats printed in blackish gray near the riverbank in the background. Opinions differ concerning which is the first edition: the one with the boats or the one without them. Some scholars argue that Hiroshige was dissatisfied with the first version, which included the boats, and had them deleted from the printing block, after which a special black-ink block was carved for the distant scenery, so that the indigo and thin black ink originally used for this scenery were replaced by thin black ink alone in subsequent versions. Others claim that the boats were added by Hiroshige II at the request of the publisher after the death of Hiroshige I. My own opinion is that the first version is the one in which there are no boats on the river— only the raft being poled down the wide expanse of water in the torrential downpour of rain. Prints in which the clouds hang low and irregularly are early editions, while those in which the clouds are

treated with an evenly graded wash are later versions. Also, in later versions, the planks of the bridge are not tinged with gray.

Other excellent prints in the series include *Gathering of Foxes at the Nettle Tree in Oji on New Year's Eve* (Fig. 23), *The Lumberyard at Fukagawa, Suzaki in Fukagawa* (Fig. 28), *Evening View of Saruwaka-cho, The Kinryu Temple in Asakusa, The Village of Uchikawa Sekiya Viewed from near Mazaki, Yabukoji at the Foot of Atago Hill, Fireworks at Ryogoku, Sunset over the Hills at Taikobashi in Meguro, The Bamboo Yard at Kyobashi, Tsukuda Island at the Eitai Bridge, Misaki by Moonlight, Tile Kilns by the Sumida River,* and *The Riverbank at Oumaya.*

Gathering of Foxes at the Nettle Tree in Oji (Fig. 23) is based on a folk legend to the effect that foxes from many parts of the country gathered on New Year's Eve under a large nettle tree at Oji to prepare for a ceremonial New Year's Day visit to the nearby Inari shrine (a shrine dedicated to the fox god and god of the harvest) and that farmers in the vicinity, by counting the *kitsunebi,* or fox fires (will-o'-the-wisps), hovering over the scene, predicted the relative abundance of the coming year's harvest. It is generally known that Hiroshige's print is based on a scroll painting on the same theme in Hasegawa Settan's series called *Edo Meisho Zue* (Pictures of Celebrated Places in Edo), compiled by Saito Choshu and Saito Gesshin and published in 1833. The essential beauty of the first edition of the print lies in the extreme clarity of the twinkling stars and the fox fires flickering in the depth of the winter night.

KUNIYOSHI Many of the pupils of Toyokuni produced landscape prints, but none of these artists are considered to have excelled Kuniyoshi in this genre. Figure 146 reproduces his *Toto Shubi no Matsu no Zu* (Picture of the Shubi Pine Tree in the Eastern Capital) from the horizontal *oban* series *Toto Naninani no Zu* (Pictures of All Sorts of Places in the Eastern Capital), which was published by the house of Yamaguchiya. The Shubi Pine Tree was a famous landmark in the Asakusa Kuramae area, where it stood above a stone wall and extended its branches down to the waters of the Sumida River. It is said to have served as a guide to

boats bound for the Yoshiwara. In Kuniyoshi's print it is visible beyond the bamboo fence built out into the river at the right. A bird flies above the pine tree, while another perches on the fence, but neither of them looks sufficiently graceful to be called a gull. The Ryogoku Bridge is visible in the remote distance at the center of the print. To the left a young boatman, lost in thought, sits with his arms around his knees. Beyond him, on the far shore, we can distinguish a few people in front of the long white wall of the Todo family residence. The blue sky, with its thin trailing clouds, is colored in three shades. More interesting than all this, however, is the foreground. From a crevice in the massive stone wall at right a chrysanthemum-like plant bears desolate-looking flowers, one in full bloom and another withered away to its calyx. Below it a monstrous and repulsive crab prepares to slither out from an aperture in the huge stones of the wall. In the lower right corner a broken barrel hoop of woven bamboo lies half buried in the mud exposed by the ebbing tide, while another hideous crab crawls about on the filthy green duckweed. Atop the triangular rock at the left a gigantic sea louse raises its feelers. *The Shubi Pine Tree* betrays its attractive name, for it is actually a picture that reeks with the rotten odor of decay along the bank of a tidal river. It is a far cry from Kunisada's depiction of the Shubi Pine Tree in his series *Tosei Bijin Ryukogonomi* (Fashionable Tastes of Contemporary Beauties), in which we see the tree leaning out to overshadow a pleasure boat with a bewitching geisha passenger who is washing her white feet in the reedy stream. Few ukiyo-e landscape prints are as peculiar as this one by Kuniyoshi. Other well-known prints in this series of his include *Miyatogawa, Mitsumata, Hashiba,* and *The Riverbank at Oumaya.*

Evening Cool at Ryogoku (Fig. 127) is from Kuniyoshi's superlative series *Toto Meisho* (Celebrated Places in the Eastern Capital), which bears the same name as the two series by Hiroshige noted above. Here Kuniyoshi delights us with a movie-like summer scene on the Sumida River during the closing years of the Tokugawa shogunate. Exploding fireworks light up the evening sky, a pleasure boat crowded with geisha and their male patrons

175. *Ando Hiroshige II:* The Kintai Bridge at Iwakuni in Suo Province *from* One Hundred Views of Celebrated Places in Various Provinces. *Oban nishiki-e. Dated 1859.*

drifts on the blue water next to the boat of a half-naked man who peddles fruits and melons, and stouthearted Edokko in the right foreground honor the god of Mount Oyama with cold-water ablutions while one of them holds aloft a sword that will be dedicated to the god in the hope of bringing them good fortune.

Kuniyoshi's *Snow at Tsukahara in Sado Province* (Fig. 126) is from his *Koso Goichidai Ryakuzu* (The Illustrated Biography of a High Priest), a set of ten prints published by Iseri (Iseya Rihei) in 1831 on the 550th anniversary of the death of the great Buddhist priest Nichiren. It would be no exaggeration to say that the value of the whole set of ten scenes from the life of Nichiren lies chiefly in this single print. Kuniyoshi borrowed the idea for the composition of the print from *Bumpo Sansui Iko* (Sketches of Landscapes by Bumpo). Prints in which the horizon line is more sharply drawn are later editions.

FLOWER-AND-BIRD PRINTS Although the history of ukiyo-e landscape prints actually dates back to the *sumizuri-e* of Moronobu and progresses through the *urushi-e* of Masanobu and Shigenaga and the *uki-e* of Shigemasa and Toyoharu, it is Hokusai who is generally regarded as the founder of the ukiyo-e landscape genre. Likewise, Hokusai may be regarded as the initiator of single-sheet flower-and-bird prints (*kachoga*) of true ukiyo-e flavor, even though earlier artists—for example, Harunobu, Koryusai, Shigemasa, Utamaro, and Toyohiro—produced excellent works in this genre. Still, Hokusai's prints of flowers and birds are not entirely free of Chinese influence. Figure 176 shows his *Shirayuri* (Madonna Lilies).

It is in the large and medium-sized *tanzakuban* flower-and-bird prints of Hiroshige that we find more of the flavor of pure Japanese painting. Approximately twenty-five of these in large *tanzakuban*

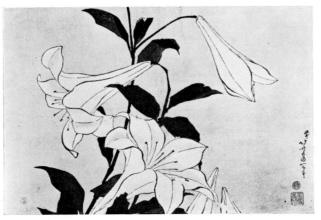

176. Katsushika Hokusai: Madonna Lilies. *Oban nishiki-e. Between 1818 and 1830.*

size (37.9 by 17.9 cm.) were published by both the Jakurindo and the Kikakudo houses, but the editions published by the Jakurindo (owned by Wakasaya Yoichi) are in most cases earlier. Hiroshige also painted fifty-seven medium-sized *tanzakuban* (34.8 cm. by 7.6 cm.) of plants, insects, fish, birds, and animals. These prints were published by Yamaguchi and Fujioka and have come to be known as true gems among ukiyo-e prints. Figure 151 shows Hiroshige's *Sparrows and Camellias in Snow,* a print in the large *tanzakuban* format.

WARRIOR PRINTS AND TOPICAL PRINTS

From early days the scope of the ukiyo-e print included both warrior prints (*musha-e*) and prints of battle scenes (*sensoga*). In Figure 40, which reproduces a single-sheet *tan-e* by Okumura Masanobu, we see the medieval warrior Kiso Yoshinaka during his last moments as his horse flounders in a marshy field.

It seems that the publication of warrior and battle prints was stimulated in the mid-nineteenth century by the prevailing sense of urgency that arose from foreign intrusions and the consequent awakening to the need for coastal defense. The Russians had invaded Japan's northern territories and were demanding the opening of trade with Japan. American warships under Commodore Perry had visited Tokyo Bay, while those of Russia had come to Nagasaki. As the Tokugawa shogunate approached its end, there appeared an increasing number of prints depicting not only the heroic warriors and battles of the old military chronicles but also contemporary battle scenes lightly disguised as episodes from medieval wars in order to circumvent the shogunate ban on picturing current events. The bombardment of Dutch merchant ships by the antiforeign Choshu clan and of Kagoshima by British warships encouraged the publication of prints allegedly depicting, respectively, the subjugation of

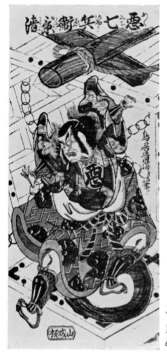

177. Torii Kiyomitsu: The Warrior Taira no Kagekiyo. Hosoban beni-e. Between 1751 and 1764.

the three kingdoms of Korea by Japan in the fourth century and the Mongol invasions of Japan in the late thirteenth century. The anti-Tokugawa rebellion of the Choshu clan in the late 1860's, which the shogunate repressed, was disguised in prints as the rebellion of the Tengyo era in 939 and as the celebrated battle of Dannoura in 1185, in which the Minamoto clan achieved final victory over the Taira clan. The Japanese invasion of Korea in the late sixteenth century also became a metaphor for the shogunate's attack on the Choshu forces, so that a print picturing the military dictator Toyotomi Hideyoshi dispatching his generals to Korea from his camp at Nagoya in Kyushu was readily understood to represent Tokugawa Yoshikatsu, commander in chief of the anti-Choshu forces, at his castle in another Nagoya—that is, the Nagoya in Owari Province (the present Aichi Prefecture)—in a similar scene in the mid-nineteenth century.

When Takeda Kounsai rose in revolt in 1864, warrior prints pictured him in the guise of the sixteenth-century warrior Takeda Katsuyori. His capture in Echizen Province (the present Fukui Prefecture) and his subsequent execution were portrayed in other prints whose ostensible theme was the death of Katsuyori in the battle of Temmokuzan. The assassination of the shogunate councilor Ii Naosuke by antiforeign firebrands in 1860 at one of the gates of Edo Castle was also subsequently pictured in ukiyo-e prints.

Again, no sooner had the shogunate forces been defeated in the battles of Toba and Fushimi (near Kyoto) by the forces of the rebellious Choshu, Satsuma, and Tosa clans than there appeared a work entitled *Morishimayama Kangun Daishori no Zu* (The Great Victory of the Government Forces at Mount Morishima). In fact, however, there was no such mountain. The name was a fictitious one, apparently an allusion to the names of three feudal clans that fought on the side of the newly formed Meiji government: Mori, Shimazu, and Yamanouchi. When the Shogitai, a group of pro-Tokugawa samurai, failed in their revolt at Ueno (in Tokyo) in 1868, the uprising was immediately pictured in prints under the guise of Oda Nobunaga's destruction of the Enryaku-ji monastery and its militant monks in 1571 or the subsequent battle of Ishiyama or, again, the episode at the Honno-ji temple in 1582, when Nobunaga, betrayed by one of his generals, was defeated and forced to commit suicide. Notable among prints on the theme of the Shogitai is the series by Yoshitoshi Tsukioka entitled *Kaidai Hyaku Senso* (One Hundred Selected Examples of Powerful Men). Here, in the *okubi-e* format, Yoshitoshi employs spectacular close-ups and masterly touches to portray the gory death agonies of a number of the rebellious samurai. One of them, Prince Rinnoji (later known as Prince Kitashirakawa), who fled from the Toeizan temple in Ueno, is disguised by the artist as Prince Daito, who lived in the fourteenth century. The eventful period from the downfall of the shogunate through the early years of the Meiji era also witnessed the publication of many prints that satirized and ridiculed contemporary events and social conditions.

CHAPTER NINE

The Collecting of Ukiyo-e Prints

IN ONE OF Kafu Nagai's novels there is a scene in which the hero, seated at a low table that covers a sunken foot warmer and is itself covered with a comforter of red *yuzen* silk, rests his head on his folded arms and gazes at the richly colored figure of a beautiful woman in a Toyokuni print. The print hangs in the semidarkness of the tokonoma behind a flower arrangement in Sekishu style, and it breathes the air of an age gone by.

Behind the foot warmer stands a two-panel screen on which are mounted, along with other pictures, the posthumous memorial portraits of such actors as Tanosuke and Hanshiro. Shivering in the draft as the cold wind from the river blows through the cracks of the room, Kafu's hero wonders if Utamaro's fingers, as he grasped his brush, were ever as cold as this, or if Hokusai ever felt such a chill as the glow of the charcoal in the foot warmer died away.

The hero of this novel—nay, Kafu himself, at a certain stage in his life—found a sedative sense of mental and physical consolation in such seductively colored woodblock prints: the products of artists from the lowest class, commoners in a feudal society living in rented houses in almost sunless back streets. Even those who cannot share Kafu's taste for decadence may, in the quiet of solitary moments, find a fleeting pleasure in contemplating the decadent art of a decadent society.

Ukiyo-e prints are a fragile and ephemeral form of art, suited to private appreciation in the gloom of a barely lit small room. A certain French collector is reputed to have shown his visitors into one of the rooms of his mountain villa, lowered the blinds, put out the electric lights, lit a candle, and slowly produced his ukiyo-e, one by one, from the drawers of a mahogany cabinet. To be sure, when ukiyo-e prints are displayed in a brightly lit exhibition hall, it is almost impossible to find any interest in them.

Collecting is a creative act. A genuine collector should refrain from purchasing the entire collection of another, even though he can afford the expense. One collector gives himself heart and soul to collecting. Eventually his collection is dispersed. Then a new collector enters the field, and later his collection is also dispersed. This process can be repeated endlessly, and it is a most desirable one.

The French novelist Edmond de Goncourt, who was famous as a collector and scholar of ukiyo-e, is said to have stated in his will that he did not wish the works of art that had been his joy during life to be carried off to the cold tomb of a museum after his death. There must surely be others who desire that the works of art they have so earnestly collected be auctioned off one by one and thus scattered throughout the world.

From quite early on, ukiyo-e prints had been

numbered among Japanese exports in the trade with foreign countries that was conducted through the port of Nagasaki. In particular, Chinese merchant ships arrived with many orders for the polychrome prints of Utamaro. Hokusai, also, gained early international recognition as an outstanding artist. At the request of the Dutch sea captain Gijsbert Hemmij and his ship's doctor, who had come to Edo from Nagasaki in the 1790's for an audience with the shogun Ienari, Hokusai painted a hand scroll depicting the life of a typical Japanese commoner from the cradle to the grave. After that, he received orders from Holland for several hundred prints every year, until the shogunate, charging that domestic secrets were thereby being leaked to foreign countries, expressed its displeasure by banning the export of his prints.

In 1853, Commodore Matthew C. Perry arrived in Japan with an expeditionary fleet whose purpose was to end the long period of Japanese isolation from the outside world. Among the souvenirs he bought during his visit were such prints as Hiroshige's *Yodogawa* (The Yodo River) from the series *Kyoto Meisho* (Celebrated Places in Kyoto), published around 1834, and *Oigawa Kachiwatashi* (Fording the Oi River), an *o-nishiki-e* triptych published in 1853. He also bought an *ehon* (picture book) by Kuniyoshi's pupil Shunsai Yoshikazu entitled *Asakura Togo Ichidai Ki* (The Life of Asakura Togo)—a disguised version of the life of Sakura Sogo, the heroic village headman who paid with his life for protesting against the shogunate's ill-treatment of the peasantry.

According to the scholar E. F. Strange, among the prints collected by the Pre-Raphaelite painter and poet Dante Gabriel Rossetti around 1861 or 1862 were battle-scene triptychs by Kuniyoshi and his pupils and illustrations for books of ancient Japanese tales. Similarly, Japanese woodblock prints strongly impressed such painters as Degas, Monet, and Van Gogh, among whom they were highly prized. The writer Edmond de Goncourt was particularly influential in focusing the attention of the public on Japanese prints. Their value as works of art was first recognized in France, then in England, Germany, and America. In the beginning they seem to have interested Westerners simply as exotic art objects that differed completely from Western paintings. Then, little by little, Western artists and connoisseurs came to appreciate them for their aesthetic values.

Ernest Fenollosa, the American professor who arrived in Japan in 1878 to teach economics and philosophy at Tokyo University and became one of the early foreign champions of Japanese art, considered it no exaggeration to say that all the new forms of European art in the half century following the Western discovery of the ukiyo-e, including even impressionism, were in some degree influenced by this form of Japanese art. People like Fenollosa devoted a great deal of study to ukiyo-e prints, which had previously been treated by the Japanese as mere playthings for children or as nothing more than worthless scraps of paper. The efforts of such scholars deserve our sincere gratitude, although it is also true that their enthusiasm helped to promote the exodus of ukiyo-e prints from Japan.

Today it is an extremely hard task to collect fine ukiyo-e prints. Despite a few exceptions like the case of the previously noted Miyagawa Choshun, the main work of the ukiyo-e artist was to produce prints—and usually to mass-produce them. It appears that the simple *beni-e*, which sell at exorbitant prices today, were printed at the rate of as many as two hundred per day. The expression *ippai tori* (literally, "full production"), which is now used among printers and publishers to denote a two-hundred-sheet unit of printing paper, is said to date from the time when two hundred prints represented the daily quota. Fast-selling prints went through edition after edition until the blocks wore out. Hence, in spite of the lapse of time and the frequency of destructive fires in Edo, there ought to be more ukiyo-e prints surviving in Japan today from the early and middle periods, but no one will deny that one of the most conspicuous reasons for the scarcity of good ones is that so many have been exported to foreign countries.

For some time before the outbreak of World War II, numbers of prints that had been exported from Japan made their way back home because Japanese collectors were willing to pay higher prices for them

than their foreign owners had paid. But during the early and middle years of the Meiji era, the exodus of prints from Japan was fantastic. Their artistic value, of which the Japanese themselves had remained disdainfully unaware, was readily recognized by Western connoisseurs, who eagerly hunted these prints down and purchased them, with the result that almost all prints of quality left the country.

Most of the ukiyo-e prints of appreciable value available in Japan today have once been abroad. Many of these works bear the seal "Hayashi Tadamasa" or "Wakai Oyaji." Hayashi was a man who early took note of the Westerners' great interest in ukiyo-e. He mobilized junk dealers all over Japan to collect countless prints at nominal prices and then made an enormous profit by selling the prints in Paris. Wakai Oyaji (Young Dad) was actually Kenzaburo Wakai, Hayashi's senior and partner. While Hayashi was in Paris, his wife took over the job of buying prints in Tokyo. It is said that for prints by artists like Utamaro she paid between eight *rin* and fifteen *sen*—amounts so infinitesimal that in terms of today's money they mean nothing at all.

As original prints became increasingly scarce, the techniques of repairing and reproduction made advances, with the result that collectors were exposed to the danger of being taken in by fakes or by prints that were decidedly not in mint condition. Enji Takamizawa was one of the true geniuses of reproduction and repair work. The painter Ryusei Kishida (1891–1929) notes in his writings that an experienced ukiyo-e dealer was taken in by one of Takamizawa's reproductions, which he bought at a high price. I once asked a certain dealer who the victim was. He replied: "It is not a question of who it was. Almost all the dealers in the Onari-michi district [where there were at one time ten or more dealers] were fooled by his reproductions." Although he was severely criticized, Takamizawa was a real genius in this field. He proved troublesome to people who were searching for original prints, but to those who were content with copies he offered bliss.

Once at a round-table conference on ukiyo-e sponsored by the Bungei Shunju publishing house and hosted by the late novelist and playwright Kan Kikuchi, Takamizawa was commended by the scholar Kisaku Tanaka, who said he thought it strange that Takamizawa had never received official honors. The late ukiyo-e scholar Shizuya Fujikake once confessed: "I couldn't tell Takamizawa's creations from original prints. That was a bit beyond me." And the late poet Yonejiro Noguchi offered the accolade: "That man was a genius in his way."

A great many ukiyo-e prints were produced in sets or series. It is truly a pleasure to turn from print to print through a complete set of Hokusai's *Thirty-six Views of Mount Fuji* or Hiroshige's *Fifty-three Stations on the Tokaido*. Westerners, however, even though they are the best customers for Japanese prints, seem to have practically no interest in sets. They tend, instead, to purchase separately only those prints that are ranked as masterpieces in any given set. This predilection has prompted dealers to break up sets that have taken a great deal of time and trouble on the part of the collector who assembled them. When it is impossible to obtain all the prints of a great series in one purchase, it takes an enormous amount of effort to assemble a complete set through the process of buying them one by one.

The late Tadashi Nemoto, as a member of the Japanese Diet, devoted some twenty-two years of patient effort to securing the passage of a law to prohibit minors from drinking, and he finally achieved his object. With the same stubborn persistence and constant effort, he succeeded in collecting a complete set of Hokusai's *Thirty-six Views of Mount Fuji*, thereby earning the admiration of ukiyo-e connoisseurs. Another enthusiast spent many years in gathering all of Hiroshige's *One Hundred Views of Famous Places in Edo*, including the supplementary prints. It might seem relatively easy to collect Hiroshige's landscape prints, since they are available on the market in considerable numbers, but the very fact that so many of them are in circulation often makes us hesitant to buy.

There are comparatively few of the works of Harunobu and Utamaro on the market. If one is

too fastidious about the composition, the state of preservation, and the quality of what is available, one may lose the chance to buy and never come across a better version. In the case of Hiroshige, on the other hand, one often buys a work that is good in some respects, only to discover better versions later on. Asking a dealer to exchange one print for another is expensive, for dealers demand astonishing amounts of money for making up the difference. A collector often finds it prudent to buy additional copies of the same print instead of paying the exorbitant price for an exchange. Even if he is satisfied with a first edition and believes that he has no need to buy more copies of the same print, he may still find prints of higher quality that, even though they are not first editions, contain improvements on the defects of the first edition. Thus he finds himself tempted to buy a variety of prints that are quite different from the first edition in design or, in other cases, contain slight modifications. In such respects, the collecting of prints by Hiroshige is never an easy task.

The "weathermark" identifies this book as having been planned, designed, and produced at the Tokyo offices of John Weatherhill, Inc., 7-6-13 Roppongi, Minato-ku, Tokyo 106. Book design and typography by Meredith Weatherby and Ronald V. Bell. Layout of photographs by Sigrid Nikovskis and Ronald V. Bell. Composition by General Printing Co., Yokohama. Color plates engraved and printed by Mitsumura Printing Co., Tokyo. Monochrome letterpress platemaking and printing and text printing by Toyo Printing Co., Tokyo. Bound at the Makoto Binderies, Tokyo. Text is set in 10-pt. Monotype Baskerville with hand-set Optima for display.